HORSE COUNTRY

A CELEBRATION OF COUNTRY MUSIC AND THE LOVE OF HORSES

HORSE COUNTRY

A CELEBRATION OF COUNTRY MUSIC AND THE LOVE OF HORSES

LISA WYSOCKY

The Lyons Press Guilford, Connecticut

AN IMPRINT OF THE GLOBE PEQUOT PRESS

**To fans of county music and to horse lovers:
may you have as wonderful an experience with horses as
these artists and I have had.**

And to horses everywhere: Thank you.

To buy books in quantity for corporate use
or incentives, call **(800) 962–0973**
or e-mail **premiums@GlobePequot.com**.

Library of Congress Cataloging-in-Publication Data is available on file.

ISBN 978-1-59921-245-6

Printed in China

10 9 8 7 6 5 4 3 2 1

The Lyons Press is an imprint of The Globe Pequot Press

Text design by LeAnna Weller Smith

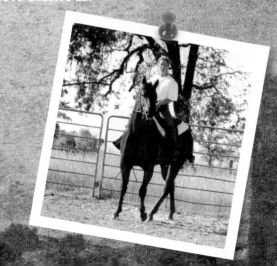

PREFACE

Horses have been teaching me about life, love, trust, determination, and friendship since I was quite small. Not all of the lessons have been easy to learn; some were, to be honest, quite hard.

When I began riding lessons at age six at Hollow Haven Farm near Minneapolis, four school horses were used quite regularly: Phantom, Opium, Paint, and Betty. Each had a distinct personality and a set of strengths and weaknesses that even a six-year-old could decipher.

From Phantom I learned that achieving a difficult goal was a thing worth waiting for. He wasn't the easiest horse to ride, but once I'd paid my dues, he decided I'd earned the right to call the shots. From him I learned that it is important to be respected by your peers.

Opium taught me that it is important to find the right fit in life. Never happy as a schooling horse, he later excelled in the show ring. Opium taught me that you can't make someone into something he's not.

Paint was a little on the lazy side. Whenever the temperature rose above eighty degrees, he mysteriously came up lame. I still remember him limping oh so pitifully to the pasture one hot summer day, only to kick up his heels and run like the wind once he was turned out.

From Paint I learned that no one likes a slacker.

Betty was tolerant. From her I learned that patience and repetition were often the best teachers. Betty taught me about dedication.

LESSONS FROM SNOQUALMIE AND BEN

The summer I turned twelve, I got a little white Appaloosa mare I named Snoqualmie. During the summers of my early teen years, my friends, our horses, and I would play polo, or cowboys and Indians. We'd ride our horses to the lake and use them as diving boards. Long trail rides through meandering woods were a regular occurrence. In the winter, I'd hook Snoqualmie to a toboggan and she'd pull me over snow-covered gravel farm roads.

Snoqualmie became my 4-H project, my youth horse, my grand entry horse, and my game horse. When I was in high school, weather permitting, I'd clamber aboard while Snoqualmie was grazing in the pasture and lie backwards, facing her tail, as I did my homework.

When I took a job as a trail guide, Snoqualmie became my guide horse and when I began giving riding lessons, my lesson horse. I took Snoqualmie to college

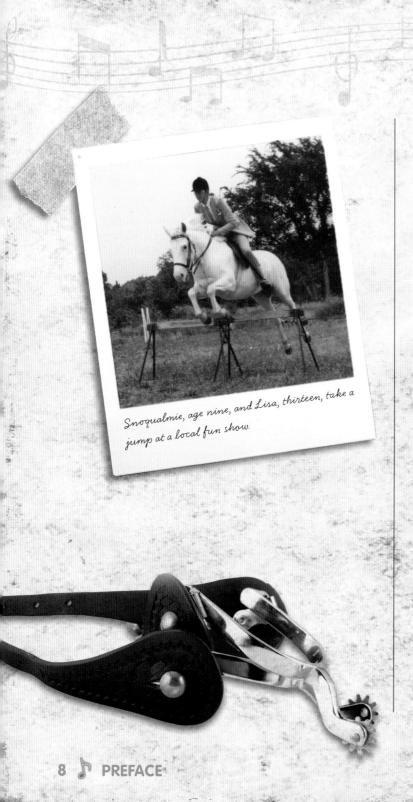

Snoqualmie, age nine, and Lisa, thirteen, take a jump at a local fun show.

with me, then to a training job. She became my pony horse when I was ponying yearlings, and the horse I chose to ride when I just wanted to relax. When I took a fall that damaged my knee and ultimately ended my competitive training career, she was the horse I first got back up on. She was the horse who delivered me from the fear of falling again.

In her later years Snoqualmie became my son's horse. When he was five, they'd canter together across the pasture, bareback, no bridle, her mane flying and he laughing with glee. They'd play pirates with our big black dog, Dexter, Snoqualmie alternately playing the parts of racehorse, Indian fort, ship, or flying saucer and wearing the costumes that went along with the roles. From her I learned the important things: friendship, trust, and responsibility.

Snoqualmie had a son, Ben, and they were as different as night and day. While Snoqualmie loved playing tricks on other people and horses, Ben loved playing with rocks. His favorite activity was to carry one around in his mouth. When he couldn't find a rock, a broom handle or a large stick would do. Ben taught me that playtime was important, no matter what your age.

COUNTRY STARS LEARN FROM THEIR HORSES, TOO

As I got older, I wanted to let others know how much these—and other—horses meant to me. Through my work as a publicist in the country music industry, I learned that many country music stars had similar

experiences with horses in their lives. Maybe it was a horse he or she had as a child, or maybe it was a horse that passed through his or her life more recently. But someway, somehow, either the horse or the experience left a lasting impression.

Every one of the country artists you are going to read about is passionate about his or her horses, but in different ways. Some love the Western disciplines of cutting or roping, some would never give up the easy strides of their gaited horses, and others find the thrills of racing or competitive show jumping intoxicating. While the individual breed and activity with horses differ, all find horses to be wonderful motivators, companions, teachers, and friends.

Those of us who know and love horses understand that they are, for the most part, kind, helpful, and intuitive. Each artist's story reflects a very personal and intimate journey with these special animals, and I am so privileged to be able to share their laughter, joy, and life experiences with horses with you.

—Lisa Wysocky,
August 2008

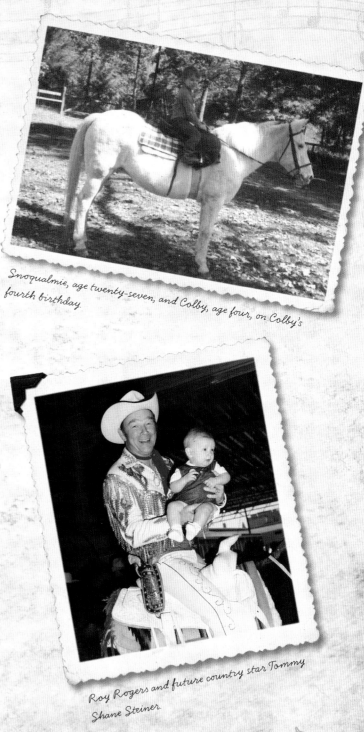

Snoqualmie, age twenty-seven, and Colby, age four, on Colby's fourth birthday.

Roy Rogers and future country star Tommy Shane Steiner.

LEDGMENTS

My sincere thanks to all the wonderful artists who shared their time, thoughts, and memories. I hope I aptly conveyed the depth of emotion in their voices and faces because these talented people truly are horse lovers.

To the many publicists, managers, tour managers, record labels, photographers, personal assistants, booking agents, spouses, and parents of the artists; and to my industry friends: my heartfelt thanks for your never-ending efforts to facilitate interviews, photos, and corrections. If I got it wrong, the fault is entirely mine. Knowing that I will forget some who helped, here is a partial list. To those whom I inadvertently left out, my apologies and my thanks. You know who you are. Thanks go to: Carol Grace Anderson, Kat Atwood, Baccerstick Records, Tony Baker, Kristen Barlowe, Sheila Shipley Biddy, Darlene Bieber, Allen Brown, Paula Brown, Brooke Burrows, Capitol Records, the Careity® Foundation, Julie Carmante, Liz Cavanaugh, Roy Cummins, Curb Records, Sharon Eaves, Don Grubbs, Howard Fields, Hallmark Direction Company, Angie Hamblen, Ronnie Hannaman, Russ Harrington, Doug Hart, Hot Schatz Public Relations, Richard Holland, Debbie Holley, Holley/Guidry Public Relations, Chris Hollo / Hollophotographics, Ann Inman, Colby Keegan, Dennis Keeley, Gina Ketchum, Mark Levine, Paul Lohr, Loudmouth PR, Becky Loyacano, Reggie Mac, Michael Marks, Judy McDonough, Ebie McFarland, Jim McGuire, David McLister, Marne Mclyman, Margaret Malendruccolo, Mike Meade, Doug Merrick, Melissa Miggo, Frank Miller, Ron Modra, Martha Moore, Marc Morrison, Mark Mosric, Mike Nash, Amy Nelson, New Frontier Touring, Tony Phipps, Turk Pipkin, Randi Radcliff, Bob Retzer, JoAnne Ritchey, MB Roberts, Jenna Roher, Schmidt PR, Evelyn Shriver, Don Shugart, Chelsey Shults, Marla Sitten, Julia Staires, Star Keeper PR, Bobby and Joleen Steiner, Lisa Sutton, Paula Szeigas, Karen Tallier, TKO Management, Webster Public Relations, Lyn Walsh, and Amy Willis.

Thanks also to Sharlene Martin at Martin Literary Management whose unwavering support is so appreciated, and to Jessie Shiers, Eugene Brissie, Kathryn Mennone, Erin Turner, Ellen Urban, and the rest of the staff at The Lyons Press.

And as always, my sincere appreciation to Pat Wysocky and Colby Keegan for all you do for me.

DUCTION

Country music and horses fit together as snugly as peanut butter and sliced bread. More than a hundred years ago, when cowboys first sang the kind of songs that would evolve into folk songs and then into the genre known in the early and mid-1900s as country western, horses provided a way of life and a quiet backdrop to the touching lyrics and rolling melodies.

In the 1930s and 1940s celluloid cowboys such as Gene Autry and Roy Rogers sang songs that helped spread the popularity of the down-home style of music. Mass-market distribution and the small-town movie theater ensured that their names, their songs—and their horses—were familiar to every American who frequented a movie theater.

ROY AND TRIGGER: A SUPERSTAR TEAM

Roy Rogers began performing in the 1920s and was one of the first modern-day country stars to be associated with horses. With his striking palomino horse, Trigger; his pretty wife, Dale Evans; and his band, the Sons of the Pioneers, Roy Rogers starred in more than one hundred movies and his own television show, and became an international superstar.

Roy was also a well-known recording artist. RCA-Victor, Capitol Records, Word, 20th Century, and MCA all released charted singles from Roy. He was inducted into the Country Music Hall of Fame in 1988, and in 1991, at age eighty, Roy was back on the country charts in a duet with country superstar Clint Black. The duet was just one song from an album of duets with major country stars, including Lorrie Morgan, Ricky Van Shelton, Randy Travis, and the Kentucky Headhunters.

And what's a cowboy without his horse? Almost as famous as Roy Rogers was his trusty horse, Trigger. While Roy actually rode several horses during his film and television career (all of whom were billed as "Trigger"), the horse we most associate with the name was born in 1934 on a ranch in San Diego.

Trigger was originally named The Golden Cloud and was first owned by a horse breeder named Roy Cloud. While Trigger's exact parentage is not known, he is generally thought to be sired by a Thoroughbred stallion who raced at Caliente racetrack and out of a

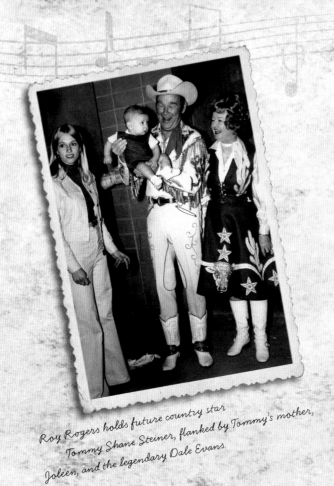

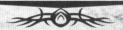

Roy Rogers holds future country star Tommy Shane Steiner, flanked by Tommy's mother, Joleen, and the legendary Dale Evans.

> **Roy became aware of Trigger in 1937 when he was auditioning horses for his first feature film, *Under Western Stars*. The rest is history.**

chestnut Quarter Horse mare. When Trigger was about three, he was sold to Hudkins Stables, a company that provided livestock for California's burgeoning movie industry. Roy became aware of Trigger in 1937 when he was auditioning horses for his first feature film, *Under Western Stars*. The rest is history. Trigger went on to have a stellar career with more than one hundred films to his credit, and lived to be more than thirty years old.

THE LASTING IMPACT OF THE SONS OF THE PIONEERS, DALE EVANS, AND BUTTERCUP

If it wasn't enough that Roy and Trigger became world famous, Roy's band, the Sons of the Pioneers, were the top vocal and instrumental group of the day, and set the standard for every cowboy, country, or western group that has come along since. The Sons of the Pioneers were also one of the longest surviving bands of any genre, performing well into their seventh decade. More impressive than their longevity was the sheer brilliance of their music. Their superb harmonies and stellar arrangements are still inspiring performers of today.

And who could forget Roy's wife, Dale Evans, and her buckskin horse, Buttercup? Dale wrote Roy's theme song, "Happy Trails," and was a noted jazz, swing, and big band singer before meeting Roy. In 1976 she was inducted into the Western Performers Hall of Fame at the National Cowboy & Western Heritage Museum in Oklahoma City, Oklahoma, and in the 1980s she and Roy introduced their weekly films on The Nashville Network.

GENE AUTRY AND CHAMPION SET THE STANDARD

While most people think of Roy Rogers as a movie cowboy first and a recording artist second, when the name Gene Autry is heard it is music that first comes to mind. Gene was the son of a horse and livestock trader who joined the Fields Brothers Marvelous Medicine Show while still a teen. He later took a radio job with KVOO in Tulsa, Oklahoma, and became known as "Oklahoma's Singing Cowboy." He also was heard regularly on the *WLS Barn Dance* radio program out of Chicago.

In 1931, Gene Autry became nationally known with the release of a song he co-wrote, "Silver Haired Daddy of Mine." The single sold over five million copies, an astronomical number at the time—and today.

Hollywood saw dollar signs in the county cowboy, and Gene Autry appeared in countless B movies, usually with his horse, Champion. Over the years of Gene's career there were three Champions, but the one who starred most often was a flashy chestnut Tennessee Walking Horse with plenty of white markings. In addition to filming movies, Gene and Champion made many personal appearance tours together.

The list of Gene's singles during the thirties and forties includes "Yellow Rose of Texas," "Tumbling Tumbleweeds," "Mexicali Rose," "Back in the Saddle Again," and "You Are My Sunshine." Each of those songs is still regularly sung and performed today. Inducted into the Country Music Hall of Fame in 1969,

Too Slim and Ranger Doug, both members of The Riders In The Sky, reflect at the grave of Gene Autry's horse, Champion, at Melody Ranch Motion Picture Studio in Newhall, California. The ranch was used for filming many Westerns beginning in 1915, and Gene Autry owned the ranch from 1952 until the 1990s.

Gene Autry also starred at a series of annual rodeos held in Madison Square Garden.

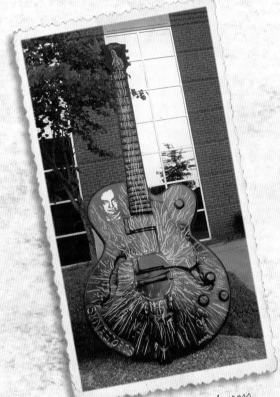

Large guitars similar to this one are found across Nashville. Each has been decorated by a country star

NASHVILLE IS BOTH MUSIC CITY AND HORSE COUNTRY

By the 1950s, at the height of popularity for Gene Autry and Roy Rogers, Nashville, Tennessee, had evolved into a mecca for country stars. With the influx of country artists, and the strength of WSM-AM's radio program the *Grand Ole Opry* (the longest running radio program in history), Nashville became known as Music City USA. Nashville's country music tradition continues today.

In recent years, Nashville has not only been home to the stars of country music. Nashville and its surrounding counties have traditionally been among the top centers for horses in the country. Leading breeders and trainers of polo, eventing, hunter, dressage, grand prix jumping, therapeutic riding, cutting, roping, and Western pleasure horses all call the area home. With horses so popular in the area, it is easy to see how country music stars might become interested in them.

Sometime between the 1960s and the 1980s, the genre of country western music began to split. Acts such as Merle Haggard, George Jones, Patsy Cline, and Conway Twitty became country superstars, while Red Steagall, Michael Martin Murphey, and The Riders In The Sky carried on the tradition of western music. Today's western music embraces the old cowboy rhythms and way of life, while country music followed rock and pop genres to reflect modern-day trials and tribulations.

Today, sometimes it is hard to tell which is which. Just as a horse might be both a 4-H horse and a trail horse, a song can be both western and country. Alternative country sometimes sounds like southern rock, western music can sound like folk music, and contemporary country can be a mix of both, with a little blues, R&B, jazz, pop, reggae, rap, bluegrass, or even funk thrown in.

Whatever the actual style, both country music and

western music are lyrically driven, and focus on real-life emotions such as love, loss, humor, and heartbreak. For decades, those themes have found great appeal with strong, caring, hard-working people, people who will give you the shirt off their backs, dig your truck out of the mud, and send over a casserole when you are too busy in the barn to cook for yourself. The themes of country music, the songs, the words, and the melodies, speak to these people: horse people.

TODAY'S STARS ARE STRONG ADVOCATES FOR HORSES

Another constant between the two styles of music is the connection between the stars and their horses. Kenny Rogers, Willie Nelson, Reba McEntire, Red Steagall, Hal Ketchum and many other country stars have not only performed in western movies, they are passionate about their equine friends. These artists are the modern day Gene and Roy, and they are still mixing their music with their interest in horses.

Willie Nelson, for example, feels so strongly about horses that he has become an advocate for both the prevention of horse slaughter and for the adoption of rescued horses. He actively works with several slaughter prevention, rescue, and equine organizations, and personally has adopted more than twenty rescue horses.

"Horses are all the things a truly evolved human should be," Willie once told cable news channel CNN. "There are countless examples of their innate ability and desire to heal people.

Kenny Rogers, Willie Nelson, Reba McEntire, Red Steagall, Hal Ketchum and many other country stars have not only performed in western movies, they are passionate about their equine friends. These artists are the modern day Gene and Roy.

"Consider the therapeutic riding programs across the country, where horses can have more progress with children with various physical and mental disabilities than their own doctors. The most superhuman thing about horses is the contrast between their unearthly strength and inherent gentleness. Humans abuse their power while horses use theirs only for good. I'd rather be a horse."

Willie is not alone in that thought, as equestrian pursuits are on the rise across the country. An American Horse Council survey indicates that more than two million equine enthusiasts own more than

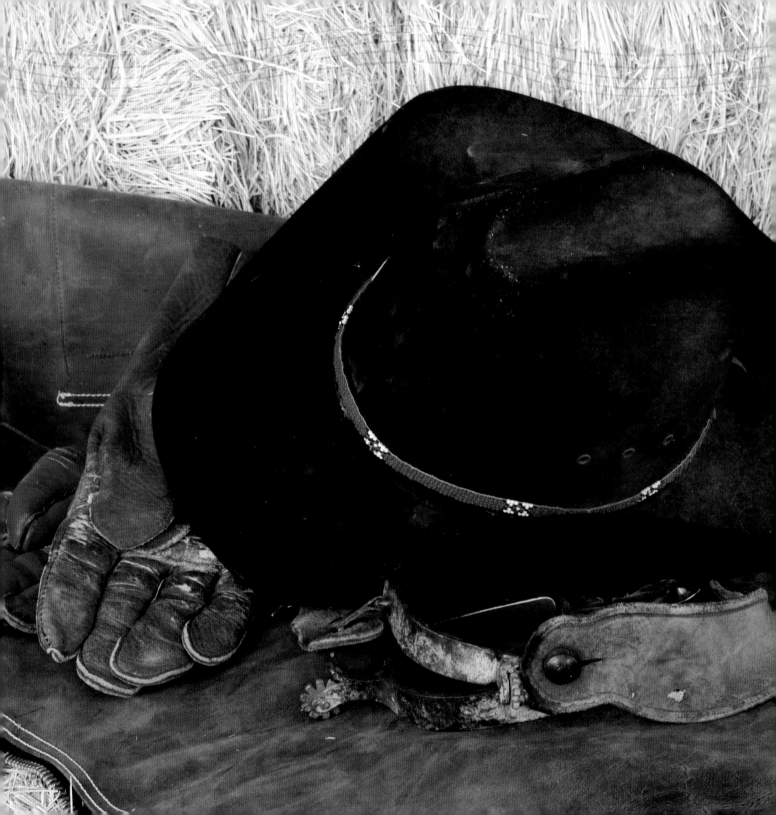

nine million horses. An additional two million people work or volunteer in the horse industry. Horses provide the United States economy with close to half a million full-time jobs and have an annual impact on our country's gross domestic product of over one hundred billion dollars. That's big business.

And matching the rise in interest in horses is the phenomenal growth of country music. The Country Music Association reports that for more than a decade, country music has been the leading radio format in the country, with over two thousand country stations nationwide. More than forty-five million people listen to country music on a daily basis, and the number is growing.

Every horse lover knows it is the deep connection a horse shares with his or her human partner that makes the relationship so special. The stories of the country stars in this book reflect that connection. And while everyone who has experienced a special bond with a horse is forever changed by it, these stars might appreciate the connection a little more. Heavy touring schedules and the crazy ups and downs of a career in entertainment make the need for a solid, unwavering, nonjudgmental companion all the stronger.

Horses have provided that companionship for our country stars for close to a century, and if the following stories are any indication of the passion today's country superstars feel for their horses, horses will provide our country celebrities that companionship for many centuries to come.

Nashville's Music Row is known across the globe.

Over the years of Gene's career there were three Champions, but the one who starred most often was a flashy chestnut Tennessee Walking Horse with plenty of white markings.

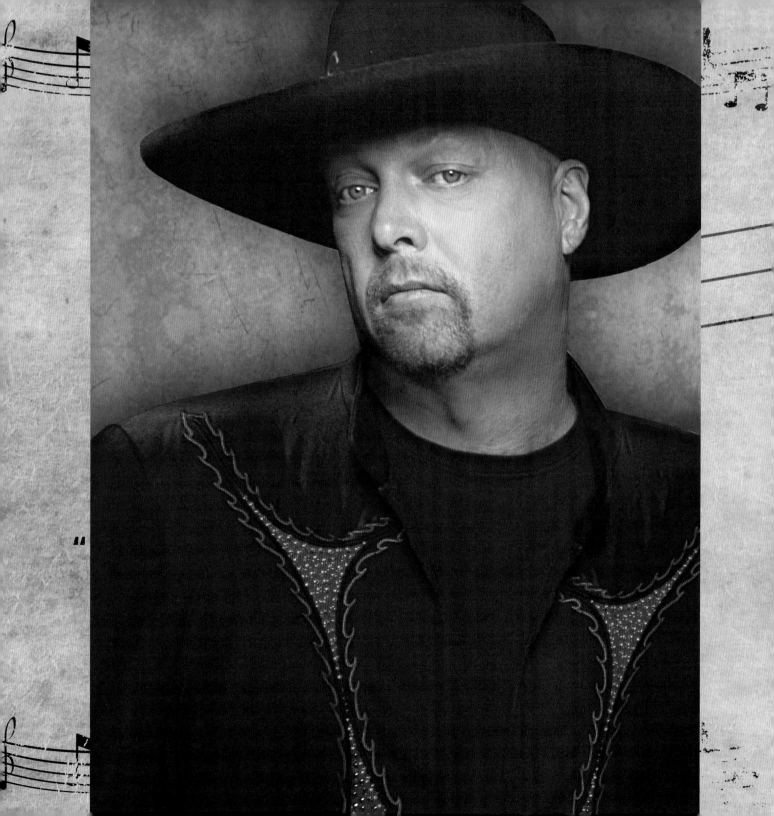

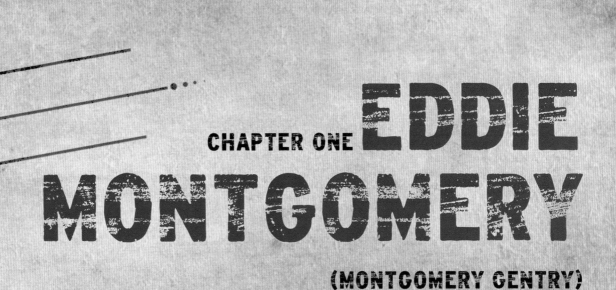

CHAPTER ONE **EDDIE MONTGOMERY**

(MONTGOMERY GENTRY)

WHEN I WAS GROWING UP, MY FAMILY DID TWO THINGS," SAID EDDIE MONTGOMERY, WHO IS ONE HALF OF THE SMASH COUNTRY DUO MONTGOMERY GENTRY, "WE PLAYED MUSIC AND WE FARMED."

Today Eddie is still playing music, although the farming has evolved into recreational horseback riding, and keeping other farm animals such as llamas and goats as pets.

When Eddie was about five, he began performing with his parents' band, Harold Montgomery and the

EDDIE WAS BORN AND RAISED AROUND HORSES AND CAN'T IMAGINE LIFE ANY OTHER WAY.

Kentucky River Express. As Eddie grew into his teens, he joined the band full-time, replacing his mom, Carol, as the group's drummer.

Eddie and his younger brother, eventual country superstar John Michael Montgomery, later created their own musical group, Early Tymz, and played in the Lexington, Kentucky area, which was near their hometown. After the band dissolved, the brothers, along with longtime friend Troy Gentry, formed John Michael Mont-

gomery and Young Country. Several years later John Michael developed a strong solo career and Eddie and Troy re-teamed to become the hot country duo, Montgomery Gentry.

The old saying "what you see is what you get" applies when you meet Eddie and Troy. Rowdy, fun loving, spontaneous, and talented, are words that are synonymous with both the men and their music. In recent years, Montgomery Gentry has been named the Country Music Association's Duo of the Year, and since 1999 has charted numerous hit singles, including "Hillbilly Shoes," "Lonely and Gone," "Daddy Won't Sell the Farm," and "My Town."

But when Eddie Montgomery is not out on the road you can usually find him at home, spending time with his family, and with his horses.

Eddie was born and raised around horses and said he can't imagine life any other way. From his earliest years, Eddie learned about horses from his grandfather.

"Paw Paw used horses strictly for working the farm," said Eddie. "His opinion was that if a horse wasn't working, if he wasn't earning his keep, then the horse didn't need to be there on the farm, and that was true of us kids, too."

But times have changed and even though Eddie's horses aren't pulling a plow, they do have a job. Eddie's horses play a vital role in helping him decompress from the rigors of the road. Horses also form a common bond that allows him to spend quality time with

his wife and children. And while Eddie has owned a number of horses over the years, it is the horse he currently rides that has meant the most to him.

BEAUTY IS FAR MORE THAN A NAME

Beauty is a tall, jet black Tennessee Walking Horse mare. Eddie's wife, Tracy, jokes that Beauty looks like a mule. Eddie good-naturedly disagrees, and said the mare's name is an indication of far more than her outer appearance. Beauty also stands for the horse's gentle and willing attitude and her winning personality.

"Beauty is fifteen or sixteen now, and I've had her since she was three or three and a half," Eddie said. "Either way, we've been together a long time."

Eddie bought Beauty several years before Montgomery Gentry was signed to a major label. In the turmoil surrounding the signing and the early years of his celebrity, Eddie decided to sell Beauty to his aunt.

"I wasn't doing her justice being gone all the time; she deserved more attention than I could give her then," he explained of the difficult decision to part with his beloved mare.

Whether he realizes it or not, Eddie's philosophy is reminiscent of that of his Paw Paw's: everyone needs to be useful. Selling Beauty to his aunt allowed Eddie to keep an eye on her while a trusted family member loved and cared for her—and used her.

"When my career stabilized a little, then I bought her back. I have to tell you though, even though I knew

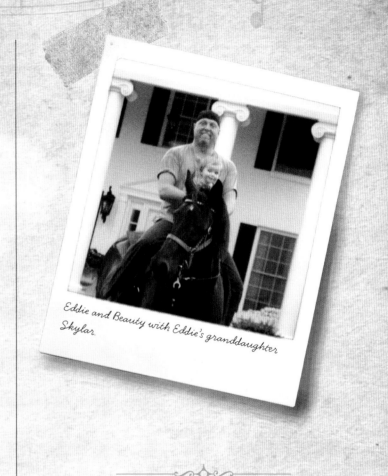

Eddie and Beauty with Eddie's granddaughter Skylar.

"I HAVE NEVER TRUSTED ANY HORSE AS MUCH AS I TRUST THIS ONE. SHE WILL TAKE CARE OF PEOPLE, FOR SURE."

where she was and I could go see her any time I wanted, I really missed that horse," he said.

Like most horse enthusiasts, Eddie is so sold on his mare that it is easy to get him talking about her.

"IT DOESN'T MATTER WHAT BREED THEY ARE OR WHAT SIZE OR COLOR THEY ARE, IT'S WHAT'S INSIDE THE HORSE THAT IS IMPORTANT TO ME . . . ACTUALLY, I'M KIND OF THE SAME WAY ABOUT PEOPLE."

"You've heard the term 'kid broke' [meaning the horse is safe for children to ride]. I tell everyone that Beauty is 'baby broke.' I trust her that much, and she is that quiet and gentle and sensible. Plus, she trusts me one hundred percent, just like I trust her."

Eddie uses a story about crossing a creek as an example of Beauty's intelligence, laid-back attitude, and willingness.

"When we come up to a creek or some obstacle she hasn't seen before, she doesn't dance sideways or back away from it like another horse might. She just slowly stops and looks at it, and then she turns her head around to look at me. It's like she's asking 'Are you sure you want us to go through that?' Then when I give her a little encouragement, she calmly brings both of us through safely and together," he said.

"We definitely work as a team. I like the fact that she is sensible and that she trusts me with her safety, just as I trust her not only with mine, but also with anyone who is around her. I have never trusted any horse as much as I trust this one. She will take care of people, for sure."

The fact that Beauty has the easy stride of a Tennessee Walking Horse isn't lost on Eddie, either.

"She's real soft and easy to ride and I find as I get older, that is more important. I don't need to get jarred around like a rougher-gaited horse does to you," he said. "When I get on she just drops her head in a real relaxed way and sets off, and we go. She's ready for anything I ask her to do, but she always has that quiet, relaxed feel to her."

A GENTLE ATTITUDE IS IMPORTANT

Beauty's quietness is important to Eddie. In years past, he didn't think twice about getting on a young or untrained horse, but now the thought gives him pause.

"I used to be a lot more adventurous when I rode. But not now. I have a lot of people who depend on me both in my music career and at home. I don't need to get hurt on a horse, and I don't need to get my head or back jerked all around," he said emphatically. "And it seems like the older I get the harder the ground gets, so I certainly don't need to fall off, so I've gotten a little smarter over the years. Now if we have a young horse or a horse that is giving some trouble I let my daughter's fiancé get on. He's a horse trainer who knows what he is doing, so all I have to do is sit back and watch. I wish I had been smart enough years ago to figure that out!"

Like Beauty, Eddie's other horses are all quiet, laid back, sensible types, and those are attributes he finds most attractive in his equine friends.

"I have a lot of kids running around the place— my kids, their friends, my friends' kids, and some nieces, nephews, and cousins—and I feel more comfortable if I know all my horses are sensible," he said. "It doesn't matter what breed they are or what size or color they are, it's what's inside the horse that is important to me . . . actually, I'm kind of the same way about people."

And while Eddie enjoys trail riding, he's just as happy riding around his farm with his wife and kids.

"I love my horses so much I'm just as glad to keep them closer to home where there isn't so much of a danger of them getting hurt. Besides, I'm on the road so much that when I'm home, I want to be home," he said. "My younger son has a nice Quarter-type Paint horse that he rides, and my daughter and my wife both ride so we can all enjoy a nice day on the farm with the horses.

"This whole horse thing adds balance to my life. I get to hang with my family and do something we all love, and I have the added benefit of knowing a horse like Beauty. You know, I just don't think it can get any better."

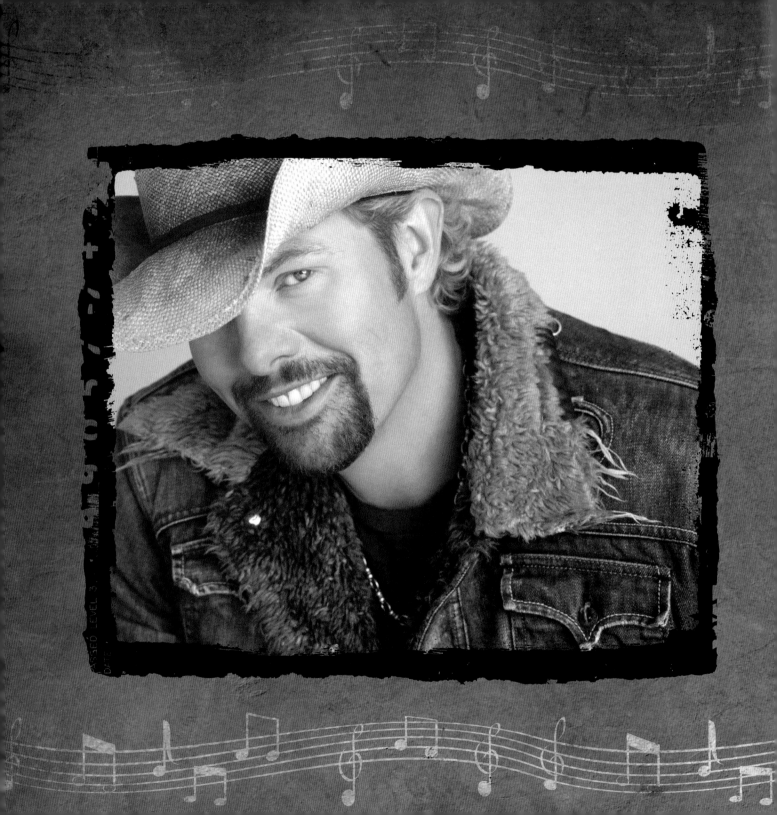

TOBY KEITH

When country superstar Toby Keith was a kid, his family bought a black Appaloosa mare. She had the traditional Appaloosa coat pattern of a white "blanket" over the hips with dark spots in the blanket. Sugar was in foal and the resulting baby, Chukka, was Toby's first experience in raising a foal.

> "My career in entertainment is a lot like my horse operation; at some point you have to have the guts to run or you'll never separate yourself from the pack."

"Sugar was a great little horse and I spent a lot of time on her back," he said.

But Toby added that Sugar did not have any special training. She was a nice safe mount for a kid, but she wasn't a show or a competition horse and she wasn't fine-tuned in any way. As he got older, Toby spent time as a rodeo hand. He rode a lot of ranch horses, and did time riding his share of rodeo stock.

"For a long time I thought all horses were created equal," he said. "I'd ridden Sugar and some other horses that were around and I'd ridden a lot of rough stock. I remember very clearly the first time I climbed on a competition horse. It was a barrel horse that had a lot of speed and would respond with just a touch of your leg. This horse was so fast that he could mow anything else around at five hundred yards. I thought how amazing it was that a horse could be so quick and fast and smooth and sensitive. I had no idea."

TWO CAREERS ARE BETTER THAN ONE

The experience opened Toby's eyes to the many different possibilities that horses could present to him, both in business and as a recreational pursuit.

"I didn't realize it at the time, but the seed for what I am doing now with horses was planted that day," he said.

And what the Oklahoma native is doing is balanc-

ing a very hands-on career in the country music industry with a strong Thoroughbred breeding, training, and racing business. As with the horses, Toby also was exposed to music at an early age.

As a child, Toby idolized the musicians who played at his grandmother's supper club. By age eight, Toby was playing guitar, but other pursuits eventually beckoned. He played high school football, and after graduation Toby took a job working alongside his dad in the oil fields. Toby never lost his love for music though, and formed a band called Easy Money that played local honky-tonks on weekends.

The oil industry hit a slump about the same time the United States Football League formed. Toby made the cut for the semi-pro Oklahoma City Drillers (a farm team for the Tulsa Outlaws).

"I missed playing football so bad," Toby said. "I wished I'd kicked my butt in high school and gone on to play in college."

At six-foot-four and 235 pounds, Toby played defensive end for two years, but he still found time to perform with his band.

With the football league on shaky ground, Toby decided to attack his musical career head-on. For seven years Toby and Easy Money worked the road. Toby eventually landed a record deal, and his self-titled debut disc scored three number-one tunes and a top five. Toby Keith quickly became a force in the music industry with such hits as "Should've Been a Cowboy," "A Little Less Talk and a Lot More Ac-

tion." "Courtesy of the Red, White and Blue," "How Do You Like Me Now?!" and "Beer for My Horses." A few years ago, Toby launched his own record label and is now one of country music's all-time leading acts. Additionally, Toby has added acting to his list of credits, starring as Bo Price in the 2006 feature film *Broken Bridges.*

"Just watching some of the younger horses working out, knowing the promise that they have, and down the road the excitement of seeing that fulfilled . . . that really gets me going."

Throughout all his careers, Toby has rubbed against the grain of the safe and ordinary.

"I worked hard to get here—musically, acting, and with the racing," he said. "But the real work has just started. My career in entertainment is a lot like my horse operation; at some point you have to have the guts to run or you'll never separate yourself from the pack."

THE THRILL OF THE RACE

Listening to his music, it is obvious that Toby Keith has achieved separation. It is also obvious that the man loves a rush. Whether it is the thunderous applause of thousands of screaming fans, or the thunderous beat of a thousand pounds of Thoroughbred horseflesh crossing the finish line, Toby's adrenaline starts pumping.

"In my business, in entertainment, there is a little window of time that you have at the top. Then, when you're done, everyone heads out to the golf course,"

"The best thing about this is I know that horse racing is something that will take me well beyond my time on the road."

said Toby. "Golf doesn't do it for me and apparently it didn't do it for Michael Jordan either because he came back, and then he came back again. Golf wasn't providing the rush he found on the basketball court."

What does do it for Toby is screaming audiences, whether it is at one of his concert venues, or at the track watching one of his Thoroughbred horses run.

While Toby definitely enjoys his success on the country music charts, he said his interest in horses will take him far beyond his touring days. Racing gives Toby a thrill that he elsewhere only finds on stage.

"There is nothing like that rush, that thrill of hearing the announcer call your horse's name first as he crosses the finish line," Toby said, warming to the subject. "And it's not just the racing part for me. Researching the pedigrees is exhilarating. I love everything from finding the right mares, and choosing the right stallions for the mares, to the kick of naming the foals, and weaning them, and watching them turn into yearlings and shipping them off to the track, and starting the two-year-olds and finally seeing them come flying down the track and crossing the finish line. The whole process is such a high."

DREAM WALKIN' FARMS

Today, Toby splits his herd of Thoroughbred broodmares and racehorses on two Oklahoma ranches. The horses and ranches are all part of his Dream Walkin' Farms, a venture he runs with his sister, Tonni.

"We have the mares and the babies at the ranch at home," Toby said, "and then we have another ranch forty miles away where we have a weanling paddock, and a yearling paddock, and a training track, and stalls. We have everything there that you need to start the horses and get them used to racing."

Thoroughbreds from Dream Walkin' Farms can be found running at any number of tracks across the

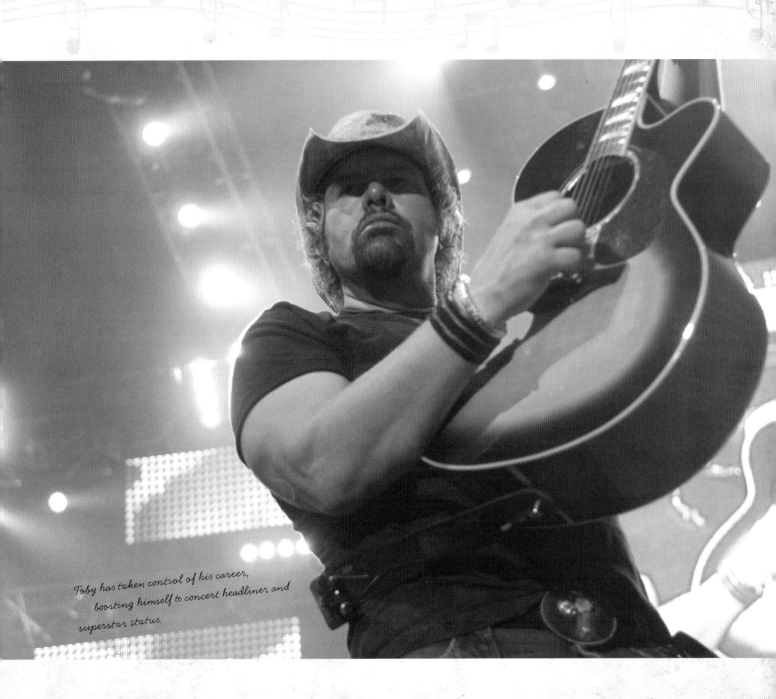

Toby has taken control of his career, boosting himself to concert headliner and superstar status.

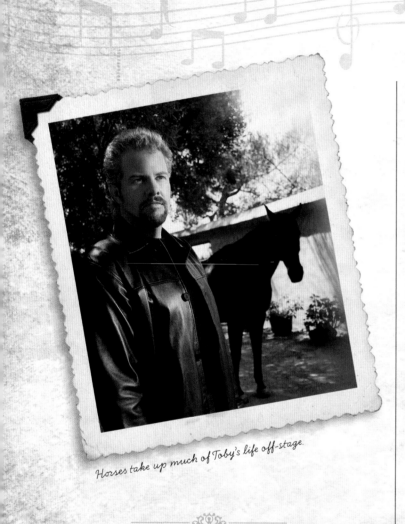

Horses take up much of Toby's life off-stage.

"There is nothing like that rush, that thrill of hearing the announcer call your horse's name first as he crosses the finish line."

country including Fairgrounds, Arlington, Oaklawn, Canterbury, and Churchill Downs. He uses several trainers and often has horses running both in the Midwest and on the West Coast. Like many breeders, Toby is constantly upgrading his broodstock and his runners, and hopes eventually to have some of the highest quality horses in the nation.

One of the things, Toby said, that he likes best about his involvement with horses is that just like his music career, it is a year-round operation.

"It's just like touring," he explained. "I am comfortable in knowing that there is always something going on, some thrill to be had. When May comes around, all the babies have been born, and what a great thing that is. Just watching some of the younger horses working out, knowing the promise that they have, and down the road the excitement of seeing that fulfilled . . . that really gets me going."

THE NAME GAME

A great deal of knowledge and horse sense needs to be absorbed before anyone can be a successful breeder or owner, and Toby and his sister spend a lot of time pouring over pedigree books and charts, choosing names for the foals, and analyzing workout times and race results.

"My sister and I get a real kick out of going back into our past, back into our childhood, and naming the babies something that means something only to us. It's our little inside joke that the rest of the world knows

nothing about," he said. "We especially try to do this if it is a horse we think we are going to keep and race ourselves; we try to tag it with a name that has some significance to us."

For example?

"Well," he said with a chuckle, "When we were kids—I was about five or six and my sister was four or five—my parents were just getting started in life and we lived in this old apartment building called Reagan Court. We named this one horse Reagan Court and we just love hearing the announcer calling the name Reagan Court in a race. And only my sister and I know this fancy Thoroughbred horse is named for an old rundown apartment building."

Mixing the names of a foal's sire and dam, or putting a clever twist on the mix, is one way to name a horse. Toby and his sister tagged another horse, the offspring of Gilded Time and Bugs Rabbit (by Storm Cat), as Golden Hare. Yet another, Toby's first big winner, was named Big Hubie after Toby's father, Hubert "H. K." Covel.

HORSES AS A LIFELONG PASSION

Toby said that even though he enjoys it, life on the road prevents him from doing much riding much these days. But he is quick to add that it is important to him to be sure that there are always a couple of horses at the ranch for his kids to ride.

"My own love is in planning the birth of these horses, and in the training, and all the way through the racing, and until they themselves are producing new babies," he said. "But we do have horses at home that my kids ride."

As Toby heads to yet another performance date, as he completes another interview, and writes one more song that will hit the charts several years down the road, you know that somewhere in there he's going to find time to check out the pedigree of the latest Derby winner and touch base with his ranch manager. He'll be watching races from the satellite TV on his bus and whenever he can, he'll stop in at one of the major bloodstock sales.

"The best thing about this is I know that horse racing is something that will take me well beyond my time on the road," said Toby. "In the music business, I have a little longer window of opportunity than a professional athlete does, but I know my time as an entertainer is here and now and I'll ride it as long as I can. And I'll enjoy the ride tremendously.

"But when I decide it's over, I will have something that excites me equally as much as singing and recording and the road. And it's the horses. If I retired tomorrow, I'd be happy and I don't know how many other artists could say that. It's hard to replace that high that you get from the fans, that total exhilarating thrill you get from being on stage, but I've found it. The only thing that I like equally as much as I do performing is horses. I'll always have them; they'll always be it for me. Horses are my future."

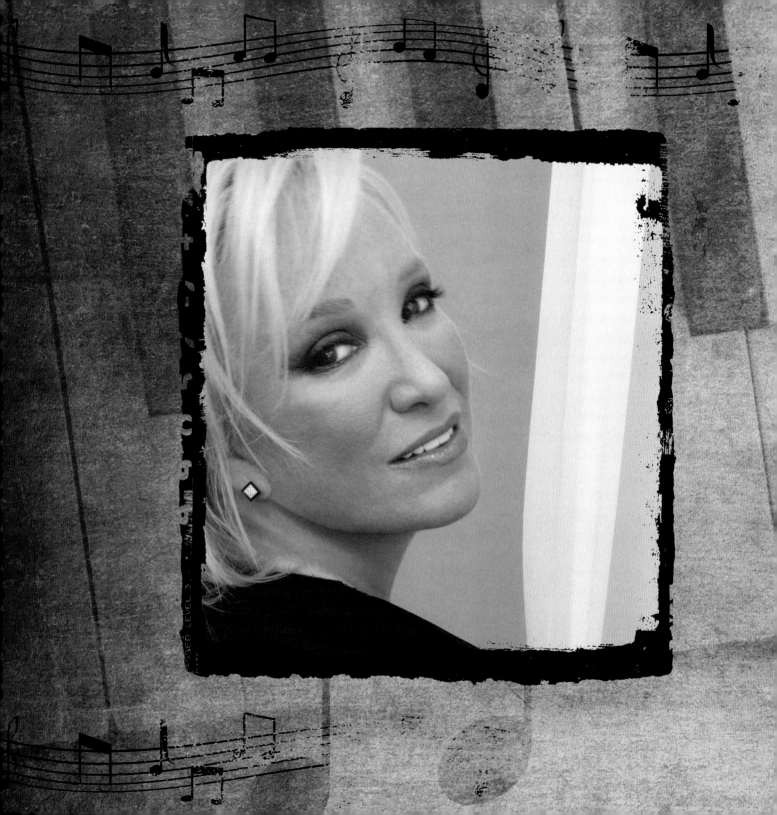

TANYA TUCKER

SHE'S ONE OF THE FINEST SONG STYLISTS IN ANY GENRE. TANYA TUCKER, THE TEXAS TORNADO, HAS DOZENS OF HIT ALBUMS AND SINGLES, AND HAS EARNED HUNDREDS OF HONORS. BORN IN SEMINOLE, TEXAS, TANYA WAS A PRECOCIOUS CHILD, DRIVING THE FAMILY VOLKSWAGEN AROUND THE YARD BY AGE FOUR, AND RIDING HORSES BEFORE SHE TURNED FIVE.

Then one day, out of the blue, Tanya began singing. The Tuckers were living in Wilcox, Arizona,

"I GOT MY FIRST HORSE WHEN I WAS ABOUT FIVE YEARS OLD AND FROM THEN ON, I WAS HOOKED."

when Tanya first appeared on stage with visiting country stars such as Mel Tillis and Ernest Tubb. Not too long after, she landed a part in a Robert Redford film, which jumpstarted her career.

While still a teen Tanya signed with Capitol Records, and recorded numerous hits including "Strong Enough to Bend," "Down to My Last Teardrop," "Two Sparrows in a Hurricane," and "It's a Little Too Late." Tanya has been named the Country Music Association's Female Vocalist of the Year, and Country Music Television's Female Video Artist of the Year. Her "Two Sparrows in a Hurricane" was named the Academy of Country Music's Video of the Year. Later, Tanya

was a top ten Most Played Artist of the Year, and Capitol Records' biggest selling female country artist. In 2002 Tanya had the honor of being inducted into the Texas Country Music Hall of Fame.

While best known for her vocal talents, Tanya is also an author and actress. Her autobiography, *Nickel Dreams* (written with Patsi Bale Cox), was a *New York Times* best seller, and in 2005 she released another book, *100 Ways to Beat the Blues*. In her 2006 hit reality program, *Welcome to Tuckerville*, Tanya opened her life to her fans on The Learning Channel. Viewers followed Tanya on tour, working her horses, playing with her dogs, and parenting her daughters Presley and Layla and son Grayson.

HORSES WERE AN EARLY LOVE

Throughout her career, Tanya's personal and professional life has been an incredible roller coaster of ups and downs, but she was fortunate early in life to find a way to clear her mind.

"I got my first horse when I was about five years old and from then on, I was hooked," said Tanya emphatically.

The horse was a pony given to her by her dad, Beau. Called Pretty Boy Floyd, after the thirties-era gangster, the pony may have been pretty but he wasn't particularly pleasant.

"Every time he raked me off I'd just pop up and get right back on," she said. "He did teach me to ride, though. I was as stubborn then as I am now,

and I wasn't about to let a pony get the better of me."

After one potentially dangerous incident, Beau Tucker apparently decided enough was enough. "He walked that pony right into town and sold him, which was a good thing. Looking back, I could have gotten hurt if I'd ridden him much longer."

Beau soon found another horse for his young daughter, a palomino gelding named Honey Bun. "He pretty much carried me for the next few years," said Tanya. "I remember riding that horse all over the place. Bareback. I didn't have a saddle back then, but we'd just fly across this field back of our house in Wilcox. I spent a lot of time with that horse and even then, when I was a kid, getting on his back allowed me to temporarily forget whatever was bothering me at the time."

A short time ago, Tanya returned to the twelve-by-fifty-foot trailer in which she, her parents, and her brother and sister, had lived.

"I have loads of memories there. When we were all living there, it seemed like a normal sized house, but when I went back it seemed so small to me. Even the area where I used to ride, it seemed so big back then, but it really is this little pasture," she said. "It's funny how things can seem larger than life when you are young."

Tanya's dad (who went on to manage her career) passed away a few years ago, but she said his memory was fresh in her mind during the visit. "I

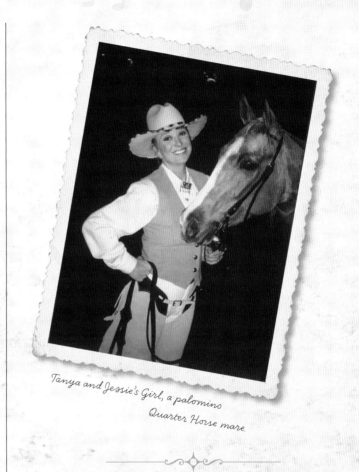

Tanya and Jessie's Girl, a palomino Quarter Horse mare.

"SOMETIMES I CAN'T SEE THE FOREST FOR THE TREES, BUT AS SOON AS I GET ON A HORSE, I GET TO BE A DREAMER AGAIN."

could remember him washing dishes or sitting there in his chair with us kids. He was so much a part of our lives. He knew how much horses meant to me and even though we were struggling financially, he found a way to be sure there were always horses in my life. I can't imagine how hard that must have been for him."

A few years after the arrival of Honey Bun, the Tuckers found a beautiful palomino mare at the Wilcox Rodeo, and bought her on the spot. Ivena

"I FELL IN LOVE WITH CUTTING WHEN I WAS FOURTEEN. I SAW A CUTE BLOND COWBOY AND A WORLD-CALIBER CUTTING HORSE AND I FELL FOR BOTH THE HORSE AND THE COWBOY."

was purchased for Tanya's sister, LaCosta, but when LaCosta went to college and lost interest in the mare, Tanya inherited her.

"Ivena was the horse I rode every day when I was thirteen, fourteen, fifteen years old," said Tanya. "She's the one horse that I have the strongest memories of. Ivena was a great horse for me at the

time. She was gentle, but had enough get up and go that I could do just about anything I wanted on her. And she was sensible. Probably had more sense than I did at the time, so if she didn't want to do something, it was for a good reason. She was a horse I could just go out and talk to or I could race up the road with my friends. Palomino is still my favorite color for a horse and it's because to this day I feel so strongly about Ivena.

IVENA GIVES TANYA A CAREER BOOST

By this time Beau Tucker knew his younger daughter had vocal talent. To get ahead financially so he could help Tanya in her career, he moved his family wherever and whenever he had to.

"We were like the Beverly Hillbillies," laughed Tanya. "We had a crate of pigeons on top of our truck and all our stuff piled up in the back, kids hanging out the windows."

In the early seventies, when the Tuckers were living just across the Arizona border in St. George, Utah, Ivena helped Tanya get her first movie role. *Jeremiah Johnson*, a movie starring Robert Redford, was being filmed nearby.

"The movie was about a trapper in the Old West and they needed a lot of horses for the movie," said Tanya. "All my friends rented their horses out to the movie company. They wanted Ivena, but I wouldn't do it. I loved her so much that I was afraid

something would happen to her. That and I didn't want someone I didn't know riding her or to have her around a lot of unfamiliar people."

Instead, Tanya rented herself out, playing the daughter of one of the movie's characters. Even though Tanya and her family had been making trips to Nashville since she was nine, the movie role gave her a lot of credibility and helped her progress as a country artist.

THE LIFE-CHANGING SPORT OF CUTTING

Since those early days, Tanya has always made room in her life for horses. And like many people she loves the thrill of cutting, a ranch sport that shows how well a horse separates a cow from its herd.

"I fell in love with cutting when I was fourteen. I saw a cute blond cowboy and a world-caliber cutting horse and I fell for both the horse and the cowboy," remembered Tanya.

The cowboy happened to be the son of a noted cutting horse trainer, so Tanya had ample opportunity to learn everything about the sport.

The first time Tanya ever competed in a cutting competition, she placed third. Over the years and many horses later, her skills and her fondness for cutting solidified. She took home top honors in the 1994 KSCS Fair Celebrity Cutting Championship,

and won both the 1990 and 1996 National Cutting Horse Association Celebrity Championship.

It was at a celebrity cutting she co-hosted with country star Marty Stuart, at her own Tuckahoe Farm, that Tanya fell in love with another palomino.

"His name is Jessie Rey Tari, and we just clicked," she said. "It was like magic. Sometimes you have this instant understanding with a horse and that's how it was with us. It was like we'd been

together forever. As soon as I thought something, he did it. He is about the most amazing horse I've ever been around. My dream is to have him right here on the farm with me."

Jessie Rey Tari is a 1985 palomino Quarter Horse stallion by Doc Tari (by Doc Bar) and out of Tami Jessie Rey. He is a noted cutting horse sire and has won more than $172,000 in competition.

Tanya is quick to credit Jessie's sharp mind, athletic ability, and intelligent personality. She believes so strongly in Jessie that she not only would like to buy him, she is writing a song about him.

"The song is called Jessie Rey. People think the song is about a man, but when you get to the end of it you realize the song is about a horse. It's one of those songs that's hard to write. Jessie is so special to me I want to be sure I get it right."

Currently, Tanya rides one of Jessie's sons in cutting competitions. "This horse is not as flashy as his daddy, but he's just as honest. He'll stay with a

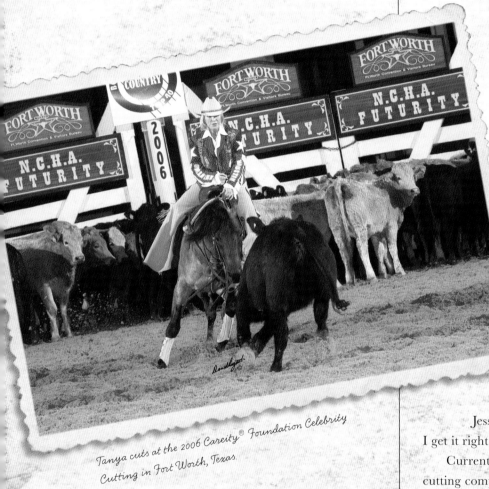

Tanya cuts at the 2006 Careity® Foundation Celebrity Cutting in Fort Worth, Texas.

cow all day long. He's actually a lot like me," she joked. "He ain't pretty until you see him work."

Tanya also has a mare by Jessie that is her daughter's horse.

BALANCE AND PERSPECTIVE FROM HER EQUINE FRIENDS

"Horses have meant everything to me," said Tanya, for once nearly at a loss for words. "I really don't know what I would have done without horses in my life. Horses give me a chance to work out problems. When I am on a horse I can put all my problems aside for a while and when I come back to them, life makes a heck of a lot more sense."

With three kids and a busy career, Tanya is often consumed with the day-to-day difficulties of balancing parenting with being an author, actress, and country music legend. Sometimes life gets so busy, she said, that her nearly irrepressible personality gets lost in the details.

"It is important to me to have balance, to get perspective," she said. "Sometimes I can't see the forest for the trees, but as soon as I get on a horse, I get to be a dreamer again."

Tanya said having dreams—both big dreams and little dreams—is important to her.

"So often dreams are limited by reality: money, time, circumstances. But dreaming big gives people hope," she explained. "It gives me direction and lets

"SOMETIMES YOU HAVE THIS INSTANT UNDERSTANDING WITH A HORSE AND THAT'S HOW IT WAS WITH US. IT WAS LIKE WE'D BEEN TOGETHER FOREVER."

me know what is important to me. Spending time with horses is about the only way I have of clearing my head, of finding space so I can dream. So many parts of my life are unpredictable, but horses . . . horses will always be a constant in my life. Having horses is that important to me."

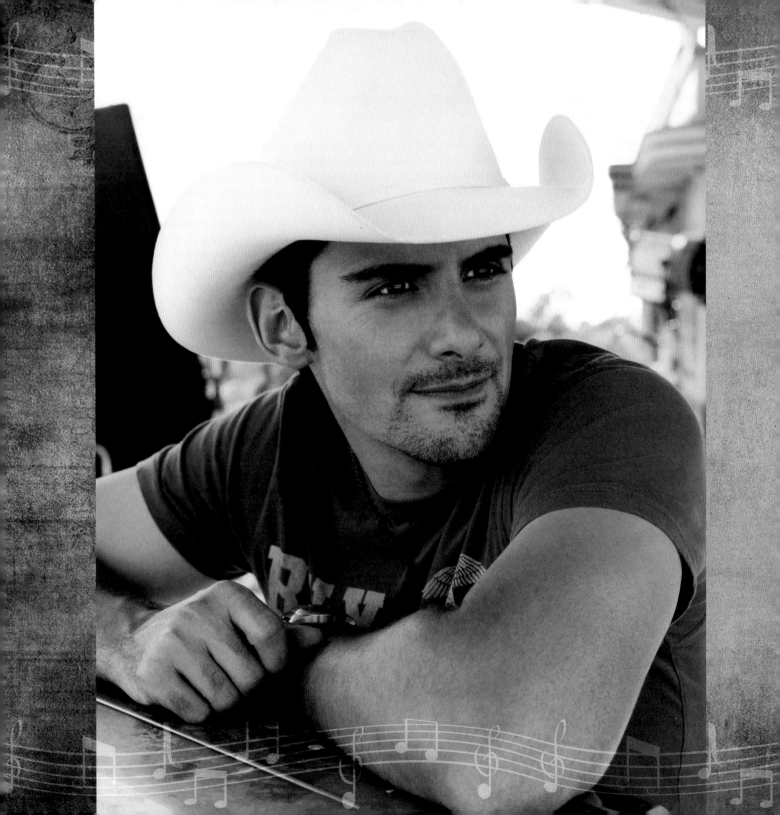

BRAD PAISLEY

No matter how you look at it, Brad Paisley is country. Many in the music community refer to Brad as the torchbearer for traditional country music. Plus, he has won awards too numerous to mention.

Brad was born and raised in Glen Dale, West Virginia, a Mayberry-type

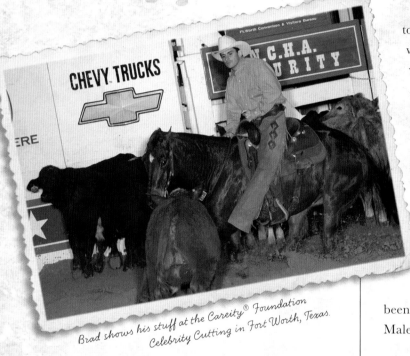

Brad shows his stuff at the Careity® Foundation Celebrity Cutting in Fort Worth, Texas.

town with a population of just 1,800. When he was eight, his grandfather, a night shift railroad worker who spent his afternoons playing guitar, gave him a gift: a Sears Danelectro Silvertone guitar with an amp in the case. The gift would change Brad's life.

Fast-forward twenty years to 1999. Brad Paisley's debut album, *Who Needs Pictures*, was certified platinum. The album produced two number-one hits, both of which Brad co-wrote. One of them was the smash "He Didn't Have To Be." Since then, among other accolades, Brad has had six more number-one hits and has been named the Academy of Country Music's Top Male Vocalist.

PAL IS TRULY A PAL

But while his career is in music, Brad's down time focuses on horses. With a heavy tour schedule, recording sessions, meetings with his business advisors, and requests for interviews constantly coming right and left, Brad finds spending time with his horse, Pal, the best way to get away from it all.

Brad had been around other people's horses all his life, but it wasn't until his first album was out that he had the opportunity to own one of his own.

"The whole thing about horses—I'm totally into all of it. Horses, and my one horse in particular, have taught me so much," said Brad. "But the one big thing

> *"You never realize how strong and powerful the connection between you and a horse can be until you actually have a horse of your own."*

I've learned I'd have to say is friendship. This horse has really taught me what it means to be a friend."

The horse that Brad values so much for friendship is a palomino Quarter Horse gelding named Palomar.

"This horse—I call him Pal because he really is my pal—he's such a great friend," said Brad. "The name fits for his color and for the friendship we have. Pal's the kind of horse that if I show up in the pasture, if he's on the far side, he could be several acres away," said Brad. "But if he sees me, he'll start coming and he'll walk all the way across that field just to stick his nose in my chest and get rubbed. And maybe I've been gone a couple of weeks, but he doesn't hold a grudge. He's my friend unconditionally, and always, he's just glad to see me."

Brad, who is just as personable off-stage as he is on, became interested in owning a horse after a friend described some of the benefits.

"I took some English riding lessons and quickly decided that Western was more my thing," laughed Brad. "My relationship with Pal was my first as a horse owner, so I learned a lot. I've been around horses quite a bit but never owned one myself until I got Pal. Even though people in my family had horses that I was around, they were never my horse, and I found that makes a big difference. You never realize how strong and powerful the connection between you and a horse can be until you actually have a horse of your own."

Brad likes the relationship he has with his horse because Pal doesn't care where Brad's single is on the charts, or how many people came to his last concert. Brad said that it doesn't matter to Pal if the artwork on the CD cover has to be redone or if Brad and his crew have to drive eight hundred miles to the next show. Pal likes Brad simply for the time Brad spends with him. It's a relationship that has enhanced both their lives.

"One thing Pal has taught me is that it's nice for me to have a friend like a horse where I can come and go as my road schedule allows," said Brad. "When I am home, I spend a lot of time out there with him. He's just the best and we've really bonded in so many ways. I was so lucky. I got such a good horse my first time out. Pal's got a really, really good disposition. He's very calm. And he's very laid back."

> **"That kind of relationship—contrast it with the absolute opposite spectrum of the music world that I live in every day. The horse part of my world has enhanced my life in a way that I never thought it would."**

Brad understands that horses are herd animals, so it never ceases to amaze Brad that the minute he steps into the pasture, Pal leaves the other horses and comes right up to him.

"Having my own horse now for a couple of years, I've come to know the relationship between horses and people is a relationship like no other," said Brad. "Here's this 1,300-pound animal who relies on you to some degree. Not only that, he lets me know in so many ways that he really is happy I am there with him. That kind of relationship—contrast it with the absolute opposite spectrum of the music world that I live in every day. The horse part of my world has enhanced my life in a way that I never thought it would."

A WAY TO DE-STRESS

For Brad, spending time with Pal is a way to forget the daily pressures his career brings. It is a way for him to get some much-needed quiet time, to organize his thoughts, and to enjoy the solitude that only a horse and a country road can bring.

"When you're riding a horse, you are not thinking about your day job, or your work, or your career," said Brad. "You're just thinking at all times about where you're headed on this horse and where you're going next."

Brad thinks so much of his equine friend that he bought eighty-five acres near Nashville so Pal would have lots of room to roam. He also added a few more horses and some cows so Pal would have some company

while he was out on the road. Additionally, Brad is in the process of introducing Pal and the joys of horses to his wife, actress Kimberly Williams-Paisley.

No matter how long or short his stay at home, Brad looks forward to his time with his friend.

"For me," said Brad, "the anticipation of riding for a couple of hours just puts my mind in a place so totally away from the music business. I just can't tell you how nice that is, or how important it is. I totally forget about anything that has to do with music, you know? I love what I do, I love making music, but everyone needs a break now and then. Anyone who has or has had a horse probably is very aware of what I'm talking about. Any problems, all problems in your life are gone for those couple of hours. It's almost impossible to really ride a horse and focus on anything else. It adds a ton of balance to my life. I need that balance and nothing else but horses, and this horse in particular—Pal, my pal—delivers it for me. He is my best friend."

It never ceases to amaze Brad that the minute he steps into the pasture, Pal leaves the other horses and comes right up to him.

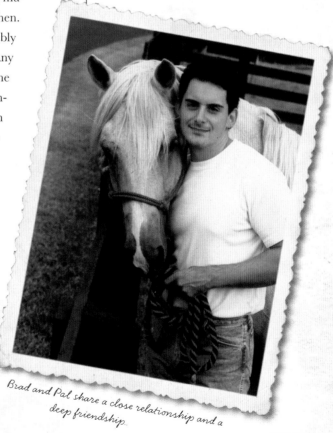

Brad and Pal share a close relationship and a deep friendship.

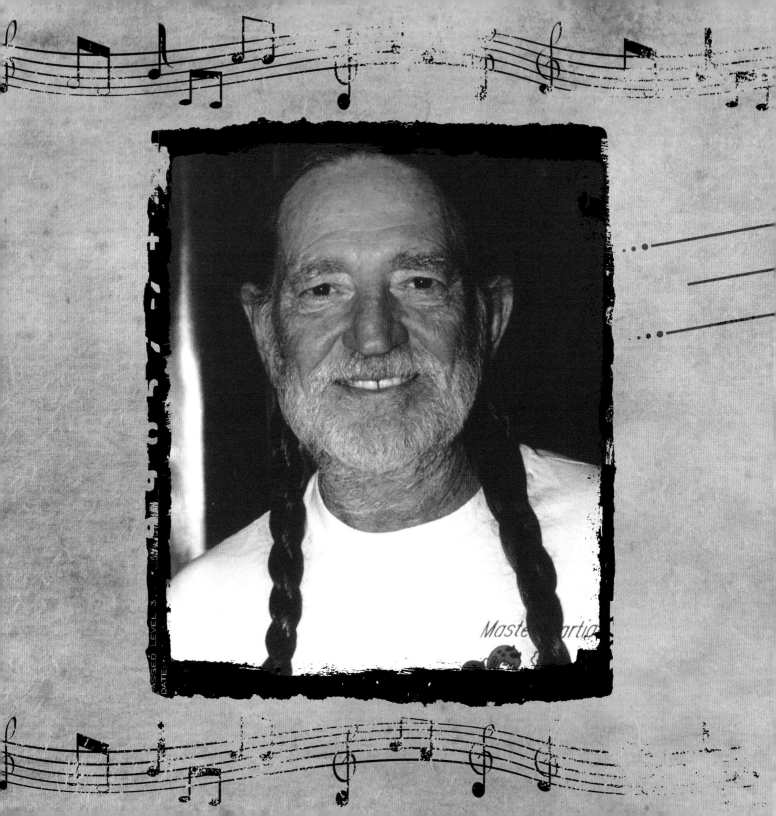

WILLIE NELSON

WHEN MOST PEOPLE THINK OF COUNTRY LEGEND WILLIE NELSON, THEY THINK OF A MAN WHO LIVES LIFE ON HIS OWN TERMS. HE IS A MAN WHO IS NOT AFRAID TO SPEAK ABOUT ISSUES HE BELIEVES IN STRONGLY, AND THE RIGHT TO LIFE FOR OUR NATION'S HORSES IS ONE ISSUE HE IS ADAMANT ABOUT.

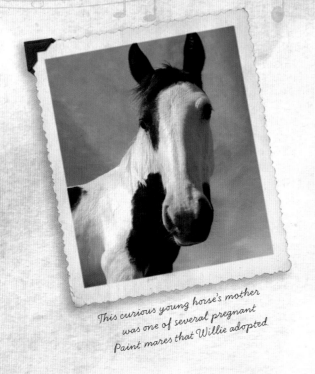

This curious young horse's mother was one of several pregnant Paint mares that Willie adopted.

Willie recently let the world know about the terrible practice of slaughtering horses in our country. He has worked diligently to pass legislation making it illegal to slaughter any horse in the United States for consumption of their meat abroad.

Working in conjunction with the Society for Animal Protective Legislation (SAPL), Willie championed a national awareness campaign that urged citizens to let their congressmen and -women know of their opposition to this practice. Now he is working on legislation that will not only completely end the slaughter of American horses here, it will also end their export for slaughter abroad.

"Now that the slaughterhouses have been shut down in the states of Texas and Illinois, the incidence of transporting horses to Mexico and Canada for slaughter has risen 350 percent," said Willie. "This means transporting horses on journeys of over seven hundred miles with no food or water only to be inhumanely killed. The need to pass this bill, the American Horse Slaughter Prevention Act (H.R. 503/S. 311), is bigger than ever now. H.R. 503/S. 311 would make it illegal to transport the horses to other countries for the purpose of human consumption. We must encourage people to write and call their representatives and get them to vote on this bill."

WILLIE MAKES A DIFFERENCE

While Willie believes wholeheartedly in the cause, he has a personal interest as well. Willie has adopted more than twenty horses from Habitat for Horses, an equine rescue organization in Hitchcock, Texas. Twelve or so of these horses are from the same herd and are gentle, well-bred horses from a loving home whose previous owner had died. Not knowing what to do with the horses, the heirs unknowingly sold them to people who took horses to slaughter auctions. Of a very large herd, only a dozen or so were saved. Willie adopted them all.

Several of those horses, who were mostly skin and bones when they arrived at Willie's ranch in Luck, Texas, were in foal when Willie adopted them. The mares have since produced foals that would never have been born had Willie Nelson not come to their rescue. Each day as he looks out into his pasture, he sees

horses who, had it not been for his aid, would have been cruelly slaughtered.

But Willie wasn't content with just adopting the horses; he has also joined the Habitat for Horses board of directors so he can actively and continually help as many horses as possible. Now, adopters who bring horses rescued by the organization into their homes will receive adoption certificates signed by Willie Nelson.

"Most people don't know it, but until recently nearly 100,000 horses were killed annually in foreign-owned slaughterhouses in America for human consumption in other countries," said Willie. "Now these horses are being send to Canada and Mexico for slaughter. And that's not right. When horse accepted man onto his back and chose to carry his burdens, it changed the world. Horses have aided mankind through his most arduous and treacherous endeavors, from the sword to the plowshare. Humanity owes an incalculable debt to the horse. In Native American teachings, Horse enables shamans to fly through the air and reach heaven. To steal someone's horse is to steal their power. With no disrespect to the eagle, I've always thought that the horse should be our national emblem."

HORSES ENHANCE A STELLAR CAREER

Willie is obviously passionate about his horses. He is equally passionate about his music, books, acting, and other endeavors that comprise a career that has spanned more than half a century.

EACH DAY AS HE LOOKS OUT INTO HIS PASTURE, HE SEES HORSES WHO, HAD IT NOT BEEN FOR HIS AID, WOULD HAVE BEEN CRUELLY SLAUGHTERED.

First known as a talented songwriter, Willie signed with Pamper Music in 1960. In 1961, Faron Young had a number one with Willie's song, "Hello Walls." Then Patsy Cline hit the top with the Willie-penned song "Crazy," and Billy Walker did well with Willie's "Funny How Time Slips Away." Willie Nelson has also written such standards as "Angel Flying Too Close to the Ground," "Night Life," "Good Hearted Woman" (with Waylon Jennings), "Me and Paul," "Bloody Mary Morning," and "Yesterday's Wine."

Long known for his Fourth of July Picnics, Willie staged and starred in his first picnic in 1973, and had his first number one as an artist in 1975, "Blue Eyes Crying in the Rain." Nineteen additional number-one songs followed over the next fourteen years before he returned to

the top in 2003 with his Toby Keith duet, "Beer for My Horses."

In 1976, with the release of *Wanted: The Outlaws*, a compilation of songs by Willie, Waylon Jennings, Jessi Colter, and Tompall Glaser, Willie became an official musical outlaw. Later, in 1985, he joined fellow outlaws Jennings, Kris Kristofferson, and Johnny Cash for the album, tour, and number-one single, "Highwayman."

Willie's 1978 album *Stardust* stayed on the country charts for an unprecedented ten years. In 1982, *Always*

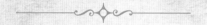

"WITH NO DISRESPECT TO THE EAGLE, I'VE ALWAYS THOUGHT THAT THE HORSE SHOULD BE OUR NATIONAL EMBLEM."

on My Mind won both the Country Music Association's Album of the Year and Single of the Year.

Willie has been inducted into the Nashville Songwriters Hall of Fame, the Country Music Hall of Fame, and the Songwriters Hall of Fame; and the Recording Academy gave him its Living Legend Award and Lifetime Achievement Award. He has won nine Country Music Association awards, including Entertainer of the Year and Vocal Event of the Year. And, Willie has won Grammys for "Always on My Mind," "On the Road

Again," "Georgia on My Mind," "Mama, Don't Let Your Babies Grow Up to Be Cowboys" (with Jennings), "Blue Eyes Crying in the Rain," and "Mendocino County Line" (with Lee Ann Womack). He even has his own channel on XM Satellite Radio, Willie's Place.

Willie's first movie was 1979's *The Electric Horseman* with Robert Redford. He followed with *Honeysuckle Rose*, which introduced the song that would become his theme, "On the Road Again." Other films include *Barbarosa*, *The Songwriter*, *Where the Hell's That Gold?!!?*, *The Last Days of Frank & Jesse James*, *Red Headed Stranger*, *Once Upon a Texas Train*, *Wag the Dog*, *Outlaw Justice*, *The Journeyman*, *The Dukes of Hazzard*, and *The Big Bounce*.

A longtime political activist, Willie co-founded Farm Aid in 1985. The purpose of the festival was and is to raise awareness about and funds for America's farmers. Willie has long been a proponent of biodiesel fuel and has done several awareness campaigns to let people know of its many benefits to our planet. So it's not uncharacteristic for a man like Willie Nelson to grab onto a cause and not let go until significant change is made.

WILLIE CONTINUES TO SPEAK FOR THE HORSE

Over several decades, Willie has owned many horses, and thinks so much of his equine friends that several longtime equine companions are buried on his ranch.

"If you've ever been around horses, especially wild horses, you know they are part of the American heritage," Willie said. "I do have a lot of respect for

my horses, a lot, and I can't imagine a life that did not include them."

Willie knows each of his adopted horses well, and he enjoys watching the new babies learn and grow: fillies Barbara Rosa, Lyric, and Spirit; and colts Music and Django. These are the horses who would never have been born, the horses whose mothers were rescued by a red-headed stranger.

"Horses aren't raised to be eaten like chickens or cattle," said Willie. "Horses are treated daily with products such as fly spray, wormers, and hoof dressings. These products have labels warning against use on animals used for food. Anyone with horse sense would not be exporting this toxic product."

Willie wants people to understand that many horses who are sent to slaughter are stolen pets, or horses who have had unfortunate circumstances, such as the horses he adopted. Many slaughterhouses are buying tens of thousands of American horses and shipping them out of the country to be killed. One of the best-known examples of this was the 1986 Kentucky Derby winner Ferdinand, who was killed in a Japanese slaughterhouse in 2002. Willie is among the thousands of outraged people in the United States who finds this inexcusable.

"More than 90 percent of slaughtered horses are young and in good health, and most are not unwanted horses," he said. "Some are pets; others have just fallen on hard times. It is disgraceful that the treatment of slaughter-bound horses is most often inhumane. They suffer injuries in overcrowded trailers and abuse by

Willie's quiet way and love for horses is apparent as he gets to know several young rescue horses who now live on his Luck, Texas, ranch.

handlers, and they are often conscious during acts of mutilation and slaughter."

Willie also supports the work of the Animal Welfare Institute, an international nonprofit organization whose primary goal is to secure passage of H.R. 503/S. 311.

"Horses have always been an American symbol of freedom," he said. "Their loyal, relentless work is part of what made this country. They are the living legends of American history. I hope everyone joins me in advocating equine adoption and ending horse slaughter. It's time for the cowboys to stand up for the horses."

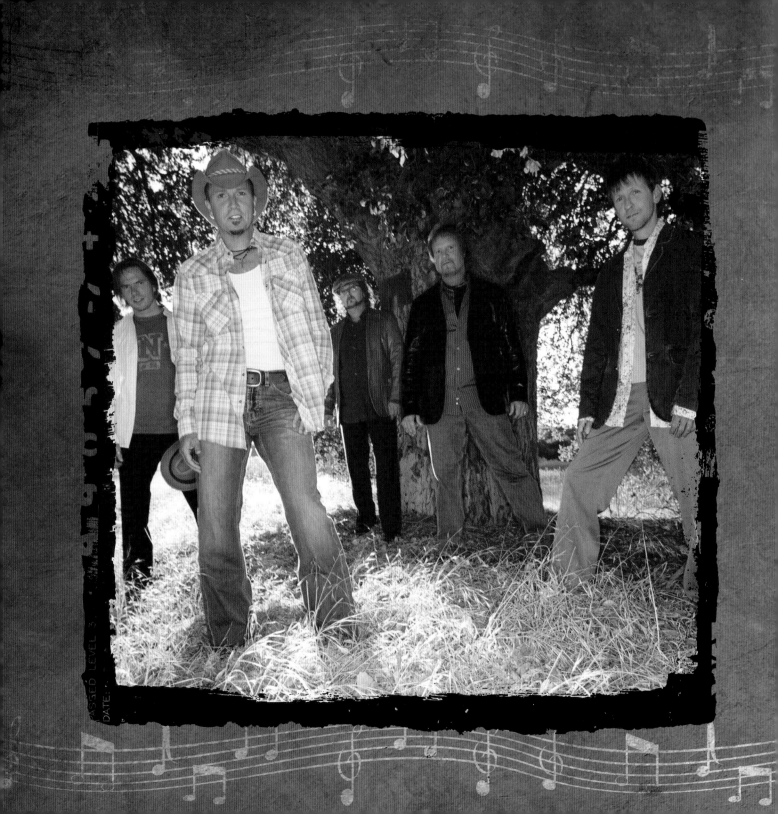

MARK MILLER

(SAWYER BROWN)

In addition to serving as lead singer for the band Sawyer Brown (which claims the title of longest uninterrupted run as a band currently in country music), Mark Miller has a host of other duties. He is also an award-winning songwriter, Grammy-winning producer, semi-pro basketball player, family man, and horse enthusiast.

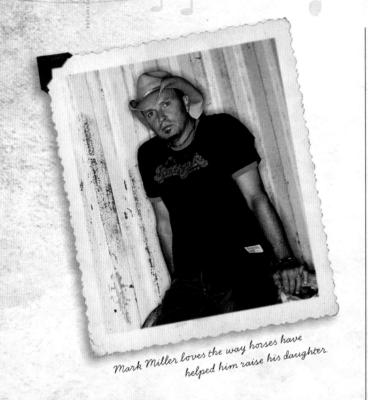

Mark Miller loves the way horses have helped him raise his daughter.

Mark spent his early years on a farm in Ohio where his family had a few Appaloosas, along with other pleasure horses to ride. He loved spending time with his equine friends and was disappointed when, after a move to the small central Florida town of Apopka, horses were no longer a part of his life.

So Mark turned to music. In grade school, the sounds of the Jackson 5, the Beatles, and The Beach Boys were found on his radio dial. As a teen, Mark broadened his interests and listened to everything he could find on the radio as he drove back and forth to his job as a trick water skier at Disney World. Athletics were also important to him, and for a time Mark played basketball at the University of Central Florida. But music kept calling.

Mark eventually dropped out of school and, along with his friend and fellow musician Hobie Hubbard, headed for Nashville, where the pair hooked up with their future Sawyer Brown bandmates.

Several years of performing five and six nights a week were followed by an audition for the hit television show *Star Search*. Mark has confessed that they auditioned just to get a videotape to promote the band. However, the group ended up winning the $100,000 grand prize and a record contract. In that way, Sawyer Brown became the original *American Idol*, gaining thousands of fans through the wonders of national television exposure. The exposure paid off. Sawyer Brown scored a top-twenty hit with their first single, "Leona." Their first number one, "Step That Step," quickly fol-

lowed, and a remake of the George Jones hit "The Race Is On" put them back near the top of the charts. Today, after more than twenty-five years, thirty-five hundred shows, numerous gold and platinum albums, and a host of awards, Sawyer Brown is one of the most acclaimed bands in country music history.

Mark, who became known as much for his energetic performances as for writing the smash hits "Some Girls Do," "The Dirt Road," and "The Walk," among others, learned to deftly balance his time and his interests early on. He worked the band's intense touring schedule around his games playing semi-pro basketball for the Indiana Fury. He found time to coach hoops for both his son's and his daughter's basketball teams. And he found his way back to horses.

HORSES AS A FAMILY ACTIVITY

"Even though I have loved horses all my life, my daughter, Madison, has *really* loved them since birth," said Mark. "When she was still pretty small, we bought her a wonderful, patient little pony, which we named Maddie, after Madison. Now we have quite a few horses."

Maddie, a stocky 12-hand chestnut pony with a star the shape of Africa on her forehead, was donated to a therapeutic riding program in 2005.

Currently, Mark counts six warmbloods, five Tennessee Walking Horse broodmares, and four yearlings as part of the Miller family herd. Mark admits to being a little partial to the Walking Horses, while Madison competes in jumping events with the warmbloods.

"I love the smooth gait of the Walking Horse," said Mark. "They are my favorite type of horse to ride because to me a Walking Horse is the Rolls Royce of horses. In addition to the gait, they have great temperaments, and great spirit. The Tennessee Walking Horse is quite popular here in Tennessee, and I can see

"I love the smooth gait of the Walking Horse. They are my favorite type of horse to ride because to me a Walking Horse is the Rolls Royce of horses."

why. To me there just is not a better ride out there."

Mark has his choice of horses to ride, and his choice is a red-roan Walking Horse named Strawberry.

"I like to pleasure ride because it gives me time to think, time to be one with nature and organize my thoughts," he said. "For me, horses and riding have become a passion. I thoroughly enjoy it personally, and as a family activity it's incredible."

Mark should know, as he is his daughter's biggest supporter in her quest to represent the United States by riding in a World Cup or Olympic competition.

"I'd love to see that happen, but whether that goal comes true or not is up to her," said Mark. "When you get into horses—or anything else—at that level, it's all about the work ethic. If you are willing to put in the time, effort, and passion to be great, well, anything is possible. Her goal is to ride at that national and international level. My goal is to be there, standing in the wings watching her reach that goal."

HORSES TEACH MORE THAN RIDING SKILLS

Mark has already seen his daughter reach many goals throughout her riding career, but not all of them have to do with horses.

"Sometimes I see the young horses out exploring the pasture, or playing together, and the older ones are standing back watching them, letting them learn about their world, and that's just what human parents do."

"After she outgrew Maddie, my daughter thought she wanted to compete, so eventually we found a larger pony called Rainbow. This was the first horse that she competed on at shows of any size, so that was a goal in itself," he said. "In the beginning, this was not a pony Madison was completely in love with because it moved completely differently than she was used to, but her trainer liked the horse and thought it would be able to teach Madison a lot."

And, Mark added, the little 13.2-hand sorrel did.

"That particular pony really taught Madison to ride. She won her first big class on him at a show in West Palm Beach, and the competition down there is so tough that the win was significant."

Significant not only as a test of Madison's abilities, but in her ability to trust.

"Because she trusted her trainer and his opinion of Rainbow as the horse for her, Madison ended up developing a lot of confidence," Mark said. "It was so interesting to me to see that grow in her and now I see it in not only her activities with horses, but in everything that she does."

WILLIE JOINS THE MILLER FAMILY

Madison has moved up in the world of show jumping and currently has her sights set at the highest level: grand prix. Her competition horse for the past year has been a 16.3-hand chestnut Holsteiner mare named Willie.

"I can tell immediately by Madison's facial expressions if she likes a horse, and when she rode Willie for

the first time, she not only was grinning, she was giggling. When she came back from taking her over a few jumps for the first time, she said, 'Oh, I'm really going to like this a lot.'"

And Mark likes Willie a lot, too, because he knows the mare will take good care of his daughter, no matter what happens in or out of the show ring.

"When she got Willie a year or so ago, Willie was a whole lot of horse for the stage Madison was at. I mentioned how I had seen my daughter grow in her level of trust through horses, but trust is an issue for me, too," Mark admitted. "The whole thing for me with her riding is finding her a horse that I can trust. I need to know that when they approach a jump, if Madison makes a mistake the horse will take care of her. If the horse makes a mistake, I need to know that horse will do everything possible to protect my daughter, and Willie is that kind of horse. I trust her."

HORSES TAKE WORK, BUT THE REWARDS ARE GREAT

In addition to trust, and the confidence Mark mentioned earlier, Mark said that horses can assist in the development of many other good qualities in people.

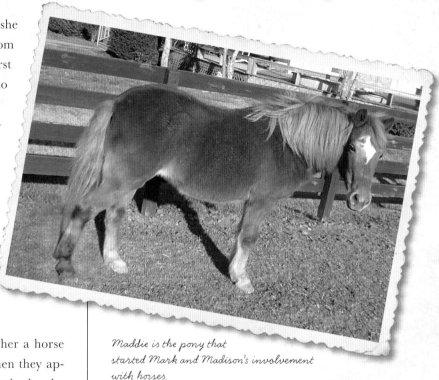

Maddie is the pony that started Mark and Madison's involvement with horses.

"**Horses are a responsibility. They teach you to be dependable because you have to be there to take care of the horse.**"

"Horses are a responsibility. They teach you to be dependable because you have to be there to take care of the horse," he said. "Horses are kind, loyal, patient, hard-working, giving animals, and they teach people about those things, too."

Mark finds so many good qualities in horses that one of his pet peeves is people who do not take proper care of them.

"I think a lot of people get into horses not fully realizing the expense or the responsibility they are taking on. They get into it because it seems like a fun activity—and it is—but they don't take the time to educate themselves about horses and horse care," he said. "It's easy to do the homework and learn to take care of a horse. There are lots of people out there all over the country who know what they are doing, so I don't understand why some people don't seek out those who have the knowledge and learn from them. Horse are big animals, but they can be quite delicate, too, so taking the time to learn before you buy is important."

Mark said that every day he and his family spend in the company of horses they learn something new. He also finds it exciting to watch his horses progress through life.

"It's great watching the broodmares take care of their babies and watching those babies grow up and learn about life," he said, "and I find it's not so different from me with my kids. Mares, and even some geldings, have a very nurturing relationship with the younger horses. Sometimes I see the young horses out exploring the pasture, or playing together, and the older ones are standing back watching them, letting them learn about their world, and that's just what human parents do."

LESSONS FROM THE MILLER HORSES

Earlier in the week, the Millers accepted delivery of three young warmbloods from Europe. The horses are potential competition horses for Madison and are three, four, and five years old.

"The day after the horses arrived, Madison wanted to ride the three-year-old and I was very apprehensive about it," said Mark. "She started out in the round pen where everything went along fine, and then moved to the bigger arena, where she had a few troubles. She rode up to me, and I asked if she was getting off, and she said, 'Oh, no, I'm just getting started.' Later, I told her how blown away I was with her confidence, her control, her determination, and her patience in getting that horse to understand what she wanted him to do. I never would have seen that from her a few years, or even a year ago, and those are all qualities that will help her later in life, no matter what she does.

"In that way, horses have helped me raise my daughter. They teach her things in a way that I can't. I see her so poised, so strong, and with so many possibilities, and I have horses to thank for that. Every parent's children are their future and horses have helped my child reach her full potential."

Whether or not Madison reaches her goal and becomes an Olympic-caliber rider, Mark knows that his family will always have horses.

"Horses give us so much," he said emphatically.

"I know that home wouldn't seem quite like home without them."

> **"Horses have helped me raise my daughter. They teach her things in a way that I can't. I see her so poised, so strong, and with so many possibilities, and I have horses to thank for that."**

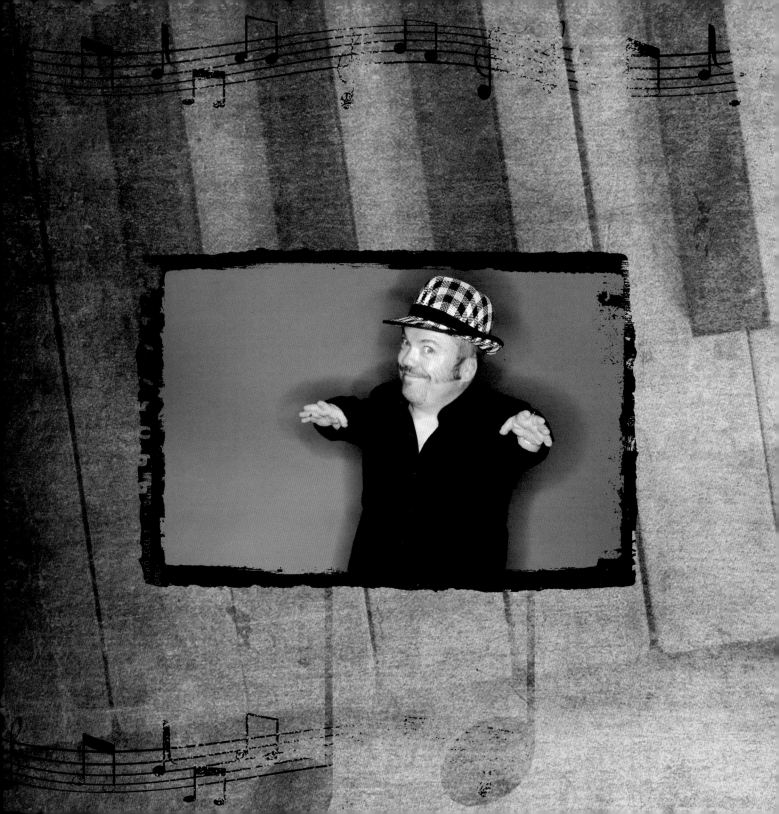

TWO FOOT FRED

FROM THE TIME HE WAS YOUNG, FRED GILL (WHOSE STAGE NAME IS TWO FOOT FRED) WANTED TO RIDE A HORSE. BUT AS WITH MANY PEOPLE, THE OPPORTUNITY WAS NOT THERE. HORSES DON'T GROW ON TREES, AND IN HIS SMALL-TOWN NEIGHBORHOOD IN INDIANA, DOGS AND CATS WERE A FAR MORE COMMON SIGHT THAN HORSES.

Since graduating, Fred has owned and operated several restaurants and nightclubs; a real estate company that owns several hundred apartment units; a movie and television production company; and a text messaging firm. Despite his success, finding an opportunity to ride a horse was always at the back of his mind.

In addition to his business interests, Fred loves country music. A chance meeting with country megastar John Rich of the country duo Big & Rich landed Fred smack in the middle of the duo's debut video. The video, which was aptly named "Save a Horse, Ride a Cowboy," didn't put Fred on the back of a horse, but it pointed him in that direction. Big & Rich soon asked Fred to emcee their live performance dates, and he now performs with them in front of hundreds of thousands of people annually. Additionally, his growing celebrity has landed him on countless television shows.

MUSIC LEADS FRED TO HORSES

Through Fred's exposure in country music, he had the chance to tour a therapeutic riding program in Franklin, Tennessee, called Saddle Up!, which helps children with disabilities. The best part of the tour? Fred finally was able to fulfill his dream and ride.

"Those of us who have never ridden really don't have any idea of what to expect," Fred said. "I know I didn't. It was so much more and so very different than what I imagined."

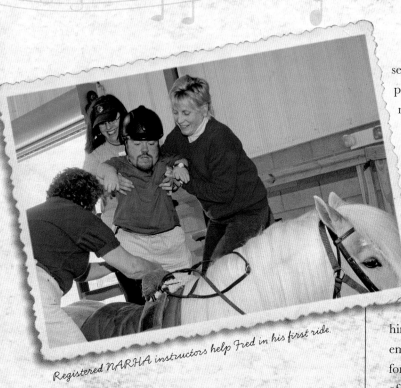

Registered NARHA instructors help Fred in his first ride.

Complicating matters is the fact that Fred Gill is a diastrophic dwarf who stands thirty-eight inches tall. His shortened arms and legs also have deformities, as do his back, ears, and feet. It is fortunate that Fred was born to extremely supportive parents who encouraged him to pursue his dreams. The business world interested him, and after starting a few small businesses while still in high school, Fred obtained a degree from Ball State University's highly respected and nationally ranked entrepreneurship program.

After waiting so many years to ride, Fred found the experience freeing, exhilarating, and just a little bit scary.

"Thinking about the ride ahead of time was somewhat unsettling," he said. "Just like anything you haven't experienced before, whether it is going on a job interview or riding a roller coaster, there is that fear of the unknown. Once you are in the middle of the experience, that fear goes away and you gain confidence."

You only have to see his smile to know that Fred is all about staying positive and confident, but he is also adept at using reason to assess stress.

"Logistically, I knew that I was in a controlled environment and had experienced people around me; these were people whose careers were built around getting people with disabilities onto a horse. But I have to admit that from a balance standpoint, I was a little nervous about actually getting on," he said. "But they took good care of me and once that part was over I could relax a little."

Fred's disproportionate limbs can make walking long distances awkward, so Fred often gets around by riding a three-wheeled motorized scooter.

"I think all that time on the scooter actually made my balance better than what I thought it was, and after about five minutes I found my rhythm and could relax and go with the horse as she walked around the indoor arena."

Several registered therapeutic riding instructors helped Fred find his seat and assisted him on his ride.

"I normally sit more on my right hip and keep my right leg kind of underneath me and toward the left," he said. "And that's how it worked out best for me to ride. I was facing forward, but I really was riding more sideways than astride, just like I sit on my scooter."

"THOSE OF US WHO HAVE NEVER RIDDEN REALLY DON'T HAVE ANY IDEA OF WHAT TO EXPECT, IT WAS SO MUCH MORE AND SO VERY DIFFERENT THAN WHAT I IMAGINED."

GRETEL HELPS FRED RIDE

The horse Fred rode was an eight-year-old, 13.2-hand, Haflinger mare named Gretel. Haflingers are small, quiet draft horses who have very broad backs.

"I know the people at Saddle Up! debated whether to put me on a narrower horse where I might possibly ride with one leg on each side of the horse, but they eventually decided the broader back would give me more stability and balance, and I think they were right. That was the first time that I ever thought about a horse having to 'fit' a rider. It's like wearing a pair of shoes or driving a car, each component has to fit well with the other."

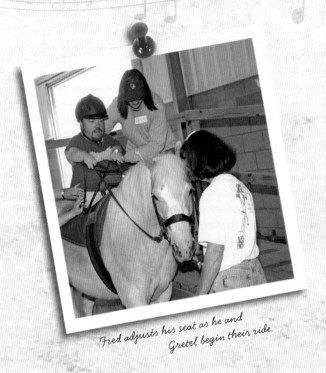

Fred adjusts his seat as he and Gretel begin their ride.

Fred said that Gretel's movement was much less jarring than he had anticipated, proving once again the theory that the biggest fear of all can be the fear of the unknown.

"I think riding is like anything else in that you want to get your feet wet in a controlled environment," he said. "I wouldn't advise anyone to just get on a horse and take off at a gallop any more than I would advise someone to start a business without having a good plan for the business, or to get on stage to perform for thousands of people if they had never performed before. Start slow. Find your comfort level. Surround yourself with people who know what they are doing. It's good to

push your boundaries a little, but within reason."

During his ride, Fred quickly realized that while it was easy to relax into the rhythm of the horse's movement, if the horse broke that rhythm and stepped out of the normal stride, it was difficult to get his body to follow with the horse.

"I can see how you really have to flex and bend to move with the horse, and that mentally you have to be in tune enough with the horse to anticipate the movement and understand why the horse moved a little differently," he said.

In Fred's case, Gretel took a few awkward steps with her hind legs to adjust Fred's weight on her back and then tensed as her shifting moved Fred further out of balance.

"I thought it was cool that Gretel was trying to help me have a better experience," said Fred. "She really listened to my voice commands and I could see her ears moving back and forth trying to figure out what I was asking her to do. That was pretty awesome, knowing that we had just spent a few minutes together but she still wanted to work with me as a team. I also realized that horses pick up emotional cues from the people around them. If I—or the people helping me— were tense, then she would become tense, but when everyone relaxed, then Gretel relaxed. That's a very powerful concept to me."

AN UNEXPECTED BONUS

The togetherness aspect of riding was most the unexpected part of the experience for Fred. Amazed at how

intuitive Gretel was to his thoughts and feelings, Fred thoroughly enjoyed the bonding experience.

Since his ride, Fred has become excited about encouraging others who are interested to get involved with horses, and used himself as an example. "If you are interested, go for it. It was an amazing experience. I've accomplished so much already in my life and I've only been able to do that by setting goals, and then seeking out opportunities to make the goals happen. I had to wait more than thirty years to get on the back of a horse, but I did it, and under the same controlled circumstances, I'll do it again."

Fred is a believer in the concept of "no excuses" and said that as a dwarf, he has every reason to say, "I can't." But he not only can, he did. And if *he* did, he reasons, then others can, too.

"I can easily see how a someone could become good friends with a horse," he said. "At the end of the ride I was back on my scooter and we were there in the center of the arena standing side by side and Gretel tapped my scooter with her nose and nibbled on it a little, just to see what it was. She was very quiet and it was obvious that this was her way of saying we were friends; it was her way of showing me that she wanted to get to know me better.

"It felt so good to me that Gretel felt comfortable enough to do that. Later she walked right alongside me as we moved back to the grooming area together. Gretel reached out to me and I totally felt the connection between us. It was very cool."

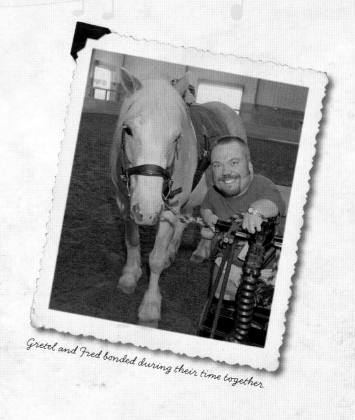

Gretel and Fred bonded during their time together.

"I HAD TO WAIT MORE THAN THIRTY YEARS TO GET ON THE BACK OF A HORSE, BUT I DID IT, AND UNDER THE SAME CONTROLLED CIRCUMSTANCES, I'LL DO IT AGAIN."

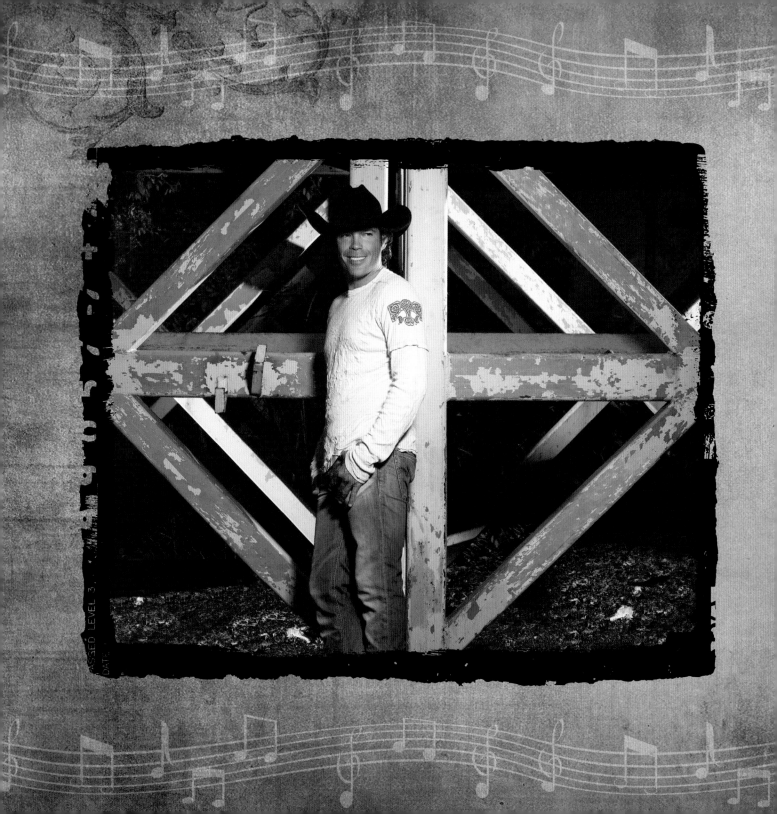

CLAY WALKER

Clay Walker is one of country music's most successful contemporary artists. By the time he was a teen, Clay was already playing the honky-tonks near his native Houston. After expanding his following to Texas, Louisiana, Oklahoma, and New Mexico, Clay signed with a major label in 1993 and released his

debut album the same year. Since then, not only has he had thirty-one songs on the *Billboard* singles chart and sold more than eight million albums, but for five straight years *Billboard* included one of his songs on its year-end top-ten country list, a record unmatched in the same period by any other artist.

Since 1995, Clay has often been the grand finale performer at the Houston Livestock Show and Rodeo, one of the biggest shows in the business. But in addition to headlining the event, another accomplishment Clay is very proud of is having placed seventh in the show's prestigious cutting horse class. He is even prouder that he rode one of his own horses, Maddie, in the competition.

GROWING UP WITH HORSES

Clay began his love affair with horses at a very early age. Horses have since developed into a true passion, and the depth of his enthusiasm is evident in his voice.

"My first horse was a Tennessee Walker named Star," he recalled. "She was a real bright sorrel with a star in the middle of her head. I was three when I got her and I remember that I named her. I had her from then until I was about six."

When he was growing up, Clay, who is the oldest of five, lived on the outskirts of town.

"We were in the middle of a rice field in the woods about five miles outside the city limits, and it was a great experience because we literally had hundreds of thousands of acres around us to grow up on. No highways or roads; we just rode horses," he said. "We had chickens, pigs, cows, and sheep; we had everything, including our own garden. It was definitely a hillbilly way to grow up, but I tell you, I loved it."

Eventually Clay became interested in Quarter Horses. He spent some time starting two-year-olds, and then selling them after they were going along well.

"That was a nice little side income and it really worked out well in a lot of ways," said Clay. "I've started a lot of colts out and that's probably what I've enjoyed more than anything about horses, except maybe foaling. I don't do it anymore because it can be a little dangerous, but I loved starting colts."

Clay added that he misses doing groundwork, the art of laying a solid foundation for a good riding horse with activities and training from the ground before the horse is ever ridden.

"There really is no better feeling than a two-year-old who has gained trust in you, and the first time you climb on its back it walks off like it has had sixty days training. I love that," he said.

CLAY AND SANDY

While Clay has started—and ridden—hundreds of horses, there is one, a line-backed dun-colored Quarter Horse mare who stands out.

"Sandy will always hold a special place in my heart," said Clay. "She bucked me off a few times, but after that we became very close. I eventually gained her trust and she earned my respect, and our relationship turned into something very, very special."

Sandy was a finished calf horse, meaning that she could rope calves with the best of them, but Clay used her mostly for everyday ranch chores.

"She had a passing gear that Ferrari would envy and she was built like a brick house," Clay recalled. "She was a pretty horse, too, and I used her in a couple of videos and promotional photos. I also bred her a few times and ended up with some really nice colts who went on to become good roping horses."

When age crept up on Sandy, Clay was so fond of the mare that he turned her out in the pasture and just let her be a horse.

"She was turned out for eight years and during that time she never failed to come up to me in the pasture for some attention and affection," said Clay. "That bond we made together lasted her entire lifetime and it was so incredibly special that it is really hard to describe."

Sandy lived to be twenty-nine.

"There really is no better feeling than a two-year-old who has gained trust in you, and the first time you climb on its back it walks off like it has had sixty days training. I love that."

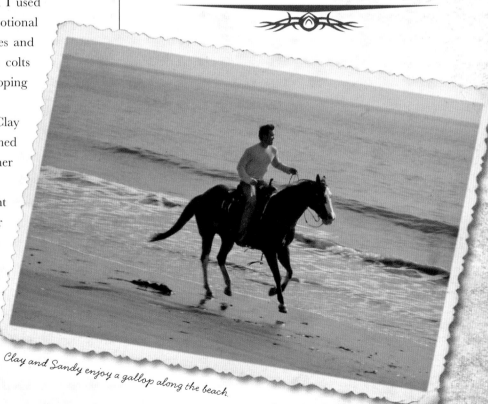

Clay and Sandy enjoy a gallop along the beach.

THE BENEFITS OF GOOD BREEDING

While Clay gets a great deal of enjoyment from the relationship aspect of his interaction with horses, he also actively studies equine conformation—the actual build of a horse.

"I am a big fan of a strong hip with a big carry down, and a nice croup," he said. "I've always been

"I think the greatest experience that I've had with horses in general is during foaling time, during foaling season in the spring."

a fan of that build in a horse because I like halter horses [horses prized for their conformation]. I like to see horses that have some pretty to them, but I want those horses to go out and do something athletic, too."

Clay said he can tell fairly early on if a particular horse has the look and athletic ability he is looking for. So early, in fact, that he likes to be on hand when the foal is born.

"I think the greatest experience that I've had with horses in general is during foaling time, during foaling season in the spring," he said. "There is nothing like the experience of being present when a new foal is born; it is absolute joy! The anticipation builds—you've waited for a year for this baby—and you feel like you've picked the right stud and the right mare to produce the ideal horse.

"There's a lot of times when the mare is having a little trouble and you're there helping them. I remember when a little buckskin filly was born and at that time there'd never been a buckskin born on the ranch. There were line-back duns and red duns and just about anything you can think of, but with over one hundred babies there never had been a buckskin, so this baby was really special."

Clay is obviously looking for some very specific attributes in his horses. His goal in breeding, riding, and training is to produce world-championship halter horses that can also have the ability to be world-class working and riding horses.

"Breeding is definitely a science. I used to think, man, this stuff is a bunch of hocus pocus," laughed Clay. "You just take two good horses and see what happens. I am now absolutely—I mean one hundred percent—convinced that it is a science. There is just no question as to who the mother and father are most of the time. You can look at the head on one, the hip and hind leg, the eye, the color, I mean you just look at them and can't believe the resemblance."

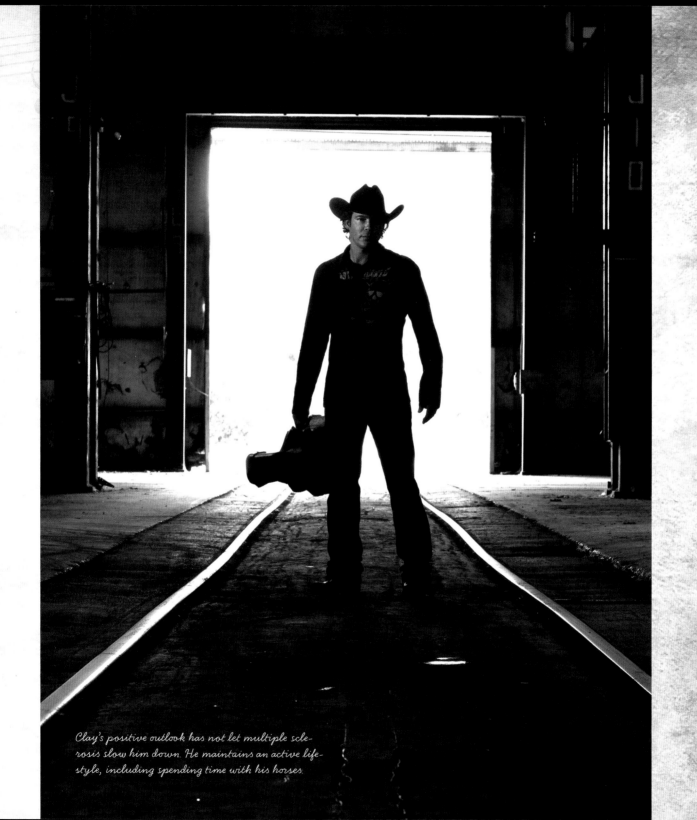

Clay's positive outlook has not let multiple sclerosis slow him down. He maintains an active lifestyle, including spending time with his horses.

HORSES AS HELPERS AND HEALERS

Clay added that horses have helped him many ways in life. From sharing family experiences to learning how to read people, horses have been there every step of the way.

Horses even helped him when, in 1996, his life was transformed when he was diagnosed with multiple sclerosis. Though the disease is in remission, symptoms do recur on occasion.

"If you'd have asked me when I was diagnosed that first day if I would still be alive today, I would have said 'No,' because that's what the doctors said," he recalled. "But here I am more than ten years later and I'm probably healthier now than I was then."

Through it all, Clay has realized how important family and friends truly are, and is grateful to his family and to his horses for helping him through.

"I have two daughters, and it is a phenomenal experience to be able to take your family and have activities based around horses because it is such good, family time," he said. "It's the little things you do together that count, and I wouldn't trade those experiences with my family and with my horses for anything.

"I've come to respect horse people greatly," Clay continued. "You can learn a lot about people by being around them and their horses. You can learn if that person is aggressive, if they are mean, if they are sweet. You can learn a lot about their personality by the way they treat their animals and by the way their animals act. If their animal puts his mouth all over you or tries to bite you, you know that horse has no sense of discipline and that carries over to the person who cares for that horse, and what kind of a person they are. So you know what's been going on there and can figure it out in about two minutes. You can literally go into somebody's barn and let them pull their horse out, and just by the way they get it out you know what kind of a person they are."

Clay said he can't truly express how deeply horses have enriched his life.

"There are so many facets where horses can fit into people's lives," he said, momentarily silenced with the thought. "Horses can be a great addition for just about anyone. You just have to find the right facet for

you. A horse can be one of your best friends, or they can be a help to you in your work, or they can be something pretty just to look at. There's tremendous therapy in just looking at a horse eat. I've gotten a lot out of just sitting and watching them graze. It's amazing. If you look at it, you can intermingle horses with any part of your life. You can use horses for sports, for pleasure riding, for art forms—and to me riding Western pleasure and that type of competition is an art.

"I think that the most important thing for me in life is to learn from whatever I'm doing," said Clay. "I don't really like to participate in things that I'm not learning something from and getting something out of. With horses, you learn constantly and you get so much back. I've learned as much from horses as I have from any human: there are honest ones and ones I wouldn't let in the driveway of my ranch."

QUIET COMPANIONSHIP

With a busy schedule, Clay finds the down time that horses give him has become increasingly important.

"Sometimes a quiet ride through the woods is better than a conversation," he said. "I love that horses provide a diversion from the unbelievable chaos in the music business. There is so much travel and demand for time put on entertainers, that being able to get on a horse's back and just lope mundane circles in a round pen is exactly what the doctor ordered."

But it is the special bond between human and horse that Clay values most.

"A lot of times there is a special intelligence that can only be communicated between you and that horse. Someone else may not have that connection with that same animal. I can't really explain it," he said, trying anyway. "It's love. It's chemistry. It's that deep soul recognition that you have something in common. All I know is if it hadn't been for horses, I wouldn't be the person I am today."

"Horses can be a great addition for just about anyone. You just have to find the right facet for you."

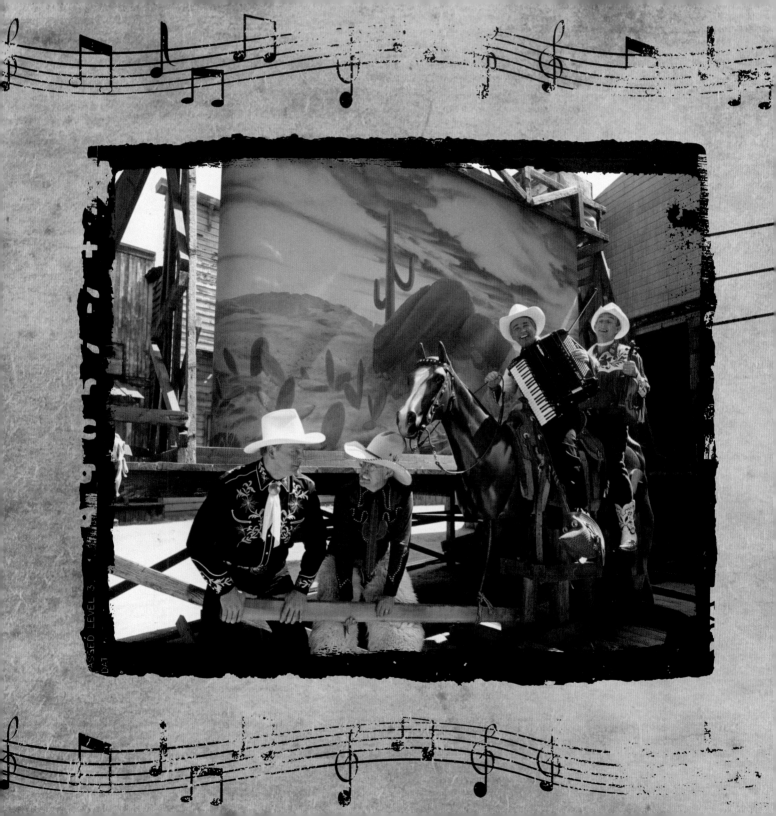

CHAPTER NINE

TOO SLIM

(THE RIDERS IN THE SKY)

WITH MORE THAN THIRTY YEARS AND WELL OVER FIVE THOUSAND PERFORMANCES UNDER THEIR COLLECTIVE COWBOY BELTS, THE RIDERS IN THE SKY, THE FOUR-PIECE, MULTI-GRAMMY-WINNING MUSIC GROUP, ARE LEGENDARY. THE INDIVIDUAL MEMBERS OF THE RIDERS USUALLY GO BY THEIR COWBOY NAMES: RANGER DOUG (IDOL OF AMERICAN YOUTH), WOODY PAUL (KING OF THE COWBOY FIDDLERS), TOO SLIM (A RIGHTEOUS TATER), AND JOEY (THE COWPOLKA KING).

Joey the CowPolka King, Woody Paul, Too Slim, and Ranger Doug

WHEN HIS SISTER MARRIED INTO A MONTANA RANCHING FAMILY, TOO SLIM WAS THRILLED.

Guitarist Ranger Doug sings lead and baritone. A yodeler of breathtaking technique, Ranger Doug is also a distinguished and well-respected music historian.

Woody Paul sings lead and tenor, and when not dazzling Riders fans with his fiddle, he's thrilling them with intricate rope tricks, which he swears he'll get right before his career is over.

Accordionist Joey King is a master musician who apprenticed with the late polka king Frank Yankovic, and has performed with everyone from Roy Rogers to U2.

Too Slim plays upright "bunkhouse" bass and is often referred to as "the sharpest wit in the West."

And while not all members of the group are active day-to-day horsemen, Too Slim tells of a dramatic, life-changing moment he shared with a horse whose name has long been forgotten.

THE COWBOY WAY

Like many boys, Too Slim grew up watching Roy Rogers and the Lone Ranger in front of a fifties-era black and white television set. His television set was located in Grand Rapids, Michigan, and as a child, he practiced being a cowpoke by riding one of the several ponies that always seemed to be around. His family regularly took trips to a dude ranch in Jackson Hole, Wyoming, and there, Too Slim got to experience firsthand the life of a real cowboy.

When his sister married into a Montana ranching family, Too Slim was thrilled, because he was now

able to spend extended periods of time riding, roping, branding, training, stacking hay, and all the other things a cowboy does every day. He was having the time of his life.

But life, as it often does, intervened. In his twenties, he worked at a series of jobs, including janitor, industrial galvanizer, puppeteer, sportswriter, wildlife manager, and electric bass player before becoming a founding member of the Riders in 1977.

"The concept from the beginning was to re-create the feel of the cowboy and the open range in the music," Too Slim said. "And, of course, have some fun with it."

The Riders have accomplished both. In 2001 the Riders won a Grammy for Best Musical Album for Children for *Woody's Roundup Featuring Riders In The Sky*. The project was a companion album for the 1999 soundtrack of the Walt Disney/Pixar animated movie *Toy Story 2*. The Riders repeated the honor two years later for their Walt Disney Records release *Monster's Inc.—Scream Factory Favorites*, another animated film.

In 2002, the Riders composed the original score to Pixar Animation's Academy Award–winning short, *For the Birds*. They also wrote the theme song for an Internet cartoon by Bugs Bunny creator Chuck Jones. Animated versions of the four members of The Riders In The Sky made guest appearances in an episode of *Duck Dodgers*, a Warner Bros. cartoon series on the Cartoon Network starring Daffy Duck in space, for which they also recorded and sang the "Ballad of Duck

The Riders in the Sky have had success in music, radio theater, movies, and even cartoons.

Too Slim (right) and his mother on a Wyoming dude ranch vacation in 1957.

> ## "I WAS ON THE BACK OF A WONDERFUL HORSE, AND I HAD THIS BEAUTIFUL CHILD WHO WAS MY DAUGHTER NEXT TO ME. WHAT MORE COULD I EVER WANT OUT OF LIFE?"

Dodgers." Their animated characters also appear in episodes of *Stanley* on the Disney network, as well as in the DVD versions.

The Riders' own radio show, *Riders Radio Theatre*, is a radio program that has been broadcast by over 170 public and commercial stations seasonally since 1989. They've also starred in their own CBS Saturday morning children's TV series, *Riders In The Sky*; hosted another, *Tumbleweed Theater*, for The Nashville Network; appeared numerous times on the musical series *Austin City Limits*; and served as spokesmen for the National Park Service, Opryland, Levi's, Taco Bell, Budweiser, Coca Cola, and Cheer. Additionally, the group performed in the acclaimed Patsy Cline biopic *Sweet Dreams* (starring Jessica Lange), and the Kenny Rogers made-for-television movie *Wild Horses*. The Riders have also been inducted into the prestigious Walk of Western Stars in Newhall, California.

FINDING THE GOOD LIFE

In the midst of all that achievement, Too Slim found time to marry and have a family. And as his kids began growing up, he found himself wanting to provide them the type of vacation he had as a child: a dude ranch vacation.

"You know, the Internet is an amazing thing," said Too Slim. "Here I was thinking about this place in

Jackson Hole that we had gone to as a family when I was young, and with a few keystrokes there it was forty years later on my computer screen."

So Too Slim and his family packed up for Wyoming. Little did he know that a quiet gray horse would not only provide inspiration for a song he was having trouble with, this horse would actually help his universe align.

"I wanted to take my daughter for a ride in the mountains. She was eight then, and I wanted to show her some of the places I had ridden when I was her age," he said. "If you can imagine clear air, sunshine, the absence of noise from highways, cell phones, and other people. That in itself was wonderful, but we found so much more. The land was virtually untouched, and how often do you get to see that? The trees were huge, and the streams and water were so clear."

After a time, Too Slim and his daughter began an upward ascent on horseback. This is a place so remote and unpopulated that it is not unusual to see grizzly bear or elk, so father and daughter were actively looking for signs of wildlife. Too Slim was riding a quiet, companionable gray horse who gently carried him to the top of a rise. And suddenly, there it was.

"I looked straight ahead and there, framed between my horse's ears, was the most beautiful view of the snowcapped Grand Teton Mountains surrounded by this incredible blue sky," he said. "My daughter and I fell silent; even the horses were silent. It seemed to me that for a few seconds time stopped and the entire world

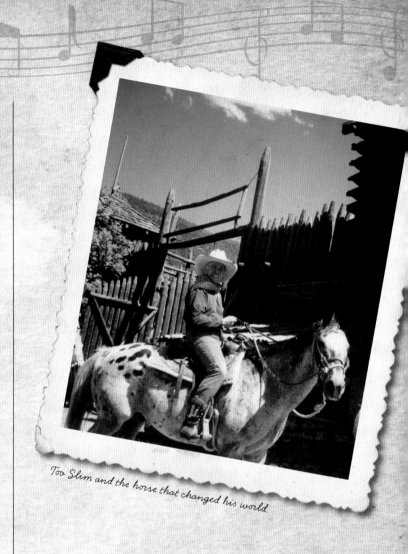

Too Slim and the horse that changed his world

was silent. And in that one single, solitary moment, I realized that this is what life is all about. Here I was in the middle of the most stunning scenery that nature could provide, I was on the back of a wonderful horse, and I had this beautiful child who was my daughter next to me. What more could I ever want out of life?"

"SEEING HOW NATURAL HORSEMANSHIP WORKS COMPLETELY CHANGED THE WAY I THOUGHT ABOUT HORSES."

Too Slim said that moment exactly captured the feeling he had been trying to get with a song he was writing for the *Toy Story 2* project. The song was called "The Ballad of Bullseye," and he had been trying to convey through melody, rhythm, and lyrics the feeling one got when riding a horse. In that moment, when his universe aligned, Too Slim knew exactly how the song should be structured, how the melody and lyrics should go, and how the song should flow.

"I wanted to write about the complete contentment a person has when he feels a horse between his knees, and thanks to this horse and Mother Nature, I think I got it," he said.

The music community agreed, as the project later won a Grammy.

THE NATURAL APPROACH

Too Slim said the experience in the mountains renewed his interest in horses, and Ken Jones, a rancher friend in Steamboat Springs, Colorado, saw the interest and introduced Too Slim to the ways of natural horsemanship. Natural horsemanship is a movement begun several decades ago that uses the horse's way of thinking, herd dynamics, natural movement, instincts, interests, and personality in a kind manner to teach them to be willing partners.

"Seeing how natural horsemanship works completely changed the way I thought about horses," said Too Slim. "I mean, it changed my thoughts completely! I watched Ken work with some wild mustangs—and these were horses that had never been touched by a human hand—and I saw the magical success he had with those horses."

Too Slim was so energized by the idea of natural horsemanship that he has tried it himself, first under the guidance of his friend, Ken Jones, and later with equine clinician Pat Parelli.

"The idea of natural horsemanship truly is a breakthrough in the way horses are trained," he said. "Basically, people have been training horses one way for hundreds of years and finally we think to bring the ideas of the horse into it. What a concept! I know the horses are glad that we humans finally figured it out."

The Riders later did a television show with Pat Parelli in Durango, Colorado, and Too Slim said they were impressed with Pat's passion for the subject and his hospitality while they were there.

"In a lot of ways, even though they have not always been a daily presence, my life has been tied together with horses: as a child with the ponies, my experiences at the dude ranch with my family when I was growing up, the time I spent on my sister's ranch, with my daughter and that incredible view of the Tetons between the horse's ears, and later with natural horsemanship," he said. "I've learned something from every horse I've been around. And, every bit of the experience has been processed and comes out in the music we do. If you listen to our music, all the rhythms are reminiscent of the horse's walk, trot, and canter. All the gaits of the horse eventually come through.

"Even though I'm not physically with a horse on a daily basis, I still feel connected because we sing about them, and our music is derived from them. And I can tell you that I will never forget that gray horse and the view between his ears. That was a life-changing moment for me, and I'll never forget it, not as long as I live."

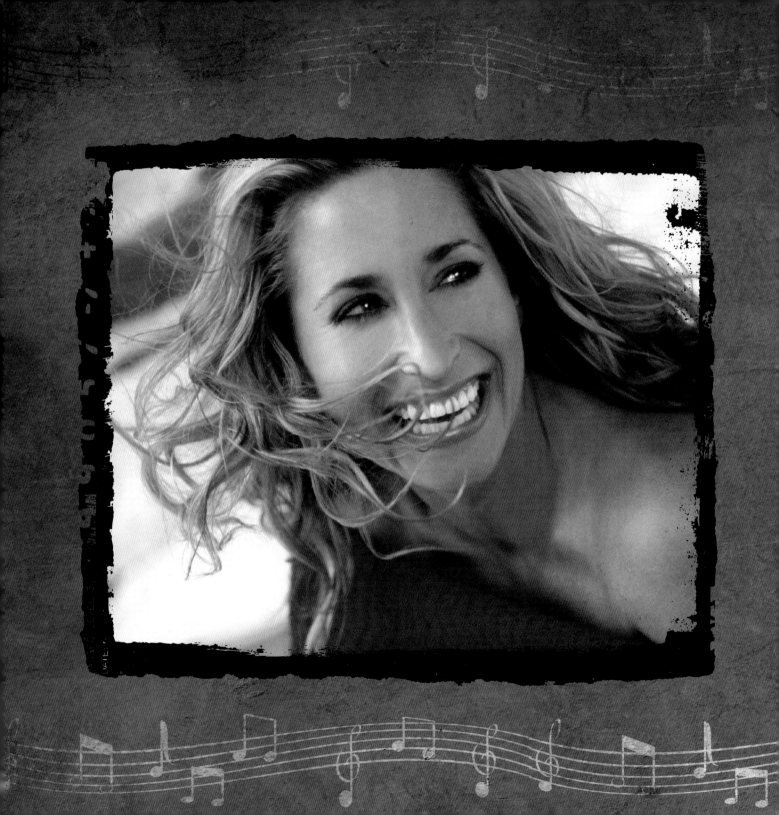

HEIDI NEWFIELD

Heidi Newfield knows firsthand that growing up on a horse farm really is as wonderful as it is cracked up to be. Heidi, the youngest of three girls, was born and raised on the Empire Oak Quarter Horse breeding and training facility in Sonoma County, California.

> **"A large amount of my childhood memories are wrapped up in memories of Cindy. She was truly my friend."**

"Horses are such a big part of my life," said Heidi. "They go back to my earliest memory; before that even, as I was probably riding before I learned to walk."

In addition to Quarter Horses, the farm also stood Appaloosa and Paint stallions, so Heidi became familiar with all three breeds very early in her life. She also became very familiar with music when she was young, and by the time she was six, Heidi had already sung the country tunes "Delta Dawn" and "Cow Patty" on a trail ride in northern California in front of three hundred people.

"That was a defining moment," said Heidi. "I knew then that what I wanted to do with my life was sing."

Young Heidi loved both singing and performing, but she also loved the small Shetland pony in her life. His name was Socks.

"Socks had been a circus pony before my dad got him, so he knew all kinds of tricks," said Heidi. "He was a little bitty thing, but he took care of both my sisters and me and gave us a really good foundation with

horses and our riding. A lot of ponies that size take advantage of young kids, but Socks was great."

HEIDI'S EQUINE "SISTER"

Heidi soon outgrew the little pony and moved up to a white Pony of the Americas (POA) named Cindy. A POA is similar to a small Appaloosa. The versatile and athletic breed features the mottled skin, striped hooves and colorfully spotted coat patterns of the Appaloosa, but the horses—or ponies—are smaller and sometimes more refined in body style than the larger Appaloosa.

"Cindy took me well into my teenage years and she, too, watched over me. That was her job," said Heidi. "All the kids in our neighborhood rode and my mom never had to worry when I was out on Cindy because she knew I'd get home safely. Cindy was very smart, and certainly she was wiser than I was at the time. Even as a kid, I knew I was in good hands when I was with her."

Cindy was about 13 hands tall, with classic POA conformation and a pretty head, and Heidi laughed as she remembered that the mare loved treats.

"That was her downfall: apples, carrots, and sugar. She loved it all, but she especially loved beer," said Heidi. "Now I know that's not something a twelve-year-old girl should know about her horse, but when you go riding with a bunch of cowboys, that's what happens.

"I just loved Cindy so much. We spent so much time together, especially in summer when school was out; a

large amount of my childhood memories are wrapped up in memories of her. She was truly my friend."

Heidi began her 4-H show career with Cindy and the two excelled in everything from showmanship to Western pleasure. When Cindy passed away at the relatively young age of seventeen, Heidi was devastated.

"Losing her was like losing a sister," she said. "We buried her under a big oak tree on our place and even though it took me quite a while to get past it, it helped to know she was there close to us; that I could go visit her when I needed to. And I still do. I still take time when I am home to visit her."

BOOGIEING TO RANCH SPORTS

As a teen, Heidi also became involved in high-school rodeo, cutting, and barrel racing, as well as showing horses. She qualified for the California high-school rodeo state finals two years in a row and said she thoroughly enjoyed the challenge of ranch sports like cutting and roping. Most of that time was spent on a big sorrel mare named Boogie.

"Boogie was aptly named as she was very fast and hard to ride," said Heidi. "I really had to pay attention on her, so for me it was a bit of a challenge, but the challenge was what made Boogie so much fun!"

HEIDI MEETS LITTLE TOWN

Another horse that helped Heidi perfect her cutting and roping skills came in the unlikely shape of the solid chestnut American Quarter Horse Association

(AQHA) Supreme Champion stallion Little Town.

"I agree that stallions are not usually the best choice of horse for a kid, but this was the best-natured stud horse I've ever seen," she said.

Little Town was a Leo- and Three Bars–bred horse that Heidi's parents stood at stud for more than twenty years. During his competitive career, he earned the AQHA status of Open Supreme Champion, Superior Race Performance, Open AQHA Champion, Open Register of Merit in Performance, and Register of Merit in Race Performance. As a sire, his foals earned world champion, superior halter, superior performance (in both race and arena), AQHA champion, and register of merits in performance and race. As Heidi said, "they don't make horses like that any more."

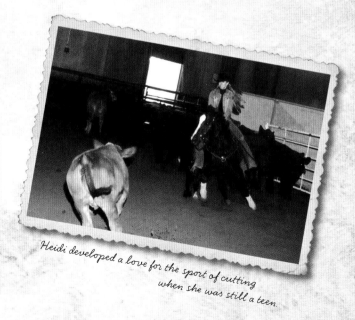

Heidi developed a love for the sport of cutting when she was still a teen.

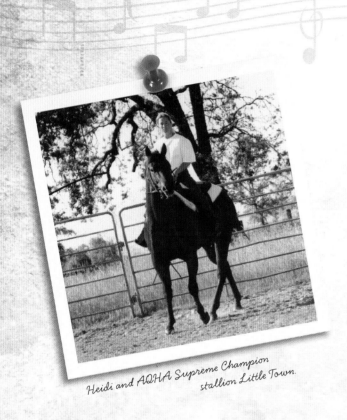

Heidi and AQHA Supreme Champion stallion Little Town.

Just before breeding season each year, Heidi's parents regularly took out multiple pages of advertising in the Quarter Horse trade magazines to market Little Town's services. Some of the ads featured a teenaged Heidi sitting bareback on the horse with only a bosal hackamore for control.

"Little Town was not a big horse, maybe 14.3 or 15 hands, and he had the most amazing doe eyes," Heidi said. "He also had these little tiny ears and the dish in his face was so deep that he almost had an Arabian head. And there wasn't a speck of white on him. Not one. He was stunning."

Heidi's parents bought Little Town as a two-year-old from a breeder in Wyoming. They later campaigned him in cutting, halter, and Western pleasure, but even though he earned just about every award the AQHA could give him, Heidi said it was Little Town's intelligence and calm disposition that impressed her most.

"For all of us kids to ride him like we did, just to hop on him bareback, was amazing," she said. "Like a lot of stallions, he was very alert and he watched everything. But there was also this calmness, this stillness, in him. He was very peaceful to be around and I think now that he must have felt very comfortable around us for him to be so relaxed.

"He was the first horse I ever rode that was a finished, well-trained horse, and not a 4-H level horse or a trail horse. After I'd ridden him awhile my dad asked me to try a spin on him. I had no idea how fast he'd spin around. Or how easily. I was totally unprepared for his quickness. Once you ride a truly athletic horse like that it changes your perspective on what a horse is capable of doing. Ultimately, Little Town was the horse that got me interested in riding working cow horses. He could really get my adrenaline pumping. He was so sensitive and so intuitive that if you thought it, he'd do it. There will never be another horse like him."

Little Town is another horse that Heidi's family buried under the oak tree. He, too, is visited often.

FROM HORSES TO HIT SINGLES

While Heidi was busy riding Cindy and Little Town, she was also busy pursuing her music career. After her

debut performance at the trail ride when she was six, Heidi kept singing. She first went to Nashville to record demo material when she was thirteen. She returned several times throughout her teen years and moved to Music City shortly after she graduated from high school. After she signed on as the lead vocalist with the hot country trio Trick Pony, they landed a steady gig at Nashville's Wildhorse Saloon and later were signed to Warner Bros. Nashville. Gaining a foothold in early 2001, several of Trick Pony's hits included "Pour Me," and "It's a Heartache." Five years later, Heidi left the trio to pursue a solo career.

HORSES ARE A PERMANENT PART OF HEIDI'S LIFE

The demands of writing and recording often keep Heidi in Nashville. But when she visits her family in California, the first place she heads is to the barn.

"It's gotten so that if I get home during the day, my dad has a horse saddled and ready for me because he knows that is the first thing I am going to want to do," she said. "When I'm home I ride every second that I can. Absolutely."

Heidi's experiences with the many different horses in her life have also helped her in her music career.

"When I was fourteen or fifteen I began breaking horses for my parents, and I found that horses had all different types of personalities," she said. "Some were mischievous, some were hard headed, and some would bend over backwards to please.

"As I've gone through life I've met so many people in the music business—fans and industry people alike. I've found it's the same with people. There are those who are difficult, those who have a sense of humor, and some who will do everything they can to help you, and I learned that from horses. My background with horses also helped build my confidence enough so I could go out and basically accomplish anything I wanted to. There is so much that horses can teach us."

"Little Town was so sensitive and so intuitive that if you just thought it, he'd do it. There will never be another horse like him."

Heidi also understands that while every horse is special, a few can become as close as family members.

"To me, just looking at a horse does something wonderful to your soul. We had a lot of horses over the years, but each of them taught me something," said Heidi. "Each one had its own special gift and hopefully they touched many other people in addition to me. Horses, by far, provide the best way of life imaginable."

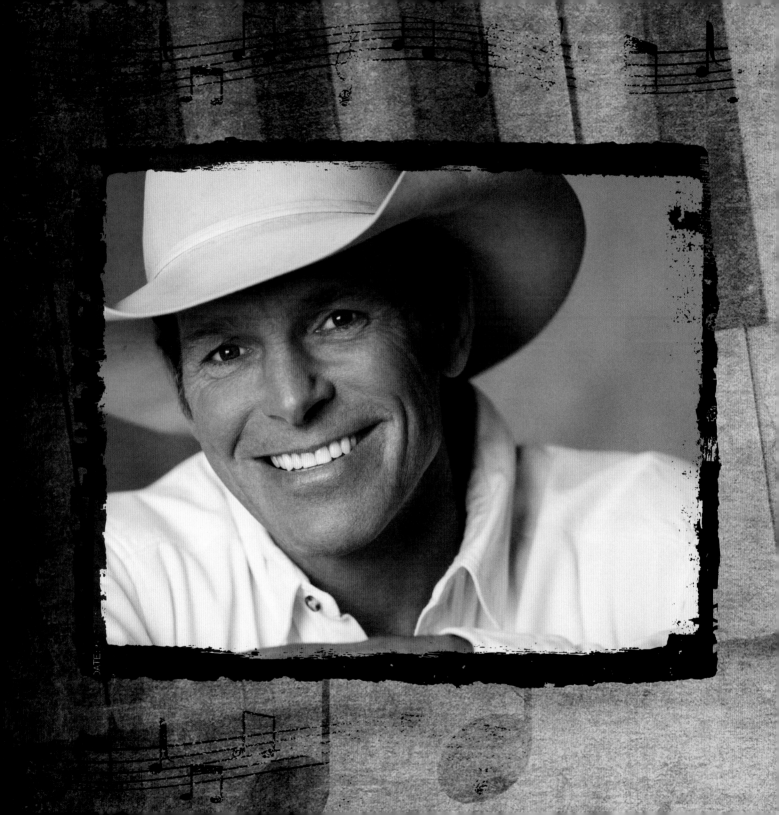

CHRIS LeDOUX

WHEN IT CAME TO COWBOY SONGS, WESTERN MUSIC, AND COUNTRY HITS, CHRIS LEDOUX WAS THE REAL DEAL. CHRIS WAS A WORLD CHAMPION PROFESSIONAL RODEO COWBOY WHO, DURING HIS RODEO DAYS, HAPPENED TO PLAY GUITAR IN HIS SPARE TIME. CHRIS BEGAN PLAYING THE GUITAR AND WRITING SONGS WHEN HE WAS ABOUT FOURTEEN, AND THE SONGS HE WROTE WERE ABOUT RODEO LIFE. HIS MUSIC ABLY CAPTURED THE

romance, the freedom, the hurt, and the dirt of rodeo, and eventually found its way into the hearts of rodeo fans across the country.

Chris LeDoux recorded twenty-two albums on his own—albums filled with music about the cowboy lifestyle he lived and loved. Chris's recording career bolted out of the chute in 1989 when country superstar Garth Brooks sang about listening to a worn-out tape of Chris LeDoux in his hit "Much Too Young (To Feel This Damn Old)." The mention was enough to kick up national interest in the singing cowboy, and Chris landed a recording contract with Capitol Records. Chris later teamed up with Garth for the Grammy-nominated top ten duet, "Whatcha Gonna Do With a Cowboy." He also performed duets with Toby Keith and Jon Bon Jovi.

The worlds of both country music and rodeo were saddened when Chris LeDoux passed away from a rare form of cancer in March 2005. He was fifty-six. In 2006, Chris was immortalized in the Garth Brooks ballad "Good Ride Cowboy," a tribute to Chris that featured several of his song titles in the lyrics.

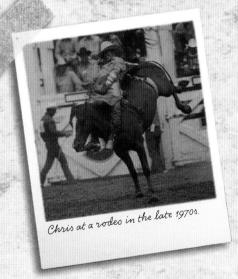
Chris at a rodeo in the late 1970s.

A COWBOY DREAM

As long as Chris LeDoux could remember, he wanted to be a cowboy. Some of his earliest memories were of sitting in front of a small black and white television and watching his heroes—Roy Rogers, the Lone Ranger, and all the others who rode across our screens during television's golden era. The only difference between Chris and the rest of us was that Chris actually lived his dream.

Chris's first real life experience with horses, an obviously essential part of his dream of the cowboy life, took place during the summers he spent in Michigan on his grandfather's farm.

"He didn't have any horses on the place at that time," recalled Chris. "He'd had teams before, you know to work the fields with before I was born. But he didn't have any at the time I was out there visiting."

But Chris fondly recalled an old horse in the neighbor's pasture.

"It was probably about thirty years old, swaybacked, shaggy hair on him, and I thought he was beautiful," said Chris with a wry smile. "I can still remember walking by there and thinking, 'Man, that's a beautiful horse.'"

THE GIFT OF COMANCHE

A youthful Chris spent hours idolizing the shaggy old horse, dreaming of the adventures they'd have when he was a real cowboy. After years of wishing, Chris finally got a horse of his own. He was twelve, or maybe thirteen.

"We'd moved to Austin, Texas, and my grandpa actually bought this horse for me," said Chris. "It cost two hundred fifty dollars, and back in the mid-sixties that was quite a lot of money, you know, coming from a dairy farmer, so that was quite a gift."

Chris's prized present was a buckskin Quarter Horse gelding that he named Comanche.

"He wasn't real pretty, but I thought he was another beautiful horse. He was good, though. Someone had broke him and done some roping on him and as years went by I realized this guy who trained him was a professional rodeo cowboy," Chris said. "Finally, after I grew up and started rodeoing I saw this guy around, so this horse actually came from someone who knew what he was doing, which helped me a lot in the early years, to ride a horse that was well-trained.

"I started roping on Comanche a little bit and the horse was good. He had some spirit. I'd fall off of him every now and again, but I'd run barrels and poles and rope on him, and learned quite a bit by just living with him."

And Chris literally lived with his horse.

"We had a lot of campouts," he recalled. "We'd ride a couple of miles alongside a crick somewhere there outside of Austin and I'd take some old dry beans with me and the dog and the horse and stay the night, cook those beans. I didn't realize that it was going to take eight hours to get the beans soft enough to eat! I about starved. And there was a roping arena that I'd go to. It was about three miles from our house. It seemed like it was twice a week that I'd go, and I'd tie my bedroll on my saddle and ride to this little arena and rope two or three calves. I remember it was fifty cents a head. And then when I was done I'd go throw my bedroll under some live oak trees out there by the arena and just bed down. In the morning I'd get up and ride on home.

"It was pretty intimate, just me and the horse and the dog. My folks had pretty much turned me loose by then. I was free. And looking back on it now, I don't think I could have been that way with my kids. That'd be pretty tough to just let a kid go ahead and do stuff like that, but my folks were pretty understanding and realized that I needed some room."

THE MAKING OF A RODEO STAR

Shortly after Comanche's arrival, Chris realized he was destined for the life of a rodeo cowboy.

"All the kids in the neighborhood were entering youth rodeos, and I'd got in the steer riding and won a

"SHE WAS MY MOTIVATION FOR SO LONG, THAT THIS ONE GO WAS . . . WELL, IT WAS JUST EVERYTHING TO ME."

little buckle. And that was it. It was like, 'Okay, here we go,'" he said. "There was just something about rodeo and horses and livestock and that lifestyle that drew me a lot more than football, which I had also thought some about. But I wouldn't have been big enough for football anyway. Rodeo was it for me. I'd grown up watching the cowboy movies, and my heroes really have always been cowboys. To get the opportunity to be one, well, there just wasn't anything better."

Chris worked hard, and when he was in high school in Cheyenne, Wyoming, he won the 1964 Little Britches Rodeo National Bareback Championship. In 1967 he won the Wyoming State High School Bareback Championship, and soon after, a rodeo scholar-

ship. The scholarship paid off. In 1969 Chris earned the prestigious National Intercollegiate Bareback Riding Championship.

NECKLACE

Although Chris had accomplished a great deal on his own, it was a rank, bay bucking mare named Necklace who proved to be his motivation and inspiration for close to a decade.

"When I was in high school, I'd get the rodeo sports news and I'd see the horses and the cowboys and there was a horse called Necklace that was kind of the rank horse on the circuit," said Chris. "I can remember any time I'd be out training, running, or lifting weights in high school, I'd think, 'Necklace, Necklace,' and it'd make me run a little faster, run a little harder, lift weights a little heavier, practice more on bales of hay, and work to get a little stronger."

At the Calgary Stampede in 1974, some seven or eight years after Chris left high school, he finally had the opportunity to ride this mare who had been so instrumental in putting him at the top of his chosen field. By this time, Necklace had been voted Bareback Horse of the Year four times. For Chris, it was the culmination of years of hopes and dreams, a proving ground, a validation of years and years of hard work.

"When I first heard about Necklace, I didn't realize that I would ever have the chance to get on her," said Chris, who years later was still amazed that the opportunity arose. "There were other horses that were

ranker than she was, later on, but she was my motivation for so long, that this one go was . . . well, it was just everything to me."

Chris had her on the short go. And for him, it was a perfect scenario.

"She was back in a pen by herself and as the crowd started coming in for the rodeo you could see her start pacing a little bit. She knew what was going on," said Chris. "And as the band started playing, she began pacing a little more; she was getting nervous. I was back there watching her, and finally they put her in the chute. She was kind of rearing up in there, and with her they said if she starts rearing up you know she's going to buck. She's ready. So I got on her and I don't think they could have thrown me off with a stick of dynamite. It felt so good. After all those years of thinking about her . . . she was great. She just fit. She just fit my style. I won the short go-round and it just felt wonderful. It was a pretty neat experience."

Chris went on to become the world champion bareback rider two years later, hanging up his spurs and chaps for the last time in 1984.

A TRUE SINGING COWBOY

But even though Chris had a busy rodeo career, his life wasn't completely consumed with bucking horses. Chris was making strides with his music as well. He made his first independent recordings in Sheridan, Wyoming, and over the next few years recorded fifteen albums in Nashville for his own American Cowboy

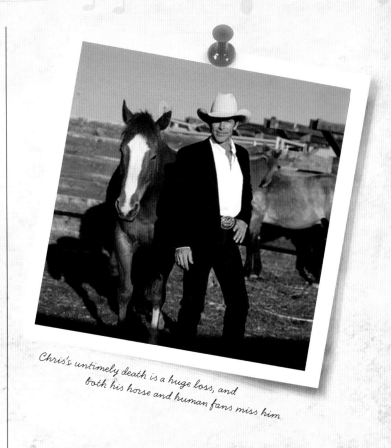

Chris's untimely death is a huge loss, and both his horse and human fans miss him

"I JUST LOVED THE WHOLE THING, THE CAMARADERIE, THE FRIENDS YOU MADE, JUST BEING YOUNG, AND WILD, AND FREE."

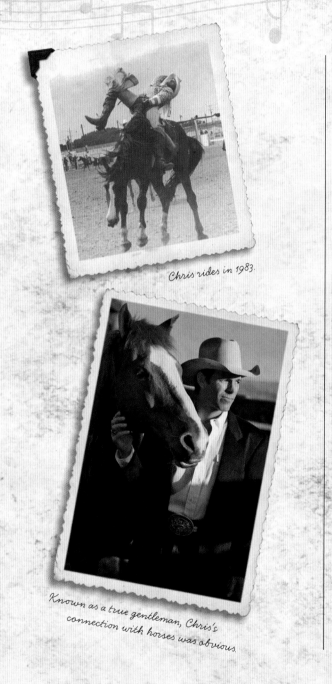

Chris rides in 1983.

Known as a true gentleman, Chris's connection with horses was obvious.

label. In those days Chris regarded the music as just a sideline to being a cowboy. But he took the music seriously enough to sell four million dollars worth of cassettes, most of them manufactured by his parents in their own home tape-duplicating room, and sold out of the back of his truck.

"I loved every minute of it," he said of both the musical and riding aspects of his rodeo life. "The people, the thrill, all of it. I loved the gypsy lifestyle, just being out in nature, seeing the sun come up in California and seeing it go down in Texas, sleeping along the highway in Montana when the sweet clover is in bloom. Just living, like living on the trail; like a trail drive. We had a Chevy Suburban and that was our covered wagon, our chuck wagon. I just loved the whole thing, the camaraderie, the friends you made, just being young, and wild, and free. I wouldn't have traded one of those experiences for anything."

Given his feelings, it wasn't at all surprising that Chris would trade one gypsy life for another, trade the Chevy Suburban for a band and a bus. But as much as he loved the rodeo, Chris said he would not advise anyone to try it before they had carefully weighed all the options in their mind.

"If you go into rodeo, there is the distinct probability that you will experience some physical pain, and the real possibility of really getting hurt badly, so before you start you need to weigh things out on a scale in your mind," he said seriously. "On one side, you've got the fact that you can get killed, or you can get maimed for

life, and on the other side you've got how bad you want it. If one outweighs the other, then you'd better go with that decision. So if you want it bad enough and if it outweighs your fear of getting maimed for life or getting hurt, then go for it. But if your reason takes over, takes the heavy end, then maybe you'd better be a doctor or a lawyer. That's really advice I'd give anyone if they were going to make any important decision. You have to realize that you might fail, but you might win tremendously, too, and in ways that you never expected."

CHRIS'S LEGACY

Chris and his wife, Peggy, had five children. All but the youngest bypassed rodeo for other endeavors.

"You know, we went through all the kids, and none of them really showed an interest in it, in rodeo, until the last one, Beau," said Chris with a chuckle. "I had a bucking machine and everything right there at the house. And finally I just gave all that stuff away. Then about a year later, Beau said, 'Hey Dad, I might wanta try to ride.' So we had to get another bucking machine."

Chris said it made him feel really good to see his son out there.

"It's scary, too, but I can see his determination, and I think he's got the ability. He's got a lot of drive, so it's not as scary for me as when he first started out," he said. "When he first started he was hanging up a lot, getting dragged, and they'd step on him a lot. But he'd get back on, get on another one. So he's got a lot of guts."

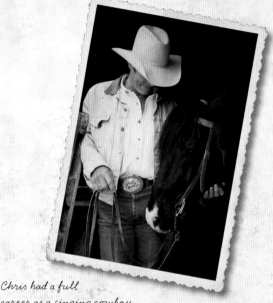

Chris had a full career as a singing cowboy long before he signed a major label record deal.

Sounds like Beau is a lot like his dad.

Since Chris's untimely passing, a Chris LeDoux Rodeo Scholarship has been established, with the first award given in 2006. Capitol Records has remastered Chris's catalog and made his entire body of work available online. An art show featuring artwork created by Chris specifically for his family and friends was recently held at the Pro Rodeo Hall of Fame. Plus, Chris was inducted into the Pro Rodeo Hall of Fame in 2005, and in one of the top honors that can be bestowed on a rodeo cowboy or performer, he was inducted into the Rodeo Hall of Fame in 2006.

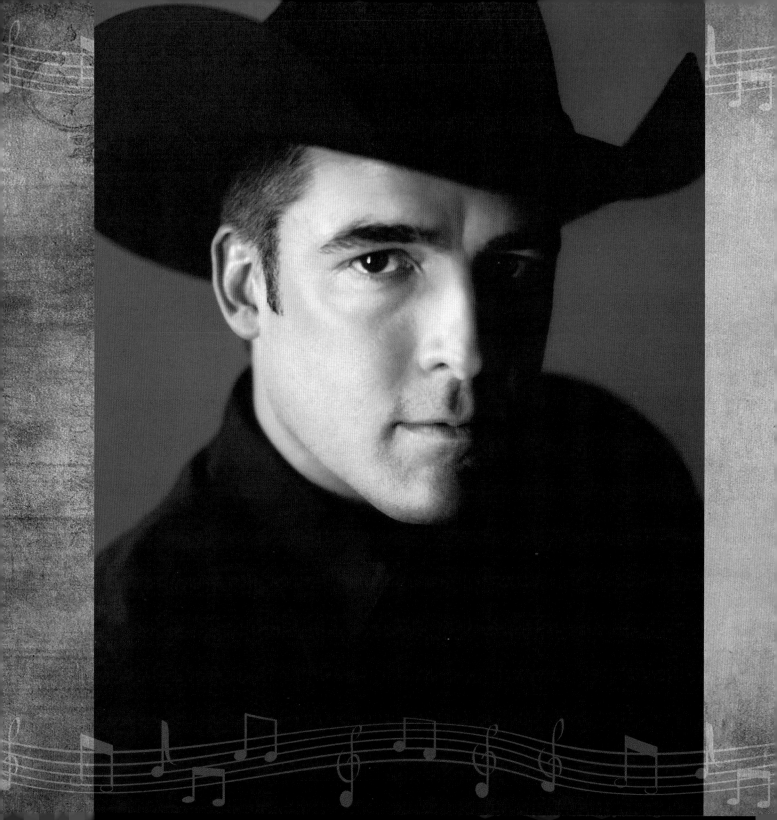

CHAPTER TWELVE TRENT WILLMON

Trent Willmon is the host of the CMT reality show, *America's Top Cowboy*. But even though this real-life Texas cowboy knows the difference between a cinch and a latigo, he is also one of Nashville's top male vocalists.

Ideally, Trent would not have to make a choice between the stage and the

roping pen. There'd be time for both. But because he has a strong dedication to excellence and puts his all into everything he does, Trent finds he has to rotate horses with his musical career.

Born in Amarillo, Trent was raised in West Texas on a ranch near Afton. He spent his first few years of high school studying agriculture, a field in which he planned make a career. But a gift from his mother when he was sixteen—a guitar—eventually changed his plans. Although Trent attended South Plains College in Levelland, Texas, as an agriculture and animal science student, he dropped out after his second year so he could play music full

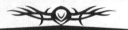

"I've had so many horses over the years that I've fallen in love with. From the sale barn horses on, when a good one came along, I just latched on."

time. After a couple of years on the Texas dance-hall circuit, Trent learned to play the upright bass and joined a bluegrass band. In 1995 Trent moved to Nashville to start a songwriting career, and by 1998 he had a publishing contract. A record deal quickly followed.

Country fans love Trent's music, including his songs "Beer Man," written with Casey Beathard; and "Dixie Rose Deluxe's Honky-Tonk, Feed Store, Gun Shop, Used Car, Beer, Bait, BBQ, Barber Shop, Laundromat," written with Michael Heeney.

COWBOYS AND SALE BARNS

When you meet Trent you easily sense both the horses and the music in him, so it is not surprising to find that his success, both as a writer and as a singer, come from his ranch background.

"All the real cowboys I grew up with were very good at telling stories," he said. "It's part of who they are. Part of it comes from spending a lot of time alone, which gives a person time to really think about things, and part of it's because of the colorful life a cowboy leads."

Trent well knows the ways of a cowboy, because he was indoctrinated into the ways of ranch life from early childhood.

"Dad had a sale barn addiction," joked Trent. "Horses, cows—if there was a sale, Dad would be sure to haul something home."

One of the first horses Trent's dad brought home

specifically for Trent was a Shetland pony named Lawnmower. Trent was three or four at the time.

"I'll tell you this: a Shetland pony may be small, but this one was smart enough and spoiled enough that it certainly taught me to ride," he said. "It was either that or keep falling off."

After Trent had met all of Lawnmower's challenges, he began training horses in his front yard. Bareback.

"I was too scatterbrained at the time to take care of a saddle," he said. "So I learned to ride bareback, which wasn't necessarily a bad thing. Riding without a saddle will definitely teach you balance. If nothing else, it gave me a good foundation."

TRENT FINDS A BETTER WAY

Trent soon had plenty of horses to ride. Because all the sale horses needed to be worked, Trent's dad roped him into riding many of them. Due to an unusual experience, one of the horses became quite special to Trent. It was a pretty Pinto that his dad had bought to resell.

"The horse was pretty, but it was a bronc and would both buck and rear over backwards, which is probably why it was at the sale barn in the first place," said Trent. "I was about fourteen, maybe, by this time and I was just old enough for this horse to make me really mad. I lost my temper several times and worked that horse in the only way I knew at the time, and that was to use some of the harsher training methods that some of the older cowboys of the day used."

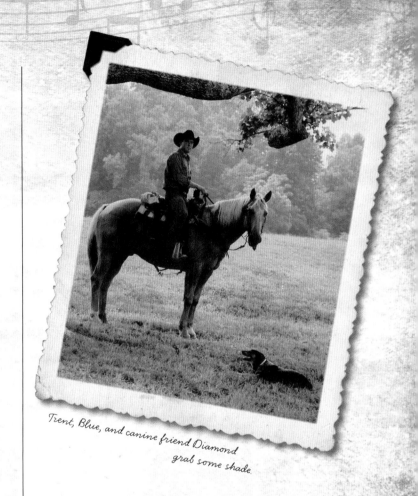

Trent, Blue, and canine friend Diamond grab some shade.

The methods were hard physically on both Trent and the horse and while they helped the horse some, they weren't as effective as Trent would have liked. But a few years later—while over at a neighbor's—Trent learned another way of working with a horse. The experience changed his life.

"They had a round pen and I heard this commotion inside it. I looked in the pen and there was this

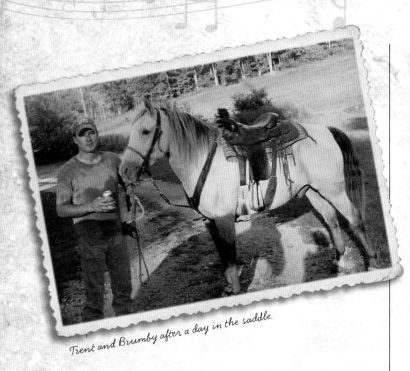

Trent and Brumby after a day in the saddle.

> **"I learned a big lesson that day: the old cowboy way we all grew up with out there in West Texas wasn't the best way."**

kid whipping a horse. Seeing that, it struck me what a terrible experience this was for both the kid and the horse," Trent said. "Fortunately, very shortly after I got there the kid got tired, and picked up and left."

Trent clearly remembers peering in the round pen at a big five- or six-year-old mare that, until hours before, had never been touched. Not sure what to do, Trent watched the still-saddled horse for a while and then cautiously approached.

"I just talked to her some and when she relaxed, I got on," he remembered. "I stayed pretty quiet with her and we were getting along okay when the owner came out and offered me a job. I learned a big lesson that day: the old cowboy way we all grew up with out there in West Texas wasn't the best way. That was a huge realization for me as I recognized there was another way. There was something else. In just a few minutes, slow and quiet had gotten me a lot farther than forcing a horse ever had."

Interested in the concept, Trent asked around and learned of an equine clinician who was making a name for himself using a gentler approach: Pat Parelli.

"I began going to his clinics and his ideas completely changed the way I thought about horses," said Trent.

FROM RANCH HORSES TO RACE HORSES

A few years later, music became the driving force in his life. But when Trent moved to Nashville to further his

music career, he found there were so many artists and songwriters trying to break through that it was tough to make a living playing music in Music City.

Instead, Trent found work cleaning stalls for a steeplechase barn in Leiper's Fork, a small community south of Nashville. Steeplechasing is an old sport in which horses race over neighboring fields and fences from one church steeple to another. It is about as different from riding ranch horses as an elephant is different from a pile of sand.

"One day in the middle of winter I was cleaning my stalls when all the jockeys called in sick," said Trent. "The horses were all banging around in their stalls and in desperation the trainer asked if I would exercise some of the horses. I ended up riding twelve of them that day."

The one day turned into a couple of years, and the singing cowboy from Texas found that riding steeplechase horses was an excellent experience.

"Steeplechasing was a challenge for me," he said. "There are such huge differences, including the saddle. With a Western saddle you have a horn, and the back of the saddle rises up to hold you in, and your stirrups are down near your ankles, so there is only a little bend in your knee. With an English racing saddle the seat is about completely flat and your stirrups are jacked up around your chin. I had to learn balance on an entirely different level.

"Plus, Western horses are often ridden with one hand. They neck rein and usually are pretty gentle

horses. Racehorses, including steeplechase horses, the trainers don't want a finished horse. They just want the horse to barrel out of a start, run like hell, and get over the jumps, so you have two hands on the reins and are pulling the direction you want to go, praying that the horse responds before you smack into a tree. For me, riding steeplechase horses was like stepping on a rocket ship."

Every day Trent rode through woods, into neighbor's farms, and over a host of sizes and shapes of jumps.

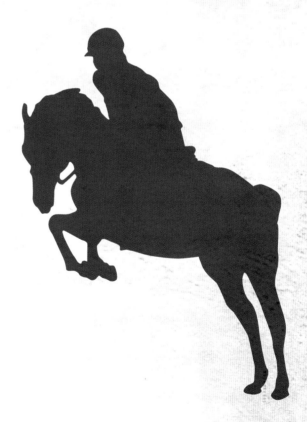

"All I can say is that it was probably the most exhilarating experience of my life, jumping over things going forty miles an hour," said Trent. "The horses were very impressive and I learned a lot from those old jockeys."

HORSES PAVE TRENT'S WAY INTO THE MUSIC INDUSTRY

Trent also rode horses for Jeff Avaritte, a then Nashville-based Quarter Horse trainer. There, Trent fell in love with a little buckskin cutting prospect aptly called Buck.

"After just a few months, Buck developed quite a bit of a handle," recalled Trent. "He'd try his heart out with those cows."

"You can't make a horse into something he's not."

However Buck didn't have quite what it takes to be a top cutting prospect and instead became a good, solid ranch horse.

"One thing I learned during that time is that you can't make a horse into something he's not. A horse is what he is and you can only develop what's there. Buck never would have been happy being constantly pushed to give more than he naturally could. Cutting is part of ranch work and Buck did great outside the competitive arena. Plus he got to rope and do other things he liked."

Between time spent in the saddle, Trent was slowly making inroads into the music business. Eventually, noted record producer and label executive Scott Hendricks bought Buck from Jeff Avaritte, and then hired Trent to ride his horses. So when Buck moved to a new barn, Trent got to move right along with him.

"After I started working there and against my advice, Scott bought a big, jug-headed Thoroughbred/Belgian cross. His feet were so big they looked like platters!" said Trent. "Did I mention that this horse was not broke?"

His initial misgivings aside, Trent soon fell in love with the big bay horse he called Houdini, for his ability to let himself and the rest of his equine friends out of their stalls.

"I had never been around draft horses. I'm not sure if this is typical of all draft/Thoroughbred crosses or just this one, but I swear that he was bipolar. He'd be playful one day, and obstinate the next. Working with him was always an adventure because I never knew which horse I had when I walked into the barn," he said.

Houdini amazed Trent not only for his bulk, but also for his ability to learn quickly.

"This big jug-headed thing progressed about as fast as any horse I've ever worked with. And he was so big, he could stop a steer in a heartbeat."

Another horse at Scott's that caught Trent's heart was an old roping horse named Diamond.

"He was about the most athletic horse I've ever ridden. And before you could rope on him, you'd have to ride him over the mountains and through the woods to wear him down. He had so much energy, so much natural ability," said Trent. "I ended up riding him a bunch, just because he was so athletic."

Trent got quiet as he told of this big, athletic horse wasting away from equine protozoal myeloencephalitis (sometimes referred to as EPM), an infection of the horse's central nervous system. "Before he died, he was my favorite horse," he said, his facial expression tight.

LIFE LESSONS FROM TRENT'S EQUINE FRIENDS

"I've had so many horses over the years that I've fallen in love with. From the sale barn horses on, when a good one came along, I just latched on," said Trent. "There's such an indescribable relationship that man has with a horse. You can learn a lot about yourself by spending time with a horse. I know that is true for me. As Americans, we live in this society that expects instant gratification. Horses make you work as a team, but on their time frame. I've learned patience from

Blaze, Trent, and Buck at Scott Hendrick's farm south of Nashville.

horses. I've learned to be more open-minded about the best way to approach a problem. I've learned to find and utilize the strengths that are already there, rather than try to manufacture something out of nothing. And that's a philosophy that works for people, too."

Trent is still busy going up and down the road with his band, with television tapings, and with writing his songs, but his ultimate goal is to have a little ranch out there somewhere in West Texas.

"Someday down the road if I had half a dozen good horses to ride, that's all I'd need," he said. "I'd be a very happy man."

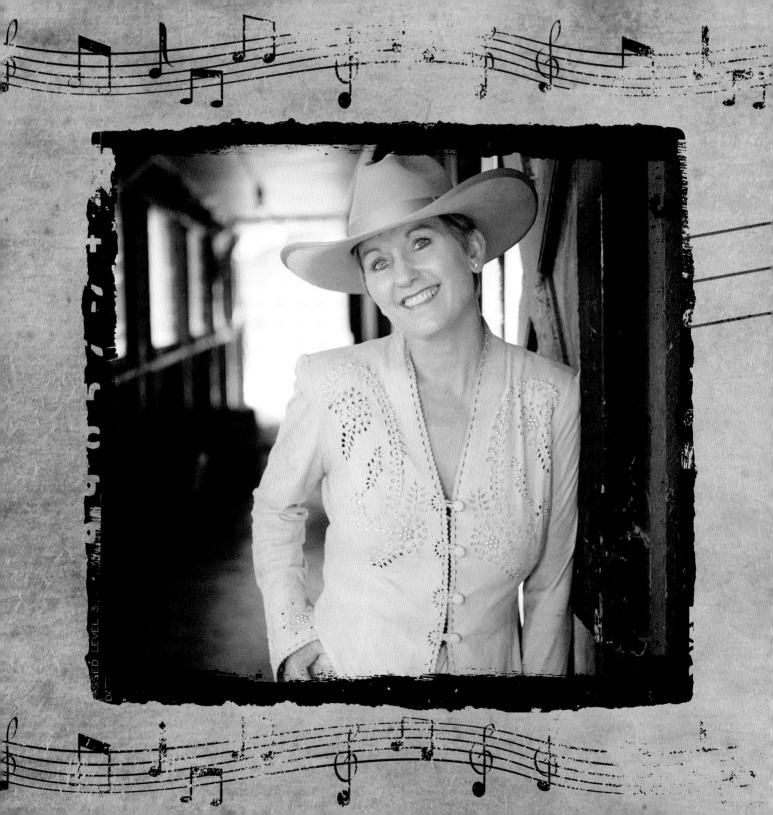

JONI HARMS

JONI HARMS AND HER FAMILY LIVE IN OREGON ON A RANCH THAT WAS HOMESTEADED BY HER GREAT-GREAT-GRANDFATHER IN THE 1870S, AND BOTH HER RANCH UPBRINGING AND THE LOVE OF ONE STURDY, DARK GELDING SIGNIFICANTLY IMPACTED HER LIFE.

"I lived on this land until I was twenty-one, when I moved away for a while. When Mom and Dad decided to slow down and travel more, my husband and I purchased the ranch," said Joni. "This place has a big sense of family for me. My dad is eighty-nine and still lives on the property."

"MY RELATIONSHIP WITH MIDNIGHT WAS LIKE A STORYBOOK."

BOTH COUNTRY AND WESTERN

Growing up on land that has been in her family for nearly a hundred years obviously gave Joni a sense of pride and an appreciation for history. Both are themes that frequently show up in her music.

A noted country artist, Joni has also been recognized by several western music associations. In 2003 Joni was named the Western Music Association's Female Vocalist of the Year and also accepted the award for Song of the Year. She has also won many awards from the Academy of Western Artists, including 2002 Entertainer of the Year. Joni is a regular guest on the stage of country music's famed Grand Ole Opry, and recently performed at New York City's Carnegie Hall.

"While I consider myself a country artist, the majority of my songs include lyrics of the West, because I love to write about things I've experienced," said Joni. "Rodeo, cowboys, and the ranch way of living show through in my music."

JONI FINDS A VERY SPECIAL CONNECTION

While the Harms family raised Black Angus cattle when Joni was a child, she also had a pony or two. But at age eight, Joni's life changed when saw "the most beautiful horse in the world."

"His name was Midnight and from that moment on, he was all I thought about," said Joni. "He was a stocky, solid-colored Morgan/Paint cross, and it was like we bonded before we even met. My goal was to somehow make that horse mine."

Unbeknownst to Joni, her mother talked to the girl who owned the 15.2-hand, seven-year-old deep chocolate brown gelding, and as luck would have it, the girl was thinking about "trading up" to a horse who could give her more of a challenge.

"That year on Christmas Eve, Mom and Dad somehow got Midnight into the stable without me

knowing about it. Of course, all the rest of the family knew what was going on," Joni said. "When my dad said he had to go check on something out in the barn that evening, I thought it was a little strange that the entire family went out there, too. But when we got there, there was Midnight in a stall waiting for me."

To say that Joni was thrilled would be an understatement; Joni couldn't believe that Midnight was actually hers! Midnight seemed pretty happy about it, too, as he and Joni quickly became best friends. It was a friendship that would last more than two decades.

"My relationship with Midnight was like a storybook," said Joni. "That was the closest connection I have ever had with a horse, and I can't really describe to you the bonding experience we had except to say that this horse knew what I was thinking even before I did."

Joni soon began doing her homework in Midnight's company. She spent every spare moment she had with Midnight and even slept in the barn with him on occasion. When the music bug bit, Joni wrote songs in his presence, and Midnight was the first to hear her fledgling melodies and lyrics.

"He actually had some pretty definite ideas about my songs. I'd be singing and he'd start rolling his ears around. I enjoyed watching him," Joni said. "And when I had a problem, I'd go out to Midnight and talk to him about it. He would make me feel so much better. I know I must sound crazy, but a person who knows how it can be with horses will understand this."

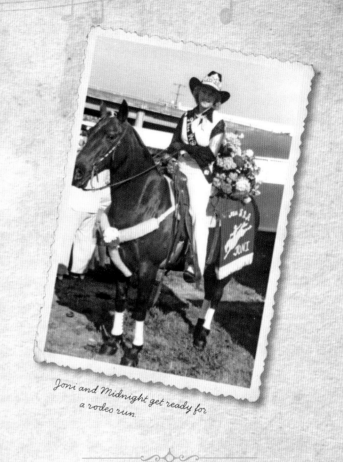

Joni and Midnight get ready for a rodeo run.

"ON ONE HAND, I COULDN'T BEAR TO SEE HIM SUFFER, AND ON THE OTHER HAND, HE'D BEEN MY FRIEND FOR SO LONG, I COULDN'T BEAR TO SEE HIM GO."

Midnight and Joni shared many things, one of which was a love of learning. When Joni taught Midnight several tricks, including how to bow, she said all she had to do was talk to him about it and he learned so quickly that it was as if he understood every word.

"He was the kind of horse who just embraced life," she said. "No matter what I tried with him, he gave it his all. When I gave riding lessons on him, he walked so gently with the little kids and with people who were inexperienced; yet if he got to a parade or rodeo he could prance and run with the best of them. He knew whatever his job was at any given moment and he did it well."

Early on in life, Joni decided that she wanted to combine horses and music, and she realized that Midnight could help her do that. She began entering rodeo queen competitions, working up the levels of competition until she was a runner-up in the Miss Rodeo America pageant.

"I found that wherever I went as a rodeo queen, I could usually also sing the national anthem, or perform at the dance after the rodeo was over," she said. "During the grand entry, Midnight and I would storm in through the gate, gallop around the arena with me doing the big rodeo queen salute, and then he'd stand very quietly while I sang."

Every horse has his or her own personality, and Midnight was no different.

"He loved to travel," remembered Joni. "He loved getting in the trailer to go new places and he and I were alike in that. And then, also like me, once he'd been gone for a while he was eager to get home. No matter whether we were going or coming, Midnight got all excited when I got the trailer out. He was always up for a new adventure."

And over the many years they shared, Midnight and Joni had lots of adventures. He was a constant presence when she got her first record deal and he was a port in the storm when she came in off the road from a long tour. But in his thirty-fifth year, the old horse rapidly declined, and Joni made the very difficult decision to have him put down.

"That was one of the hardest days of my life," she

said. "On one hand, I couldn't bear to see him suffer, and on the other hand, he'd been my friend for so long, I couldn't bear to see him go."

Midnight is buried there on the farm; Joni visits him often. She has also written a song about her friend, "Old Midnight," which she recorded for her *Are We There Yet?* album. Of all the songs she has written, "Old Midnight" is one of her personal favorites, and it is one of the most requested songs in her live performances.

THE COMMON BOND OF HORSE PEOPLE

While Joni mostly rides Paint horses now, her career has taken her to horses all across the world. And while she'll always be partial to a stocky chocolate brown horse, she's found that a good horse can be any breed, or any color.

"I did a music video with this beautiful palomino horse in Australia, and in France I sang our national anthem on a beautiful black stallion," she said. "Both were wonderful and amazing animals.

"I have found that horse people around the world really do speak the same language. We may not understand the specific words each other uses, but we understand the sentiment, the love of the horse, and that's enough for me to know that horses and their people really do share a unique bond. Not everyone will be fortunate enough to have a relationship like I had with Midnight, but if they get even half of what I had with him, they will be in for the ride of their life."

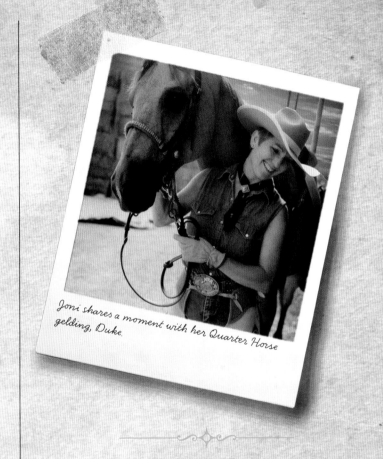

Joni shares a moment with her Quarter Horse gelding, Duke.

"I FOUND THAT WHEREVER I WENT AS A RODEO QUEEN, I COULD USUALLY ALSO SING THE NATIONAL ANTHEM, OR PERFORM AT THE DANCE AFTER THE RODEO WAS OVER."

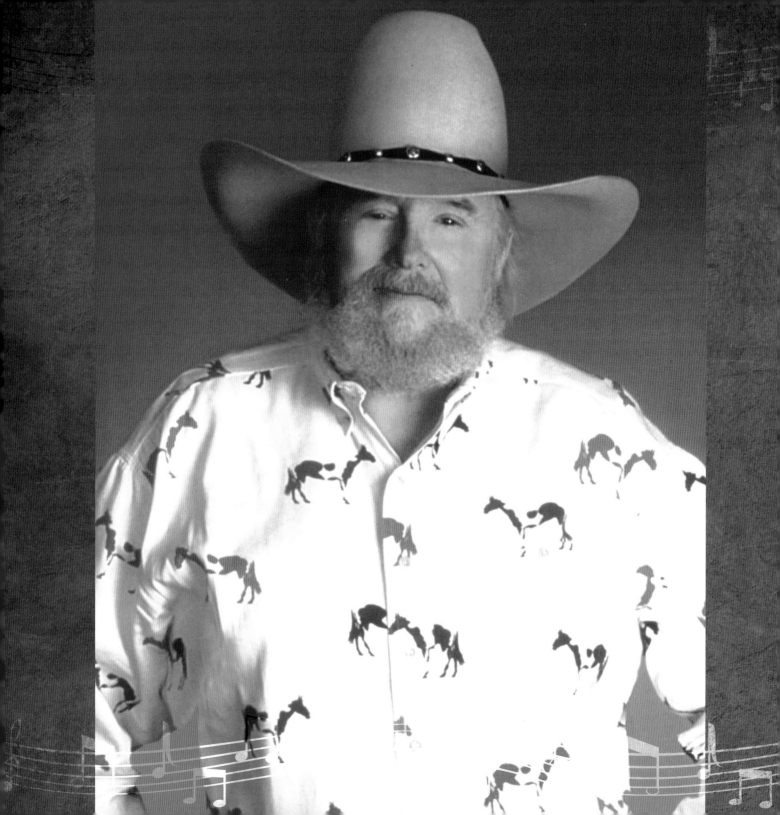

CHAPTER FOURTEEN

CHARLIE DANIELS

Charlie Daniels is a Southern country legend. His signature bull rider hat and belt buckle represent life on his Twin Pines Ranch. They also represent his love of horses, cowboy lore, rodeo heroes, Western movies, and Louis L'Amour novels. Those loves, along with his music, have connected Charlie with millions of fans across the globe.

Not too many years out of high school, Charlie co-wrote the song "It Hurts Me," which became the B side of an Elvis Presley hit. He also served as a musician on recording sessions with Bob Dylan. Eventually, Charlie broke through with his own rebel anthems "Long Haired Country Boy" and "The South's Gonna Do It." Both songs are well known by fans of every genre.

"Any horse that serves me well is welcome to my pasture as long as they live, even after their riding days are over."

In 1979 Charlie delivered "The Devil Went Down to Georgia," which became a platinum single, topped both country and pop charts, won a Grammy, earned three Country Music Association awards, and became a cornerstone of the *Urban Cowboy* movie soundtrack. In addition to the Country Music Association Awards, Charlie has earned numerous awards from the Gospel Music Association and the Academy of Country Music.

In 1998 two former United States presidents paid Charlie tribute when he won the Academy of Country Music's Pioneer Award. "In his time he's played everything from rock to jazz, folk to western swing, and honky-tonk to award-winning gospel," said former president Jimmy Carter. "In Charlie's own words, 'Let there be harmony. Let there be fun and twelve notes of music to make us all one.'"

RIDING IS A WAY OF LIFE

Throughout his exceptional career, horses have been one of Charlie's greatest joys. He was born in Wilmington, North Carolina, and horses were such an integral part of Charlie's early life that he doesn't remember learning how to ride.

"It's that much a part of me," he said. "We had farm animals as I was growing up, and some of the horses doubled as saddle horses. We rode those sometimes for work and other times for pleasure."

Although Charlie had a farm background and really enjoyed time he spent around horses, it wasn't until he was in his thirties that he bought a horse of his own. Although he is now heavily into Quarter Horses, the first horses Charlie bought were just horses that he happened to like. They included a Midnight Sun–bred Tennessee Walking Horse, an Arabian that had formerly been owned by a member of the Marshall Tucker Band, and several mixed-breed horses.

"We had moved to Tennessee by then and I had to board the horses because we didn't have a place to

keep them yet. In fact, the horses were the motivation to buy the farm," said Charlie, whose Twin Pines Ranch is located near Nashville. "The whole family rode then, including my wife, and it was a very large part of our life. Our family was always close, and riding horses was an activity that we could all enjoy and do together."

Once Charlie had bought the land for Twin Pines Ranch, he decided to make his lifelong dream of having a horse ranch a reality. When purchased, there was only a double-wide trailer on the property, so Charlie added a barn (three stalls with a tack room) and a paddock. He later added a new barn and an arena. Charlie had always wanted to rope, so most of the Arabians and Walking Horses were sold, and by 1980 he had mostly "cowboy" horses. With the addition of some Corriente roping and dogging cattle, the ranch was taking on a working aspect.

A MAJOR TEACHER

Thurman Mullins is a friend of Charlie's who came by to help out on the ranch in 1980 and has been there ever since. He now serves as the Twin Pines Ranch manager, but one of the first things he did for Charlie was find a horse Charlie could learn to rope on. The gelding's name was Major.

"Major was a good solid horse for someone like me, who was just learning to throw a rope," said Charlie. "He wasn't flashy, but he was a hard worker and did well for me. So well that I enjoyed it enough to stay in it all these years."

FAT GAL

A few years later, Charlie found a registered Paint mare, Rialto's Lady, who soon became known around the barn as Fat Gal.

"Charlie would get out amongst the cattle and talk to old Fat Gal and she'd just do whatever he asked,"

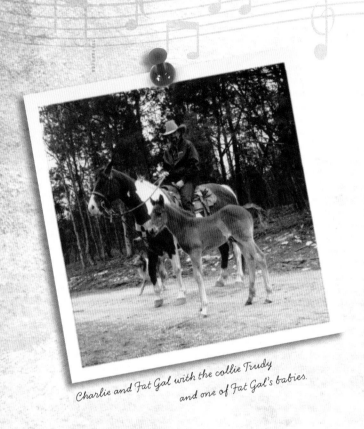

Charlie and Fat Gal with the collie Trudy and one of Fat Gal's babies.

said Thurman. "She was smart, and solid, and honest, and she was tough."

"Fat Gal was a big, chunky Paint horse and had a great personality," added Charlie. "She was a very loud white and dark chestnut mix—she looked black and white from a distance. Fat Gal was only about 15.1, but very stout. Eleven or twelve hundred pounds and a number two shoe, so she was definitely big enough to carry me. She'd go all day long and work hard every minute. She had the mental capability to both head and heel, and do both well. We lost her a few years ago, at age twenty-two."

Fat Gal is buried on the Twin Pines Ranch.

"Any horse that serves me well is welcome to my pasture as long as they live, even after their riding days are over," commented Charlie. "I think you owe them something. Fat Gal was very welcome around the place even after we retired her."

When Fat Gal died, Thurman cut some hairs from her long, white tail.

"He sent the hairs to someone in Colorado who braided the hair very fine and made a watch chain. Thurman gave that watch chain to me and it is one of the nicest gifts I've ever received," said Charlie. "I'd never forget old Fat Gal, but the watch chain is a very nice way to remember her."

Charlie also found another way to honor and remember his good friend. Recently, the American Paint Horse Association (APHA) awarded Charlie with its Legendary Achievement Award. He was honored for his work over the past twenty-five years in breeding Paint horses and spotlighting their beauty, versatility, and athletic talents.

In his acceptance speech, Charlie said, "For years my favorite working ranch horse was an APHA mare, Rialto's Lady, affectionately known as Fat Gal. She headed and heeled, broke brush gathering cattle, made a great turn-back horse in the cutting pen, and her tobiano paint pattern made her stand out in the pasture.

"Due to Fat Gal's legacy, there are a number of APHA horses on the Pines," Charlie continued. "Everyone comments on the color in the pastures. Al-

though our bloodlines reflect cutting and working cow horses, we hear from customers that some of our former ranch horses are winning in endurance, Western pleasure, trail, and even English."

FRECKLES

While Charlie gave a wonderful tribute to the horse who meant so much to the legendary entertainer, Fat Gal isn't the only horse who stands out in Charlie's mind. Freckles was a gray Quarter-type horse who also found a permanent home on the Twin Pines Ranch.

"Freckles was the kind of horse that we could load him up and take him down to a rodeo at the spur of the moment and win some money on him," said Charlie. "He was solid and consistent. That's the type of horse that makes me sit up and take notice, and that's the type of person I most admire, too. Just that steady effort to get the job done."

During the eighties and early nineties, Charlie had regular clinics and seminars at the ranch and Freckles became a big part of those clinics.

"If you were inexperienced or nervous, Freckles could read you," said Charlie. "He'd read you like a book and know exactly what you did and didn't know. But rather than take advantage of that, as some horses—and people—will, he was one of those rare horses that will actually teach you how to rope."

Freckles was close to thirty-five years old when he died.

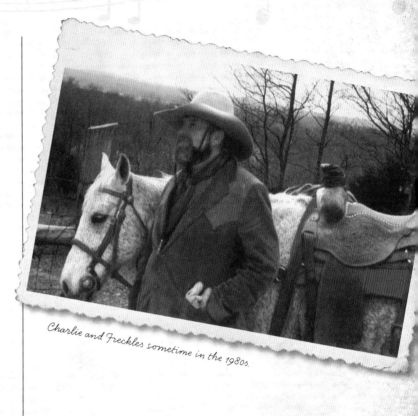

Charlie and Freckles sometime in the 1980s.

"There is a whole code of ethics that true cowboys abide by that includes honesty and honor, and that's something we don't see enough of anymore."

"He was in a field with two mares and a colt, and he started falling off some," Charlie said. "He earned his keep with us and he was happy, but after a certain age, we got to where we worried about him some."

CHARLIE LOVES HORSES AND THEIR PEOPLE

Charlie loves the time he spends on his ranch and he loves the people and the horses who share that time with him.

"There is a whole code of ethics that these people, that true cowboys, abide by that includes honesty and honor, and that's something we don't see enough of anymore. That's the cowboy way, and we like doing things that way at the ranch," said Charlie. "That's just how we run our business operation. And I enjoy it so much. I enjoy everything about it, the horses, the people, the cattle, being outdoors. I mean, I think I'd rather rope than have supper at the White House."

In addition to roping at Twin Pines, for many years Charlie was heavily into the competitive and working end of roping. Charlie especially loves team roping, a sport in which one horse and rider combination ropes the head of a calf or steer and a second horse and rider "heel" the calf by roping the back legs or heels. Charlie is a heeler.

"I used to really enjoy going to see friends out West in the spring and helping brand the calves, used to love loading up and going to a rodeo to rope—I loved all of it. But I seem to be so much busier these days; I don't have the time I used to so I don't get to do things like that as much," said Charlie.

THE TWIN PINES STALLIONS

At one time, the Twin Pines Ranch had over forty Quarter Horse broodmares. Now the ranch runs a more manageable herd, including three stallions. Each of the stallions has roots at Twin Pines, including TP King Bear, a 1982 son of Sun Fritz (a Plaudit- and King-bred Quarter Horse) and one of the first horses foaled at Twin Pines.

"He's really our foundation sire," said Charlie. "He's given us a lot of good, solid colts and we're

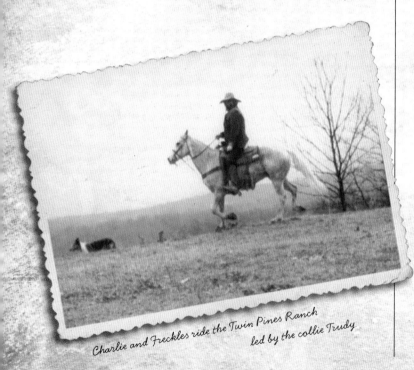

Charlie and Freckles ride the Twin Pines Ranch led by the collie Trudy

actually breeding his grandchildren now."

TP King Bear was recently retired to outside mares, but still breeds a few of Charlie's Twin Pines mares.

By Clarks Dream TP is a young bright bay son of TP King Bear, and HLF Smokin Ace is a Paint who was foaled in Pennsylvania, but whose bloodlines trace back to Twin Pines stock.

Charlie also still owns and breeds a few Spotted Saddle Horses. As he said, he loves them all.

THE BENEFITS OF RIDING

"I would highly advise anyone to just get on a horse and ride. It is that simple," Charlie said. "There is something about riding a horse that is unique. There just is no other feeling like it. Once you get close to a horse mentally and emotionally, once you learn to trust them and they to trust you, you sit on their back and they've got their ears perked forward and there just is nothing better.

"I used to ride every day I could, and I rode a lot at night. I'd go down to the arena and just ride. What a great feeling, just you and your horse, and nothing else in the world exists for me during those times. Riding horses puts everything in life in perspective. It helps put your mind in order. I ride mostly for pleasure now. Horseback riding is second nature to me. To take care of a horse, put a saddle on one, and get on and ride out in the woods and fields, it is so much a part of my life that I can't imagine not having that. I can't think of a better way to spend leisure time than to sit on the back of a horse."

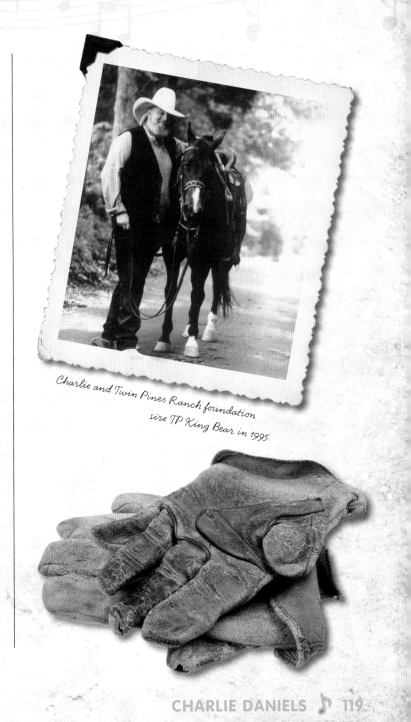

Charlie and Twin Pines Ranch foundation sire TP King Bear in 1995.

CHAPTER FIFTEEN **JANIS OLIVER**

(SWEETHEARTS OF THE RODEO)

JANIS OLIVER'S EXPERIENCE WITH HORSES HAS BEEN AN INTERESTING JOURNEY. SHE'S GONE FROM PUBLIC RIDING STABLES, WESTERN PLEASURE, REINING, CUTTING, AND TRAIL RIDING, TO HER MORE RECENT PASSION OF FRIESIAN HORSES.

"I grew up in Manhattan Beach, California, and was a beach girl until my early twenties," said Janis. "I loved horses, but we were a very modest, middle-class family so there was no way I could have a horse of my own."

Janis's mother was a homemaker who somehow dug up the time and money to take Janis to various stables in the Los Angeles area so Janis could ride.

"In retrospect, this was a huge thing for her to do for me," said Janis. "I didn't realize the sacrifice at the time, but for her to brave the LA freeways to get me to the stables was a huge labor of love."

When she wasn't indulging in her passion for horses, Janis and her sister Kristine were singing together, first as the Oliver Sisters, and later as the award-winning duo Sweethearts of the Rodeo. With their first two albums spawning seven consecutive top-ten hits, the Sweethearts filled country radio with classics such as "Midnight Girl/Sunset Town," "Chains of Gold," "Satisfy You," and "Blue to the Bone."

The duo was nominated nine times as the Country Music Association's Duo of the Year. Additionally, they won Best Vocal Duo in the *Music City News Awards*, and were chosen as Favorite Group in The Nashville Network's Viewer's Choice Awards.

In the early 1980s Janis married country star Vince Gill, who at the time was a member of country rock act Pure Prairie League. The couple eventually moved to Music City.

FROM PUBLIC RIDING STABLES TO HORSE OWNERSHIP

"When Vince and I moved to Nashville, I finally had a rural setting and could buy a horse," said Janis.

But Janis realized right away that her public riding stable background had left her totally unprepared for horse ownership. Janis knew that she wanted her first horse to be a Quarter Horse, but her first two choices were young horses that were inappropriate for her limited background and skill. After two bad experiences it is a testament to her love of horses that she chose to try a third time.

"I began learning about different breeds and how the breed of the horse and the horse's mind and movement affect how I ride and the style I ride," she said. "It was a new concept for me and one that really opened my eyes."

After considerable research, Janis became interested in both Paint horses and the hunter under saddle English style of riding. In time, she found a tall, bright chestnut solid-colored Paint gelding with four white socks and a blaze named Nelson. Nelson is a quiet and intelligent grandson of the great AQHA sire Sonny Dee Bar.

"Nelson had over five hundred points when I first saw him," said Janis. Points are earned in competition based on the number of horses entered in a specific class and the placing in that class of an individual horse. Five hundred points is an exceptional number and means the horse is a pro at what he does. "Nelson taught me a lot about riding and connecting with a horse. He is such a trooper because I know I made mistakes with him, but he was so patient with me."

Nelson was later donated to a therapeutic riding program in Franklin, Tennessee, where he is still exceptionally kind to and patient with the people around him.

THE SPORT OF REINING BECKONS

Janis's eyes were opened once again when she became interested in the sport of reining.

"That's when I learned that a good horse is not so much about looks but about athletic ability," she said. "Reining taught me to really communicate with my horse. There are two brains working here. One brain is horse and one is human, but both brains have to be connected somehow in order to meet a common goal.

"NELSON TAUGHT ME A LOT ABOUT RIDING AND CONNECTING WITH A HORSE. HE IS SUCH A TROOPER BECAUSE I KNOW I MADE MISTAKES WITH HIM, BUT HE WAS SO PATIENT WITH ME."

Through reining I had to learn what is the smallest effort I can make, the tiniest signal I can give to my horse, that will get my horse to understand what I want him to do."

By this time Vince and Janis had divorced and she had met her second husband, horse trainer Roy Cummins.

"Our entire courtship was reining," she said with a smile. "Through Roy's depth of experience and incredible finesse with horses, I learned so much."

Although Janis has moved on from reining competitions, she still has an old reining horse that she rides regularly, and who will probably live out his days at her farm.

JANIS AND REDONDO: MEANT TO BE

While Janis has had incredible relationships with Nelson and her other horses, it is to her new Friesian, Redondo, that she feels the closest.

Many Friesians are imported from the Netherlands, and Redondo is no different. Arriving in California's Sonoma wine country in fall of 2006, he had been in the country for just a single day when Janis found him.

"IT WAS LIKE ALL MY TRAINING, ALL MY KNOWLEDGE OF HORSES, ALL MY ABILITY, JUST MESHED COMPLETELY WITH THIS HORSE."

"I had done a Web search and found a woman named Janna Goldman through one of the searches," Janis explained. "She specializes in Friesians and has a lot of them. I'm new to the breed and she seemed to have the type of family-oriented, bombproof horse that I wanted."

Friesians, a warmblood breed, are still quite rare in the United States. The high-stepping breed originated in Friesland, a province of the Netherlands. One of Europe's oldest breeds, Friesians were originally imported to North America in the seventeenth century but were later lost due to crossbreeding. Friesians were reintroduced here in 1974 and are now always black in color. They are very versatile and can be used in pleasure, dressage, trail riding, driving, and light farm work.

"I went out to California to visit Janna and had chosen two horses—I'm so terrible, I can't buy just one. I had actually decided and written the check when I thought to look at the Web site one more time, and Janna had just posted information on this amazing new horse," said Janis.

Janis extended her stay in California specifically to look at the new arrival and reconsider her earlier decision on the other two. She admitted that it was a little scary, riding this horse who had just come into the country, but after a few minutes on his back something magical happened.

"There was something about him," she mused. "We went around a corner and it was like all my training, all my knowledge of horses, all my ability, just meshed completely with this horse. I felt like I was floating, weightless, and I just knew that this was the horse I was supposed to have."

A LEARNING PROCESS

That was nine months ago, and Janis and the massive 16.1-hand, eight-year-old Redondo have since become best friends. Every day, weather permitting, Janis and

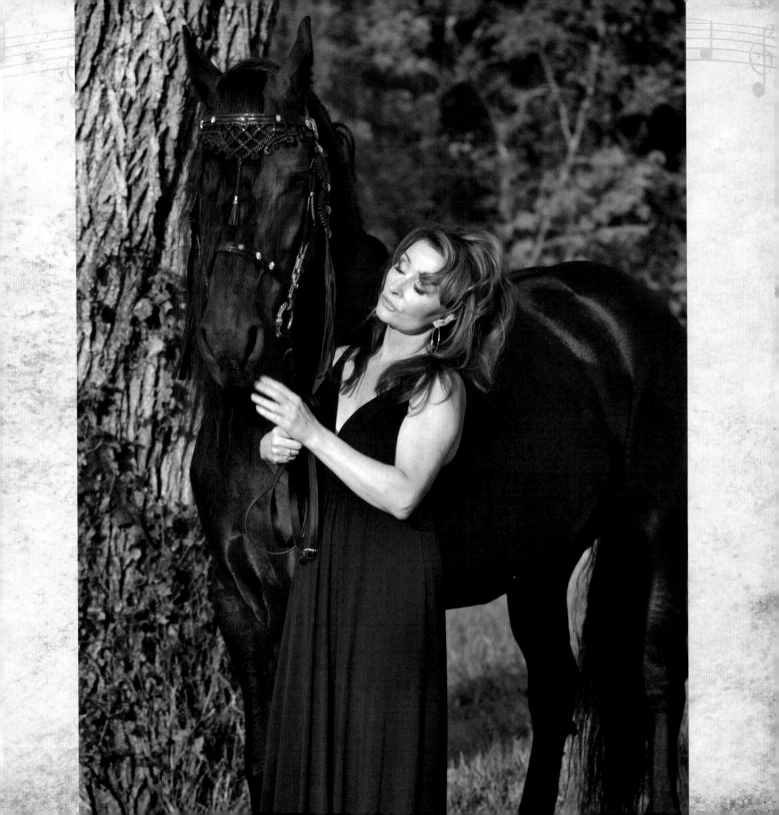

Redondo can be found riding the trails around her farm, or the trails at one of Nashville's many parks.

"I've developed this very spiritual bond with him, and we have gotten very close," she said. "Now, I can make the tiniest touch to his mouth, the tiniest correction to my seat and he responds so beautifully. Sometimes I think he reads my mind, because I don't even remember giving him any kind of signal. I think it and he just does it."

While there was an instant bond between the two, the learning process has been a little slower, and Janis is specifically sensitive to the language she uses with Redondo, who was trained using the Dutch language.

"When I got him he was far more used to hearing a person speak Dutch than English," she said. "So whenever he hits an exceptionally good lick, I say something like, 'Ja, dis is goot' in a tone of voice that I heard his Dutch trainer using. I try to mimic his voice and I think it has helped ease the transition.

"When I speak in a certain tone of voice when he, for example, is speeding up, he slows right back down when I ask him to. I have spent most of my time with him just trying to communicate and have our minds join up. I not only want him to understand what I ask of him, I want him to teach me what he is thinking," she said. "I want to learn to understand what he is telling me."

It's good that both Janis and Redondo are willing partners because it would be difficult to find two more different disciplines than performing a reining pattern on a Quarter Horse and riding the big-moving gait of a Friesian.

"His has a big trot and he feels so animated," said Janis. "His entire movement is so different from what I am used to that in some ways I think I am learning to ride from scratch. Most of my experience is with Western styles of riding and the knee action of the Friesian is so much more pronounced than that of a Western horse. Friesians are mostly used today for

saddle seat and dressage styles of riding, and there is a huge cultural difference between what you do on a saddle seat horse and what you do on a reining horse. But, it would be fun to teach him to rein!"

A VISIBLE BOND

The many hours in the saddle have given both Janis and Redondo familiarity with each other.

"Now that I've learned to relax and sit into the trot, sometimes I feel like I'm not even touching the earth," she said. "I have been close to other horses before but the oneness Redondo and I seem to have, well, I can only call it amazing."

Janis added that the willingness to please that Redondo has shown her has been extraordinary. Friesians are known for their ability to bond with one person, much like a dog, and that is true in this instance. When visitors went out to the paddock to admire Redondo's arched neck, flowing mane, and substantial build, Redondo looked only at Janis. Despite attempts to direct his attention elsewhere, his entire being was focused on her. The big horse's body language was eager and inquisitive, but also very respectful.

"I think Redondo would crawl in my lap if he could," laughed Janis. "The number one thing I've gotten from my experience with horses is this specific horse's desire to please. He tries so hard to deliver what I ask that it never fails to astonish me.

"Every day I get up and I can't believe how lucky I am to have him," she said. "I'm really proud that I found him all by myself, without the help of a trainer, and that I made such a great choice for me. I trusted my intuition and I've learned that my intuition was right! At this point in my life I was just looking for a friend, but I have gotten so much more. I am so excited that he and I have this long future ahead of us. Truly, getting Redondo has turned into one of the best things I have ever done."

"I HAVE BEEN CLOSE TO OTHER HORSES BEFORE BUT THE ONENESS REDONDO AND I SEEM TO HAVE, WELL, I CAN ONLY CALL IT AMAZING."

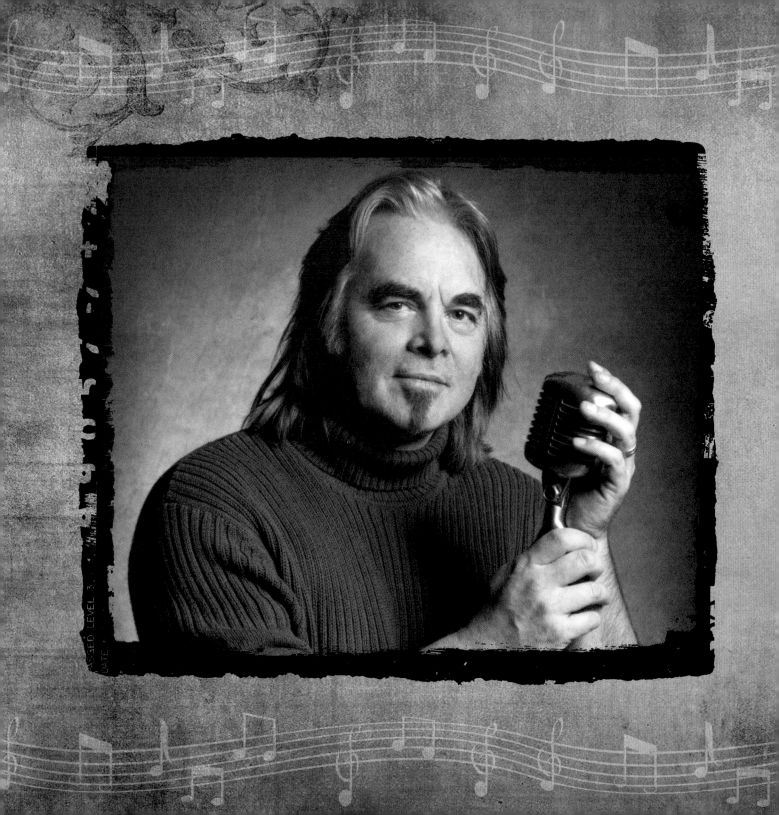

HAL KETCHUM

Hal Ketchum grew up on a farm in upstate New York with an ancient Belgian workhorse that his grandfather had used to work the fields. In addition to Hal plodding around the farm on the big horse, when Hal's mother was a child, she used to ride the old Belgian to school.

The Belgian provided a small boy a safe introduction to horses. As he got older, Hal and his brother would chip in together on a horse, ride it for a while, and then sell it. These experiences taught Hal very early on that horses have an innate sense of where a rider is mentally and emotionally.

"As a kid, I got on some horses that I didn't belong on, and they told me straight up that I didn't belong," said Hal. "Those were good lessons to learn early on in life, mainly that I needed to take time to assess a horse—or a particular situation—before diving in blindly."

Hal began playing drums when he was fifteen, and wound up writing songs, playing dance hall gigs, and working full-time as a cabinetmaker in San Marcos before moving to Nashville in the early 1990s.

While it takes some artists several tries before breaking through, Hal struck gold with his first single, the now-classic "Small Town Saturday Night," which quickly shot to number one. A subsequent string of hits included "I Know Where Love Lives," "Hearts are Gonna Roll," "Five O'clock World," and "I Miss My Mary." Hal's continued success includes fifteen top-ten hits and more than four million album sales, and he has performed a concert of his own music that was danced by the Nashville Ballet. Hal was inducted into the Grand Ole Opry in 1994 and often hosts *Opry Live*, a television program that airs Saturday nights on the Great American Country cable channel.

As a songwriter, Hal has had songs recorded by such diverse artists as Trisha Yearwood and Neil Diamond. And, he has five separate million-air awards from BMI, acknowledging songs of his that have been broadcast over one million times.

THE MAVERICK SHOOT

It is interesting that while Hal started life with horses present, his career both took him away from them and then brought him back. In 1993 a film was being made in Arizona. Called *Maverick*, it was based on the 1957 to 1962 television show of the same name and starred Mel Gibson, Jody Foster, and James Garner. Hal had a role in the film as a bank robber.

"My manager called me one day and said, 'You have to be at Lake Powell tomorrow for a couple of days of shooting.' Lake Powell is in Arizona," said Hal. "Then my manager dropped the other shoe and said, 'You *can* ride, can't you?' I hadn't been on a horse in fifteen years, but I said, 'Of course! Of course I can.'"

Fifteen years out of the saddle, Hal wasn't at all sure how competent his riding skills were, but he wasn't about to let that small fact keep him from this acting role. So Hal spent three days in the brutal Arizona sun

robbing a bank with seasoned actor Danny Glover, who has an uncredited part in the movie.

On the third day, Hal and Danny filmed the get-away scene.

"We started early in the morning," remembered Hal. "The gist of it is, they blew up this bank building at the edge of the lake and here Danny and I come running out of the bank. We jump up onto our horses, and ride through the smoke and dust with a bag of 'money' in one hand and a gun in the other. The only problem was that I had a very contrary horse. He wasn't at all sure about the noise and dirt. And I'm sure I wasn't helping him any trying to balance the money and the gun, hold the reins, steer while going thirty miles an hour on a horse who didn't want to be there, and look like I'd been doing it every day of my life.

"Horses are so intuitive, and this horse knew I hadn't ridden in a long time. I wasn't giving him any confidence and he certainly wasn't giving me any. And to be fair, it was going to take a very special horse to be able to deal with the noise of the explosion, all the stuff flying through the air, the lights, cameras, all the people around . . . and me. This horse was a good horse, just not for me and not in that situation."

MOSES SAVES THE DAY

After a number of takes, the cast and crew took a lunch break while a wrangler on the shoot beckoned to Hal.

"He said, 'Come with me. Let's walk out into the herd and see what happens,'" said Hal.

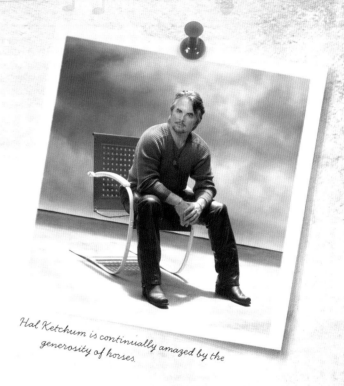

Hal Ketchum is continually amazed by the generosity of horses.

"Horses are so intuitive, and this horse knew I hadn't ridden in a long time."

The wrangler knew the importance of the horse/human bond and hoped to find a horse that wanted to be with Hal. Otherwise the cast and crew could be filming this scene for a week and still not get the shots they needed. As Hal stood in the center of the corral, a sorrel mare came up and nuzzled him. Hal liked the mare, but unfortunately, she wasn't all that well trained. The wrangler suggested Hal wait to see if another horse approached him. One did.

"Moses decided that he would be the one to offer his friendship and support for whatever I needed. I am still awed by it all."

"This little dark gelding with a white face came up and we bonded right then," said Hal. "His name was Moses, which I thought was very appropriate because the Moses we all associate with the name was a leader, and I certainly needed a horse who could lead me through this scene."

Hal and Moses had lunch together that day on the set and rested companionably side by side until the crew was ready to resume shooting. The time was well spent.

"There are some great takes of us going hell bent for leather, just exploding into the scene, riding all out," said Hal. "This wasn't Moses's first time on a movie set and that made all the difference."

While not tall, Moses was a very sturdy horse with a high head carriage. Because of his build, Hal thought Moses might possibly have some Morgan remount blood in his background. On screen, Moses's personality, his stout build, and the trust he and Hal had as a team came together to create a dynamic visual.

In the scene, Hal, looking suitably disreputable in a faded brown ten-gallon hat and a bandanna, lights the fuse that blows open the safe. Moments later, the windows in the bank building explode as horses and people scatter. And just as Hal said, he and Danny come flying through the swirls of dust and glass, jump on their skittering horses, wheel them around, and ride off into the brush. Thanks to Moses, Hal really did look as if he had been robbing banks all his life.

After eight hours in the saddle, Hal bummed a ride on the Warner Bros. jet to San Francisco, where he was performing. His bank-robbing partner and friend, Danny Glover, tagged along.

"I have to say, we were both pretty stiff after all the riding," said Hal, "and we both shuffled very slowly off the plane holding our boots. I can definitely say that spending eight hours in the saddle after not having ridden for fifteen years can make you sore in places you never knew you had!"

Years later, Hal took part in an equine therapy class and the class made him realize even further what an amazing horse Moses was.

"They actually integrated you as part of the herd and it was obvious that the horses had a remarkable sense of what I was feeling at any given time," he said. "Horses are so insightful, so much more so than we are. It was an amazing experience. Afterward I understood so much more about how much Moses had given to me, how quickly Moses decided I was a person who needed help, and how generous he was in offering it. When I stood there in the corral on the set, any one of those horses could have come up to me . . . or none of them. Moses decided that he would be the one to offer his friendship and support for whatever I needed. I am still awed by it all."

HAL HANDS THE GIFT OF HORSES TO HIS DAUGHTER

The experience with the equine therapy class encouraged Hal and his wife, Gina, to begin riding lessons for their daughter Fani Rose.

"Fani is a very, very active child," said Hal. "Normally she is into everything. But when she is riding, I see a level of concentration that I don't see at any other time. She is entirely focused on whatever task she has with her horse and she gets it done. Someone once told me that you can't put the desire to ride and be around horses into someone, but you can't take it out of them

Hal, Sami, and Fani Rose.
Sami is a four-year-old part Haflinger
gelding Fani Rose sometimes rides during her lessons.

either. Fani has that desire in spades; she lives to ride."

Hal and Gina currently live in Nashville. In addition to Fani Rose, they have daughters Ruby Joy and Sophia Grace. Will their younger two girls also ride?

"If they want to," said Hal. "Horses have given Fani a sense of purpose and a focus in life. In different ways they have taught me to trust, and to think before I act. I'm sure there are many things horses could teach the younger girls. Horses are so much smarter than we are. We just have to be open to what they can tell us about ourselves."

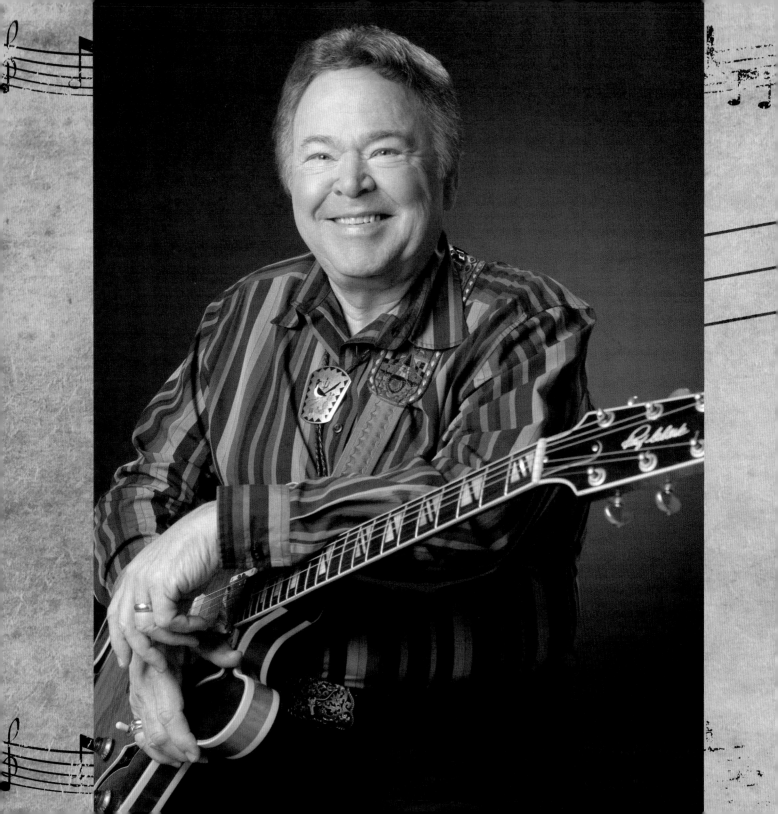

CHAPTER SEVENTEEN ROY CLARK

FROM AN EARLY AGE, THE HIGHEST HIGHS AND LOWEST LOWS IN ROY CLARK'S LIFE HAVE BEEN WITH HORSES.

"EVER SINCE I WAS A KID THERE WAS SOMETHING INTERESTING TO ME ABOUT A COWBOY MOVIE AND A HORSE," SAID ROY, A TALENTED MUSICIAN AND VOCALIST WHO HOSTED THE POPULAR TELEVISION SHOW HEE HAW FOR TWENTY-FIVE YEARS. "WE NEVER HAD RIDING HORSES AROUND WHEN

I was young, but I used to ride mules and working horses back when I was six, seven years old. Five years old. I remember that I always rode bareback."

When Roy was in his early twenties, he and a friend grabbed some horses one day and went riding. It was supposed to be a fun day out on the range, but the ride turned into a life-changing experience for Roy.

"A HORSE REALLY WILL DO EVERYTHING IT CAN NOT TO HURT YOU."

"I think the horse I was on was a Morgan. This was in the early spring. This horse belonged to my friend and I know the horse had not been ridden since the previous fall so he was a little skittish," said Roy.

Roy's friend also had a German shepherd, and as the two friends were riding, the dog began barking and nipping at the horses' heels.

"Well, as long as my horse could see this dog, he was all right," Roy explained. "But the dog got under my horse's back feet and my horse reared up. Looking back, if I had just given the horse his head, we'd have been all right. But when he reared, you know, I got scared and pulled back on the reins. The horse had a Mexican bit and if you are familiar with them you know when you pull back hard it can cut the roof of the horse's mouth. But I kept pulling back and pulling back. This poor horse not only got up on his hind feet, he started walking backwards. Finally, he hit a little up bank and I was still pulling on that bit, and really, it forced him over backwards. I felt him fall. But by that time, I had slid off and was sitting on the ground. I had just turned to get out of the way when he fell backwards across my leg."

Roy broke both bones in his leg, straight across between the knee and ankle, and didn't walk for eleven months. Roy said he never blamed the horse; instead, he took full responsibility for the fall. But because Roy was not able to get right back up on the horse, because he'd had eleven months of rehabilitation, his subconscious, unbeknownst to him, had gone to work.

A DIFFICULT RECOVERY

"I've often heard that if you fall off, or if you get hurt on a horse, you need to get back on as quick as you can so you don't build up a fear," said Roy. "Well, I physically couldn't, you know, get back on a horse for some time."

Fellow recording artist Elton Britt (who around the time of World War II had the first million-selling country record, a song called "There's a Star Spangled Banner Waving Somewhere") was a friend of Roy's.

"Elton was a real horseman and outdoorsman, and about three years after my little mishap I went up to his farm and he had a yearling colt he wanted

to show me," said Roy. "Elton took me out to a round pen to show me this horse, and I realized that this was the first time I had been around a horse since the accident. I stepped into the pen and this horse took two steps towards me, just two ordinary walking steps. He just walked over like any horse would, being inquisitive, kind of slowly, and I broke out in the coldest sweat and started shaking. Just uncontrollable shaking, and I realized that a real fear of horses had been in me since the accident, but it had been dormant. Because I had not been around horses, there had been nothing to bring my fear to the surface. Somehow I climbed out through the pen, but I was shaking and sweating like all get out."

Rationally, Roy knew that the horse who had hurt him had not meant to, but that rationale was hard to explain to his shaking, sweating body.

"A horse really will do everything it can not to hurt you," he said. "I mean, if you fall off in front of a horse, he'd do his best to step over you. I'd fallen many times before. I'd ridden a horse down a grade and lost my balance and slid off. I slid right under that horse's feet and he stepped right on over the top of me so I wouldn't get hurt."

After the incident with the colt in the round pen, Roy understood that he had to do something to get over his fear.

"I realized how ridiculous this fear was. I knew logically that it was just a freak accident that I, myself, out of my own fear and ignorance had caused," he said.

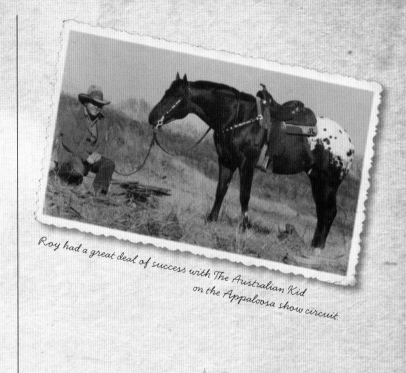

Roy had a great deal of success with The Australian Kid on the Appaloosa show circuit.

"I HAD THOUGHT A LOT ABOUT HORSES AND THE FALL OVER THAT YEAR AND HAD BEEN ABLE TO CONQUER MY FEAR."

But it took some time for the shaking to go away. A year or so later, Roy had an opportunity to see if he had conquered his fear. He'd spent a solid twelve months thinking continually about all the good things horses brought to people. But was it enough?

"I was out in West Texas when a friend invited me to ride," said Roy. "So I went out and got on this horse. I felt a little uneasy that first time I climbed aboard, but it didn't last very long. It really was okay. I had thought a lot about horses and the fall over that year and had been able to conquer my fear. I think that time we rode two or three days. I was really elated that I could ride that horse. It was probably four years from the time I fell until I got back on. That expression about getting right back on after a fall is true. I mean it is true to the hilt."

Since then, Roy, who is a member of the Grand Ole Opry, developed a strong Thoroughbred breeding and racing operation. He also showed Appaloosa horses for a time and had great success with a black and white son of Hank's Plaudit named The Australian Kid.

SIX DECADES OF MUSIC

As Roy is now his sixth decade of a stunning musical career, he does not have all the time he would like to devote to the horses he loves so much.

Roy was the first country music artist to guest host *The Tonight Show* for Johnny Carson, and has hosted many television specials, including "The Disney Anniversary Special," the Academy of Country Music Awards, and three specials for England's BBC. He has been seen on many other shows as well, including a regular guest role on *The Beverly Hillbillies*.

Roy was the first national ambassador for UNICEF, has received the Entertainer of the Year award from both the Academy of Country Music and the Country Music Association, and the Comedy Act of the Year from the Academy of Country Music. Roy was honored as Instrumentalist of the Year six times by *Music City News*; Picker of the Year from *Playboy* magazine's reader's poll, Best Country Guitarist from *Guitar* magazine, and the list goes on.

Through the years, Roy recorded a string of hits, including "Honeymoon Feeling" and "Thank God and Greyhound You're Gone," but he is best associated with the stirring, "Yesterday When I Was Young" and his own twelve-string guitar version of "Malaguena."

A SEDUCTIVE MARE CHANGES THE CLARK FAMILY'S LIFE

Believing that music can bridge continents, Roy has taken his music to many countries around the world.

But when Roy is on his ranch near Tulsa, Oklahoma, for many years horses have occupied his time.

Once Roy had conquered his fear of horses, he decided that he actively wanted them in his life. Through the help of another friend, Roy claimed a Thoroughbred racehorse at a track in Maryland. Roy's wife, Barbara, soon became extremely interested in the sport.

"She wasn't into the racing part so much as the horse itself. She really got into pedigrees and blood strains, what horses crossed well with other horses and that part of it," explained Roy. "She was so excited about it that I gave her a Thoroughbred mare for Christmas one year. That was more than thirty years ago."

The mare, a beautiful 1970 bay named Seductive Lady, became a huge part of the Clark family and lived on the Clark ranch until the ripe old age of thirty-two. But after several years of racing, Seductive Lady developed a bone chip in her knee, and the Clarks' veterinarian and trainer gently suggested they not go through the expense of repairing the joint.

"Everyone advised us that she was not that expensive of a horse," said Roy, "that it was going to be an expensive operation and we shouldn't go through all that expense with no guarantee."

But Seductive Lady was more than just a horse to Roy and Barbara Clark. She was a thoughtful gift from one caring partner to another, and she represented their first success on the racetrack. So they took the chance.

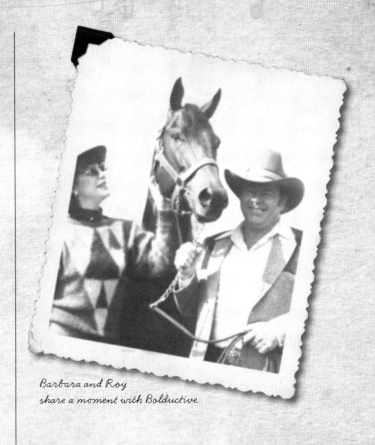

Barbara and Roy
share a moment with Bolductive.

"After the operation, the surgeon came back and said, 'Well, we're glad you made this decision,'" said Roy. "They said the bone chip was about the size of the end of my thumb. It was a big bone chip, but it had done no damage. It had not torn any ligaments or anything. So we put her back on the farm and let her rest for about a year and brought her back to the track and racing and she won more races."

When Roy and Barbara retired Seductive Lady from the track, they let her be a broodmare.

"We sent her to Florida and bred her to Boldnesian, who was a son of Bold Ruler," said Roy. "Well her first foal, Bolductive, turned out to win about $236,000 for us. That was our first race horse that we had bred so we were a little spoiled. And very proud, too, that we had taken this horse that I had given Barbara for Christmas and she turned out to be such a super broodmare."

Through the years, the Clarks also bred Seductive Lady to several top studs in Kentucky. When Bolductive's racing career was over, the Clarks put him out to stud. One thing led to another, and they built a broodmare facility on their ranch. Roy turned around one day and realized he had sixty horses on the place.

"After that we started cutting down on quantity and paid more attention to quality," he laughed.

Roy says that out of all the horses he's been around, Seductive Lady is the one closest to his heart.

"She always ran good for us. She was a very dependable horse. You know, I really miss looking out in the pasture and seeing her there. It's just not quite the same without her. Her life with us was like a fairy-tale story," he said.

HORSES PROVIDE ROY MANY SPECIAL MOMENTS

Even though Roy felt a special closeness to Seductive Lady, he has found joy with many horses.

"Every horse, I have found, has their own personality, their own aura," he said. "When you get to know them, there are no two horses alike. They may be similar but they all have their different traits, and that is a wonder in itself.

"And there is nothing—even as thrilling as the racing part of it is—that can come close to helping a mare have a foal, helping pull it out, cleaning it off, helping it to stand and seeing it start nursing. It does not take long, and then they're out there in the paddock, run-

ning around, jumping up and down, and really enjoying life. And then you're starting them in training, and taking them to the track, seeing your colors on their back and seeing that horse running in a race. And you have been there since the very beginning."

Roy Clark has recently decided to further scale back his horse operation so he can devote more time to his wife, children, and grandchildren. But he said he will always have a big place in his heart for his equine friends.

"Just being around the different horses, you never know what to expect. Horses really take your mind off any other problem that you have. You come in off the road, you've been out on a long tour, you go to the farm and start just walking around the horses, seeing how they are maturing. You just go into a different world and boy, that's a wonderful place."

"I REALLY MISS LOOKING OUT IN THE PASTURE AND SEEING HER THERE. IT'S JUST NOT QUITE THE SAME WITHOUT HER."

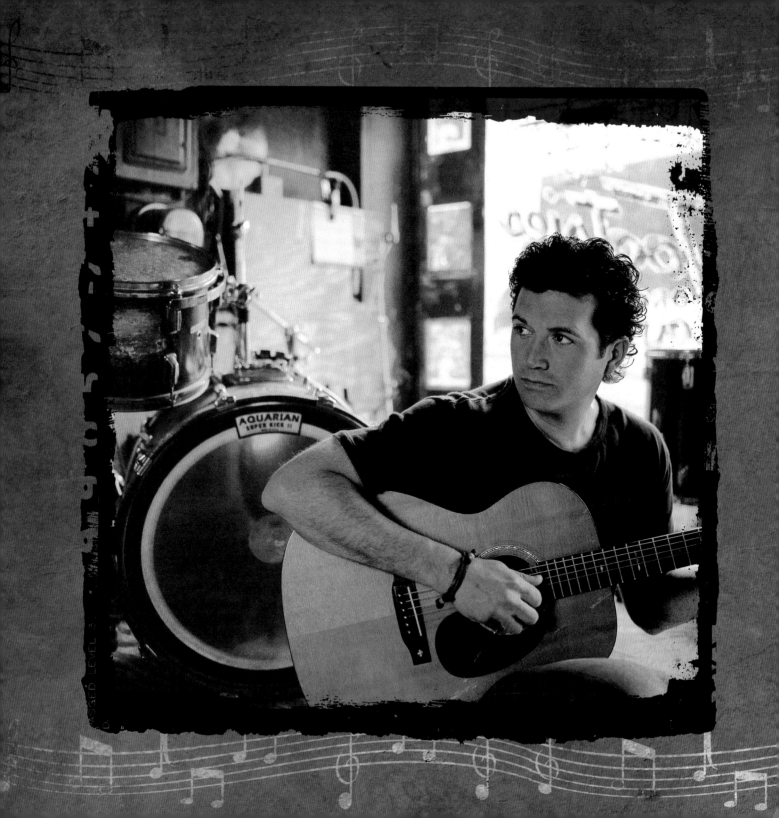

TRACY BYRD

Like most celebrities, Tracy Byrd is busy. Between recording and touring schedules, and in Tracy's case, tapings for his television shows on the Outdoor Channel, it is difficult for him to find ways to kick back and de-stress. At least that was the case before Tracy discovered the sport of cutting. Now, whenever Tracy is home and has

a free hour, he heads to the barn and works a horse or two.

"I love cutting," Tracy said, his eyes and face animated, his body relaxed. "I love the speed of cutting, riding the caliber of horse you have to have to get the job done, connecting with the horse and being right in the middle of it when the horse faces off with a cow. It's this indescribable experience of sound and movement, skill and athletic ability, the connection between you and your horse, and then your horse and the cow."

Born in Beaumont, Texas, and raised in nearby Vidor, Tracy was around horses from a very young age, but not all the horses who came into his life were top-of-the line cutting horses, and that, he said, is a good thing.

LESSONS FROM LITTLE BUG

"When I was about seven or so I got this red roan Appaloosa named Little Bug. He was out of my uncle's mare, Red Bug," said Tracy. "We had this horse from the time he was a foal, but from the beginning he had mind of his own."

Tracy recounted several tales of Little Bug scraping him off on the nearest tree and added, "I remember going off both sides and his rear end . . . several times. But one thing is for sure: I learned to ride on that horse. If it hadn't been for Little Bug I wouldn't have the skills I have today and I definitely wouldn't appreciate the athletic ability and training of the horses I cut on today. I was fortunate to have had Little Bug there to teach me."

Tracy said that Little Bug not only taught him how to ride, but also how the mind of a horse works. "It got to the point that I didn't want to fall off anymore, so I learned to anticipate what the horse was going to do and I figured out how to change the horse's mind about what he was thinking. Little Bug wasn't all bad, though. As he got older he turned into a pretty good horse."

Eventually Little Bug moved on to a new owner. Tracy had uncles who roped and worked cows, so rather than riding a horse of his own he spent increasing amounts of time riding their horses, and the horses of other people in the area. That, too, was good experience.

"When you go from riding one horse to riding a lot of different horses, you really start to discover all the unique personalities that horses have," he said. "And believe me, every horse has their own unique personality. Some are funny, some are focused and serious, some try unbelievably hard, while others like to play. It was a good time for me because I got to see all these differences. Now when I come across a horse with a similar personality, I have a foundation to go from."

FROM HORSES TO A RECORDING CAREER

A stint studying business at Southwest Texas State University was followed by an explosive music career. Tracy has had thirteen top-ten singles, including "Watermelon Crawl," "The Truth About Men," and "Keeper of the Stars," which won the Academy of

Country Music's Song of the Year. He first hit number one with "Holdin' Heaven," and his first five albums went gold, with *No Ordinary Man* being certified double platinum and remaining in the top ten for over thirty weeks. In addition to his recording career, Tracy has become a popular television personality, hosting several shows on the Outdoor Channel.

CUTTING DOES IT FOR TRACY

With all he has going on, it is easy to see how riding a cutting horse provides Tracy with a needed break.

"When I'm on a cutting horse the only thing I am doing is trying to remember every button on that horse and not messing him up," smiled Tracy. "I'm focusing on staying on, on anticipating what that horse is going to do and being ready when he does it. These cutting horses are so smart and so athletic, so unbelievably sensitive and into the cutting itself that it is an experience like no other."

Tracy clearly remembers the first time he sat on a cutting horse.

"Until I got involved in cutting, I had never realized what a really athletic, well-trained horse felt like. I did not realize the beauty of the movement, or that a cutting horse loves to be out there working the cow as much or more than I love sitting on him while he's working," he said. "The first time I cut, I was hooked. That quick. It took about five seconds and I began hollering without even realizing I was doing it. I was having that much fun! I knew right away that this was the

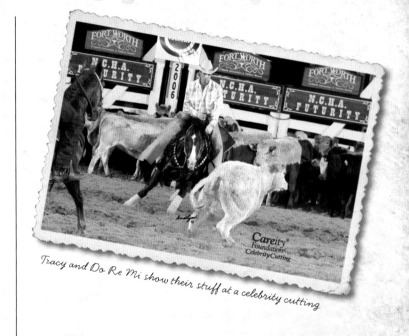

Tracy and Do Re Mi show their stuff at a celebrity cutting.

"The first time I cut, I was hooked. That quick."

kind of horse I wanted to ride and the type of activity I wanted to be involved in."

That defining moment happened about five years ago. Since then, Tracy has spent countless hours learning the moves of a cutting horse and becoming skilled at the sport. He has even won the prestigious celebrity

cutting that is held each December in conjunction with the National Cutting Horse Futurity in Fort Worth, Texas, not once, but twice.

PINOCCHIO

In 2005, Tracy won on a horse that he is especially fond of, the bay 1999 Doc Bar–bred Quarter Horse stallion, Alena's Choice. The horse is by the great cutting sire SR Instant Choice and out of a Freckles Playboy mare called A Lena. Although the horse competes under his registered name, Tracy calls him Pinocchio.

"I call him that because this horse will lie to you," he said, grinning ruefully. "He'd either be really good and win the event, or he'd be so bad he'd about throw

me, and you never knew which. There is no gray area with this horse. It's all black and white with him."

Tracy said on the day of the celebrity cutting competition he loped and loped and loped the horse, because Pinocchio was having a day where he was completely unfocused.

"He was just crazy all day," Tracy said. "These horses know they are going in the pen and they get excited about it. With this horse, he had to be tired before he'd cut good. When he was a little worn out he could get his mind on the cows and forget everything else. When we actually went in to cut, he was a dream. That day is certainly one of the highlights of my life."

CONFIDENCE, BUFFALO, AND GOOD HORSES

Even though Tracy is a skilled rider and competitor, he said he is far more nervous in a cutting competition than he is on stage.

"When I get up on stage, performing is second nature to me. It feels so natural for me to be there singing. And when I'm on stage, there is only me to think about. But when I'm cutting, I've got the horse to consider, too, so I'm not as confident in that situation as I am on stage."

But Tracy has a cure for his lack of confidence. Whenever he is home, you'll find him regularly driving the few miles to a friend's ranch.

"They always need someone to help work horses," he said. "In summer I usually ride several times a week

so I know the horses there and they know me. Because I ride these horses regularly, I get to be part of the process of helping the horse excel, and that's a lot of fun."

Tracy said they often practice cutting buffalo, because buffalo don't get as tired as steers do.

"You can cut on buffalo all day long; they never quit," he said. "With a steer, you have to rotate them every few gos because they get worn out a lot quicker."

Obviously, Tracy is sold on cutting, and on horses in general. In encouraging others to get involved he has one piece of advice: don't skimp on horseflesh.

"The extra money you spend to buy a good horse will be saved in other areas, like training fees," he said. "And, you will get much more enjoyment out of a horse that is well bred and well trained than you will out of a horse that has no athletic ability or education."

TRACY'S "SOMEDAY" HORSE

To date, Little Bug is the only horse Tracy has actually owned, although he definitely sees horse ownership in his future. He wants to wait until things slow down in his career in entertainment, however, before committing to all that owning a horse entails.

"We thought about it a few years ago," he said wistfully. "But right now as much as I am gone, I can't give a horse the time or attention it needs and deserves. To me, that's the whole point of having a horse, being there to establish that relationship and learn that horse's personality. At some point, I can definitely see myself with a few cutting horses. I can't imagine a time

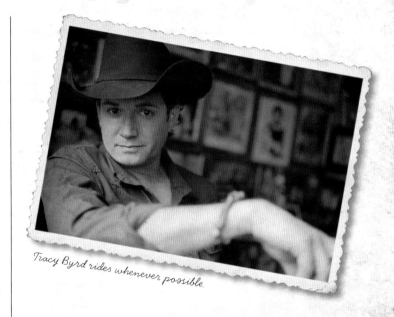

Tracy Byrd rides whenever possible.

when I won't be out on the road, but if there is such as thing as semi-retirement, that's the time I could see myself getting a small breeding program going."

Until then, there are a lot of horses to ride up the road from Tracy's Texas home. And when the time comes to once again become a horse owner, Tracy plans to follow his own advice.

"The horse I buy will have a lot of cow in it," he said. "It will be the best horse I can find at the time and it will have that extra something that stands out and you go, 'I know that's the horse for me.' It won't happen tomorrow, but it will someday. Someday I know I'll be on the back of a horse and it will be mine."

From the look on his face, you know he is really looking forward to that day.

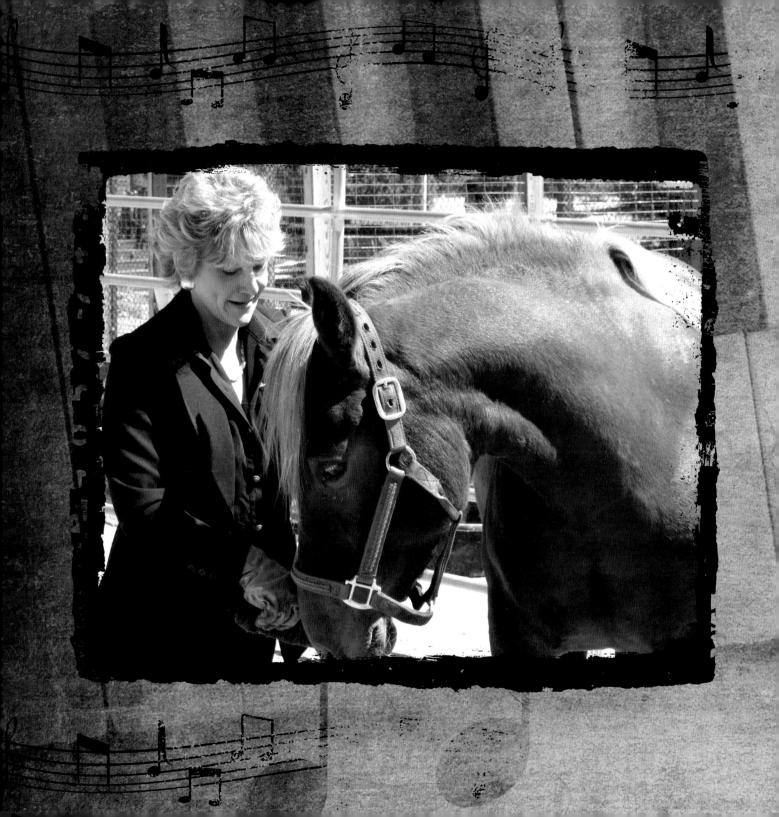

LACY
J. DALTON

IT'S NOT OFTEN THAT A PERSON FEELS SO STRONGLY ABOUT AN ISSUE THAT SHE MOVES ACROSS THE COUNTRY TO BECOME INVOLVED, BUT COUNTRY MUSIC LEGEND LACY J. DALTON DOES . . . AND DID.

"I PERFORMED AT NEVADA CASINOS TEN TO TWELVE WEEKS A YEAR," LACY SAID, "AND I FOUND THAT AFTER A RUN LIKE THAT I NEEDED A PLACE TO UNWIND FROM THE BUZZ OF THE CASINOS."

One night while visiting a friend in the historic mining town of Virginia City, Nevada, Lacy heard an unusual sound in the street.

"What is that?" Lacy asked her friend.

Her friend lifted her finger in the air and said, "Shhh. Listen! There's a horse coming."

Lacy quietly stepped out onto the porch and watched a little band of wild horses walk right up E Street.

"I knew then that if horses could be wild and free and roam the streets right here in Virginia City, maybe I could too," she said. "I knew I would move here someday. That was in 1998 and I've been a resident ever since."

THE VIRGINIA RANGE ESTRAYS

Lacy soon discovered that Virginia City and the surrounding Virginia Range of the Nevada Mountains are home to the largest contiguous herd of free-roaming horses in North America, and the horses trace their roots to the mining industry. In 1849 the area, which is southeast of Reno, offered up great wealth in gold and silver in what became known as the Comstock Lode. The lode quickly boosted Virginia City into prominence.

But as the mines played out, the horses used in mining and other industries were set free—it was too expensive to feed them. The hardiest of the horses survived to establish a very successful free-roaming herd. Today the region is home to between seven hundred and one thousand free-roaming horses. The horses have been designated as "estrays" by the Nevada Department of Agriculture, because they are descendents of horses once owned by explorers, miners, and early entrepreneurs.

For decades the horses roamed relatively safely, but recently the area has become one of the most rapidly urbanizing regions in the country. The growth, unfortunately, does not always mesh with the needs of the horses.

"The horses used to stay in the higher elevations during the summer, and most of the horses only wandered down into more human-populated areas to forage in the winter," said Lacy. "Now homes are being built above the 6,200-foot level, where the horses roam. This pushes the horses further back into the hills and into developed neighborhoods."

Another result of development is that it often brings in new people whose values don't include protecting the range and the horses. In December 1998, three young men tortured and killed thirty-four of the Virginia Range horses. Conflicts with automobiles have also been an ongoing problem.

"I know of several horses that have been struck and killed by cars in residential neighborhoods," said Lacy. "It simply does not occur to many people new to the area that there could be wild horses on the road around the next bend. Horses and highways are not compatible, and horses displaced from their historic grazing and migration corridors become a great danger to motorists—and to themselves."

DEATH FORCES LACY TO TAKE ACTION

Lacy mentioned the plight of one wild horse that she had grown very fond of.

"There was a gorgeous bay stallion with two white hind stockings that produced beautiful foals," she said. "He would come by the house every day. You'd think that he was showing off his babies, and you could tell how proud he was of his band. Then one day I was driving into town and I saw him dead on the side of the road. I was just sick and I realized that I could no longer stand by and let these kinds of things continue."

In 1999 Dalton and her co-founder, Carolyn Cardinale, organized a group of friends and formed the Let 'Em Run Foundation, a nonprofit corporation.

"Let 'Em Run's mission is to develop partnerships between government, businesses, and the community to protect the remaining wild horses, wildlife, and our Western heritage," Lacy said.

A CAREER AS WILD AS HER HORSES

While Lacy now dedicates her life and much of her career to helping wild horses, she had a diverse career prior to championing wild horse issues. If you combined the blues of Bonnie Raitt, the rock of Janis Joplin, and the folk of Joan Baez into one performer, and then threw in a little country, you'd have Lacy J. Dalton. She was born in Bloomsburg, Pennsylvania, into a family of music lovers. Lacy's father played many stringed instruments, sang, and wrote music. Her mother sang harmony and played guitar, and her sister played guitar and keyboards.

> **"IT SIMPLY DOES NOT OCCUR TO MANY PEOPLE NEW TO THE AREA THAT THERE COULD BE WILD HORSES ON THE ROAD AROUND THE NEXT BEND."**

While attending Brigham Young University, Lacy caught the folk-singing bug and moved to Santa Cruz, California, to pursue her music. Not to be trapped by any one musical genre, Lacy's first band was a rock group called Office. Later, Lacy was offered many record deals singing the country music she grew up with.

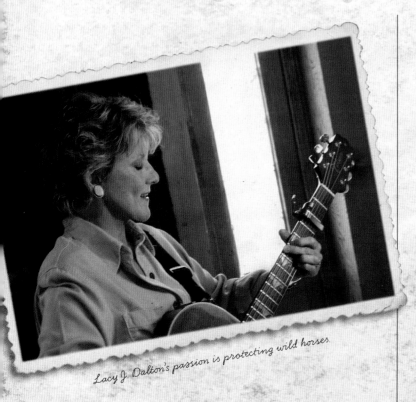

Lacy J. Dalton's passion is protecting wild horses.

Lacy co-wrote her top-twenty debut country single, "Crazy Blue Eyes," which was released in 1979, and on the strength of that song, she won the Country Music Association's Best New Female Artist award that year.

Lacy enjoyed a long run of hits over the following years including "Takin' it Easy," "Black Coffee," a version of Roy Orbison's "Sweet Dream Baby," and "16th Avenue," which was voted one of *Billboard* magazine's Top 100 Country Songs of All Time. Her latest CD, *The Last Wild Place Anthology*, includes five of her songs that have been played on radio more than one million times.

LACY'S MUSIC BENEFITS HORSES

Now when she writes or performs, Lacy often has her wild horses in mind. Proceeds from *Wild Horse Crossing*, a CD that she made with friends, help support the Let 'Em Run Foundation's projects and activities. The foundation currently is working with other organizations to preserve large tracts of open space for horses and wildlife, and to develop management plans that will reduce conflicts between the horses and exploding human populations.

"We hope to create the Comstock Wild Horse Reserve, where horse habitat can be preserved and the public can interact with the animals in a noninvasive way," said Lacy. "We built our civilization on the backs of these incredible creatures. We believe they've earned a place in our community where our children and their children can experience real wild horses in the real West the way they really are."

The foundation (along with the Nevada Departments of Agriculture and Corrections, and other organizations) has already established a successful wild horse adoption and training program in which inmates from the Warm Springs Correctional Facility in Carson City, Nevada, gentle and train wild horses. The horses are then offered to the public for adoption.

"The horse training program not only helps prepare these horses for transition into domestic life," said Lacy proudly, "but the program is reported to be the most successful inmate rehabilitation program in the state."

And there are a lot of horses to train and adopt. Today, large numbers of horses are being removed from the open range, and many factors, including suburban sprawl, contribute to this. Lacy said the steadily shrinking open range affects other interests as well.

"Cattle ranchers are faced with declining open acreage available to graze their stock," she said. "And wild horses that are pushed from their ranges often compete with cattle on grazing land. The result is that more horses are removed from the range."

Lacy added that more wild horses are removed from the range than the prison training program can prepare for adopters, and there are more horses available than the adoption market can absorb. That's why the Let 'Em Run cooperates with several other horse organizations, so each horse is provided the best possible chance.

The typical Virginia Range horse is sturdy, and well adapted for living in the rugged local terrain. They range from tough, pony-sized animals to near draft horse size, and they come in virtually all colors. All have amazingly tough feet, can withstand temperature extremes and survive with little water, and make their home in physically challenging terrain.

It is not necessarily a good thing that the increasing intrusion of humans has caused some of the bands of horses to become quite docile.

"You wouldn't believe how tame some of these horses can get," Lacy said. "A number of them will walk right up to people. We don't encourage people to feed or approach the wild horses, as they can be unpredictable and dangerous, particularly during the breeding season or when small foals are present. Also it is not in a wild horse's best interest for humans to weaken a horse's instinctive behavior patterns."

"THE PROGRAM IS REPORTED TO BE THE MOST SUCCESSFUL INMATE REHABILITATION PROGRAM IN THE STATE."

MACKAY

While Lacy tries not to become too attached to any one horse, one who became special to her is an unusually colored white stallion with a dark gray mane, tail, and legs. The horse came to the attention of the foundation after he began jumping fences and breeding residents' purebred mares.

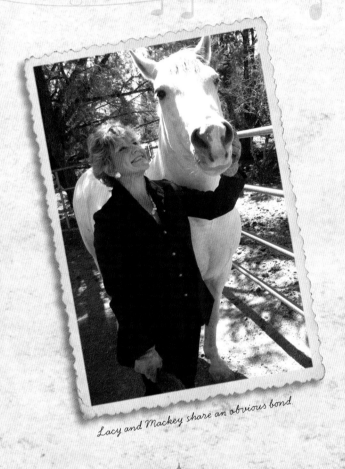

Lacy and Mackey share an obvious bond.

"WHEN HE LEFT, HE PUT HIS HEAD IN MY HANDS. I CAN HONESTLY SAY IT WAS ONE OF THE MOST EMOTIONAL MOMENTS OF MY LIFE."

"Everyone hated this horse, even though he was only doing what was natural to him. It is instinctive for a stallion to want to find mares, and he found a veritable mother lode of mares in the local corrals and paddocks. The outraged mare owners would throw things at him and were actually shooting at him when the foundation finally rescued him," said Lacy.

The foundation named the horse Mackay (pronounced "Mack-ee") after John Mackay, the man who discovered the area's silver strike. They soon discovered that humans had become such a threat to Mackay that it was over a year before he didn't overreact when someone was near his corral.

"This horse was so scared that if I stood at one end of his corral and simply raised my arm, he'd immediately bolt and crash against the opposite side of the corral," Lacy said.

She decided that no creature should remain that frightened, and was determined to help. For months she would enter Mackay's corral and sit quietly with hay spread out nearby. It took about four months before Mackay would eat while she was inside the corral.

"It took seven or eight months before he'd let me touch him," she added.

Mackay eventually did become tame, and could be handled by 4-H students. He even appeared at the Western States Wild Horse and Burro Expo in Reno. However, Mackay was a free spirit who was happiest when he had room to roam, so Let 'Em Run released Mackay and one of his mares on five thousand acres at

the Wild Horse Sanctuary in Shingletown, California.

"When he left, he put his head in my hands," said Lacy. "I can honestly say it was one of the most emotional moments of my life. For this horse to trust me that much was incredible. It was a very tough decision to make, to turn him out so far away from us, but it was the right decision for this horse. He was bred to run free. It's what he does best."

EDUCATION IS THE KEY

Lacy noted that some of Mackay's training involved Least Resistance Training Concepts (LRTC), a non-profit group that organizes educational programs and locates mentors to assist wild horse adopters. These services are free to anyone who adopts a wild horse.

To help educate the public, the Let 'Em Run Foundation produced a documentary about the wild horses of the Virginia Range called *In the Company of Horses*, which aired on the A&E channel. The foundation also completed a documentary for PBS called *Sanctuary*. And a second fundraising CD was produced, *The Girls from Santa Cruz*, which features cuts from the live PBS performance of the same name.

Let 'Em Run is working to secure grazing rights and lease or purchase land for a permanent wild horse and wildlife preserve. The Comstock Wild Horse Sanctuary, as proposed, will include a visitors center, gift shop, wild horse training and adoption facility, digital theater, and, of course, overlooks where bands of wild horses can be observed.

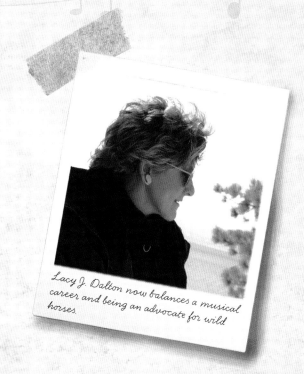

Lacy J. Dalton now balances a musical career and being an advocate for wild horses.

"This project could serve as a pilot for other preserves and sanctuaries," Lacy explained. "Just as Virginia's Chincoteague pony preserve on Assateague Island inspired our project, we hope our program will inspire others."

Of course Lacy J. Dalton will be right in the middle of it all, advocating for her wild horses and for wild horses all across the country.

"There are only about forty thousand wild horses left," Lacy adamantly pointed out. "The survival of our wild horses is clearly endangered, and most people don't know it. I want to change that. I'm involved because I really believe I can help."

JASON MEADOWS

In what was arguably the hottest competition on USA network's country reality series *Nashville Star*, Oklahoma cowboy Jason Meadows went head to head in the season three finals with Tennessee teenager Erika Jo. Erika won the competition by a narrow margin, but as with the *American*

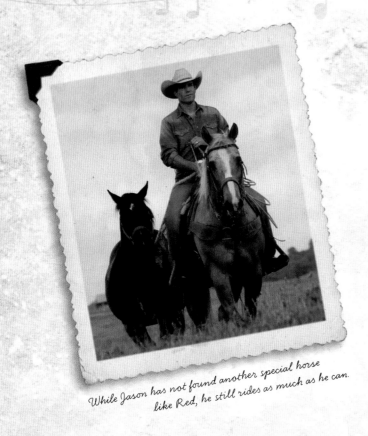
While Jason has not found another special horse like Red, he still rides as much as he can.

"Just like that, my life was torn completely apart and I knew I would never see or ride my friend again."

Idol contestants, no one on *Nashville Star* is a loser. Like many of the finalists, Jason came away from the competition with thousands of die-hard fans—and a record deal. His debut video, "100% Cowboy," entered Country Music Television's (CMT) "12 Pack" at number four. The song was also selected as the theme song for CMT's *America's Top Cowboy*, a reality series hosted by Trent Willmon.

The song is an appropriate one for Jason Meadows. Since he was six years old, music and rodeo have been his two greatest passions. His earliest memory of his interest in rodeo is playing in his mom's living room in Calera, Oklahoma, where he'd pretend the living room footstool was a rodeo calf. He'd turn the footstool upside down and spend hours roping it.

"I've been around horses as far back as I can remember," he said. "Growing up, everyone I knew learned to rope and ride, and we all took part in rodeos pretty much every weekend. I spent a lot of my time in the Vo-Ag building and with the FFA [Future Farmers of America], learning about animals."

DANCING WITH SMOKY JOE AND ROPING WITH BUCK

Jason's first horse was a little black and gray POA-spotted Shetland-type pony named Smoky Joe.

"This pony was so small that my dad would actually dance with him," said Jason, still a bit dumbfounded by the idea. "Dad would put Smoky's front feet up on his shoulders, and they would dance back

and forth together. I've never seen anything like it before or since."

Jason's next horse was a larger buckskin pony he imaginatively called Buck.

"This horse was special to me because he was the first horse I ever roped a steer on," said Jason. "I still remember that throw and catching that steer. Buck could be a handful, but he taught me a lot about roping. Because Buck had done it so much, he knew more than I did about where to position himself, how fast or slow to go, and how to turn a steer."

SALE BARN PONIES TAKE JASON FOR A RIDE

Between riding his own ponies, Jason, his brother, and his dad would head regularly to the sale barn to pick up a few young ponies that had never been ridden.

"Then we'd haul them home and we'd see how long it took us to get one going," he said. "That was our entertainment, going out and riding those little things, getting thrown off and getting up and getting back on again. When we got 'em so they were somewhat broke to ride, we'd take them to the sale barn and come back with a whole new group. I wouldn't necessarily recommend the idea to others, but I had fun, and those ponies taught me to ride. After you hit the ground enough, you start looking for ways to stay on and that leads you to studying how the horse moves, which leads you to studying how the horse thinks."

JASON'S NEW BEST FRIEND

When Jason was about fourteen, his uncle Bob gave his dad a skittery young sorrel horse called Old Red. Despite the horse's tendency to spook, Jason's dad worked and worked Red, hoping he'd turn into a good rope horse. Eventually he did.

"My dad made Red into one of the finest horses in the country, winning lots of money and lots of fans," said Jason. "At one time, my dad was offered eight thousand dollars for Red at a roping and he turned it down, saying he would never sell him."

Little did young Jason know that his dad eventually planned to hand Red down to him; he was just waiting

> "After you hit the ground enough, you start looking for ways to stay on and that leads you to studying how the horse moves, which leads you to studying how the horse thinks."

until Jason was old enough to handle a horse who was highly trained, but still a bit unpredictable. When the time came, it was Old Red himself who caused the handing over of the reins.

"I don't know why, but Red and my dad had one little problem," recalled Jason. "Red didn't like to be caught by my dad. I, on the other hand, could walk right up to him and catch him any time I wanted. I guess you could say we just bonded. It got so I would ride Red every day to exercise him for my dad. Then I'd feed him and clean his pen and make sure he had water and so on. During that time, I got to like the horse a lot."

Jason's hard work paid off. There came a day when Jason's dad gave him the nod, letting him rope off the big, spooky gelding.

"That was the fastest horse I had ever been on in my life, and the strongest," Jason said. "We started out in the practice pen and it didn't take us too long before we went on to the big leagues."

Jason joined the OYRA (Oklahoma Youth Rodeo Association) and began winning points. He racked up more than enough to qualify for the state finals and placed fifteenth out of several hundred. Jason was very pleased. After that, Jason roped in a lot of jackpot team ropings, winning quite a few buckles and even some money.

"There was just something about me and Old Red," he said. "We just clicked. He knew where he stood with me and I knew where I stood with him. Even though he couldn't talk out loud, he would listen and talk back with

his body motions. I knew exactly what he was saying, and he could read me like a book."

Jason said the bond he and Red had may have been strengthened by the fact that Red was handed down from family, first from his uncle to his dad, and then from his dad to him. What he does know is that once he and Red made eye contact, there was an instant rapport.

"I always look a horse in the eye because horses are just like humans," said Jason. "Once you get that eye contact going, a horse knows exactly who and what you are, and you know the same about the horse. I had that eye contact with Red and I loved it because he was so big and strong and beautiful. His eyes told me so much . . . like I knew he was ready to rope when his eyes got real big. You don't get that special closeness with every horse, but when you do, it is unlike any other kind of relationship you will ever have in your life. It's really quite incredible."

A DIFFICULT DECISION

Then one day Jason went out to catch Red for their daily ride, and Red didn't look like his usual self. Cautious, Jason eased Red into their usual workout, but as close as this horse and human were, Jason knew something was off. He just couldn't put his finger on a specific problem. The next morning is one Jason will never forget.

"I went out to feed Red and there he lay, flat out on the ground. He was unable to move; it was like he

"I believe there is a horse out there for everyone, myself included."

was dead," said Jason. " I called for my dad to come right away. Red could move his head to look up at us but that was it. He struggled to get to his feet several times. I knew Red wanted to get up; he wanted everything to be okay. But for some reason he couldn't control the back part of his body."

Jason and his dad called a neighbor to help them put Old Red in the trailer and they rushed him to their local vet.

"I remember that the vet put him in a hoist and lifted him to his feet," said Jason. "I could see the fear in Red's eyes, not knowing if he would be all right or not. I tried to reassure him with my voice and my body language, but I'm not sure I helped him. I was just a kid then, maybe fifteen, sixteen years old, but I did everything I knew to do to reassure him, because he was my friend."

For some reason, Red's stifle muscles had tightened to the point that Red could not move. Stifles are

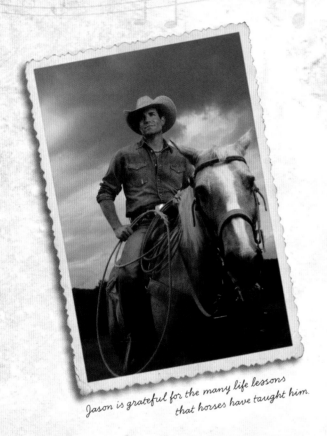

Jason is grateful for the many life lessons that horses have taught him.

joints in a horse's hind legs, and play a large part in the movement of a horse's hindquarters. The vet did more to reassure both Jason and Red than Jason could do by himself when she said that a simple surgery would fix Red right up.

"I was there when the vet cut right through Red's stifles, and it sounded as if she had cut a stretched rubber band. You could see the relief Red's face, and probably mine, too," said Jason. "He knew the vet was helping him, and that my dad and I had helped him by taking him to the vet. I could see all that very clearly on his face in that one moment."

The vet said it would take a while for Red to heal, but heal he would.

"Put him in the pasture and when he comes running and bucking up to you he will be ready to ride," she said.

Jason waited patiently and thought that day would never come, but a month or so later there he came, running and bucking up to the gate as if he was a wild mustang turned loose out on the prairie. Jason couldn't get the saddle on him fast enough.

"We went back to roping and riding just as before, and we thought he was as the vet had promised us—as good as new," said Jason.

But Jason's world came crashing down several weeks later when he went out to the pasture in the morning and Red once again lay there, unable to move. This time the vet sent Red to a specialist. The unfortunate news was that Red, who was only eight or nine years old, was diagnosed with a rare form of equine spinal cancer and would never walk again.

"We only had one option that day and that was to end Red's pain and suffering," said Jason, his voice heavy with emotion years later. "I couldn't stand the thought of what would happen next. Just like that, my life was torn completely apart and I knew I would never see or ride my friend again. I knew my life would

never be the same, because I loved that horse so much. We were that close. That day was one of the saddest days of my life. Still is."

Red was quietly put to sleep and Jason and his dad buried the big red horse behind their house, under a large pecan tree.

"I make a point to visit Red's gravesite when I go back to the home place," said Jason. "It's always an emotional visit, but I enjoy remembering my friend and the good times we shared. I don't ever want to forget him, or the experiences we shared."

JASON LOOKS FOR ONE SPECIAL HORSE

Since Red died, Jason has not found a horse that has meant nearly as much. One reason might be that Jason got his first paying music gig not too long after that, and his music career began taking off. Somewhere along the way Jason so impressed actress and country superstar Reba McEntire that she made it her business to help set him up in Nashville. Then *Nashville Star* happened, and along with it, a record deal. Someday, though, Jason hopes to experience again that special oneness with a horse.

"There are so many things you can do with a horse," he said. "Roping, pleasure riding . . . there are different breeds for different styles and events. I believe there is a horse out there for everyone, myself included. If someone is looking for a horse, just look for a well-broke horse with a kind eye. Chances are that horse has been looking for you just as hard as you have been looking for him.

"I was very lucky to have Red. There will never be another like him. But someday . . . maybe . . . at the right time, there will be another special horse for me. It won't be Red, but when the right horse and I hook up, I just know I'll be able to grab a little bit of that magic that comes when you bond so completely with a horse you can almost read each other's thoughts. That's a day I am really looking forward to."

"I always look a horse in the eye because horses are just like humans."

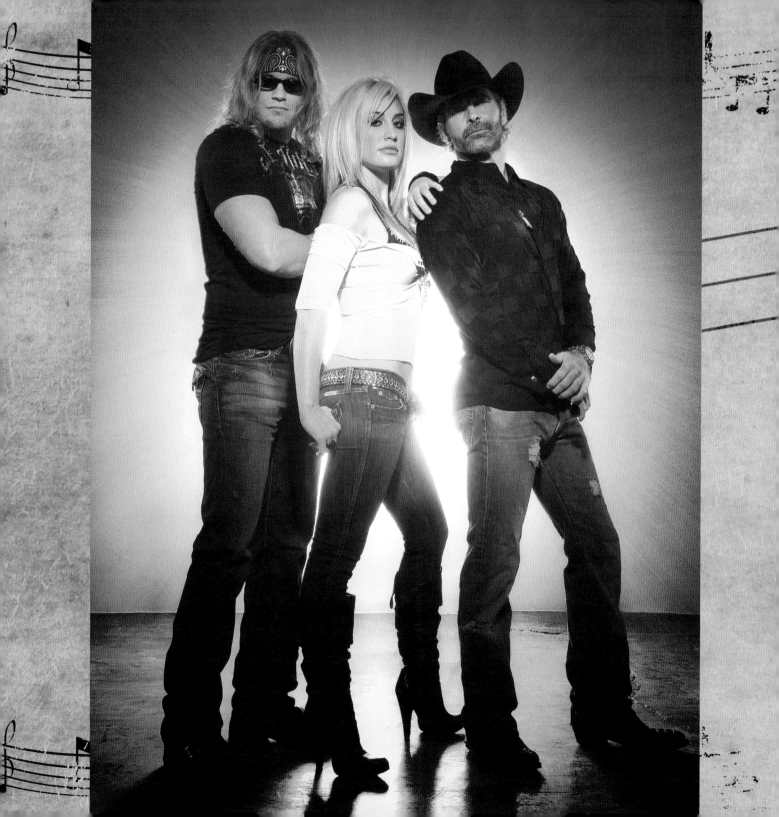

CHAPTER TWENTY-ONE **IRA DEAN**

(TRICK PONY)

FOR TWELVE YEARS, IRA DEAN WAS THE TALL, ECLECTIC BLONDE BASS PLAYER FOR THE ENERGETIC, PLATINUM-SELLING TRIO TRICK PONY. WITH HITS SUCH AS THE SELF-PENNED "POUR ME," AND THE GRAMMY-NOMINATED "JUST WHAT I DO," TRICK PONY ESTABLISHED THEMSELVES AS A FORCE IN THE COUNTRY MUSIC SCENE IN 2000. THE BAND, WHICH ALSO FEATURED GUITARIST KEITH BURNS

and vocalist Aubrey Collins, won both the American Music Awards' Top New Artist and the Country Music Association's Artist of the Year. Their CD, *On a Mission*, brought five Academy of Country Music nominations including Album of the Year and Vocal Group of the Year.

When Trick Pony first got together, Keith was touring with country superstar Joe Diffie, and Ira was working with the legendary Tanya Tucker. They added a female vocalist and began playing the Southern club circuit. Trick Pony quickly built a following, and by 1999 they were performing over three hundred shows a year.

"Some days we were doing four or five shows a day. It was a lot of fun, but so exhausting," remembered Ira. He added that many of the shows did not pay much. "Sometimes we would be out on the road and be so broke we'd run out of gas. I'd have to

scrounge up some change and put my Rollerblades on to go get some fuel."

A MINIATURE MULE NAMED ERNIE

Since then, life has changed drastically for Ira. In recent years, the Ponies only played one show a day and the bus hadn't run out of gas in some time. But the increase in fans, fame, and fortune also brought about a need for real life. People can find down-home simplicity in many ways, but for Ira, it comes in the shape (and sound) of a miniature mule named Ernie.

"To me, Ernie is almost human," said Ira. "Often I grab a handful of carrots and go out to the barn and hang with Ernie. Mel Tillis once told me that he feels that every hour you spend fishing adds an hour to your life, and I feel that way about the time I spend with Ernie. He's my boy."

Ira first met Ernie when he went trail riding through the mountains with a friend between gigs. Ernie was the pack mule, and the all-important bearer of the beer.

"At first I loved Ernie for what he was carrying, and then I got to know his personality and fell in love with him," Ira said. "He's like a great big live teddy bear."

When Ira's thirty-fifth birthday rolled around, his friend walked in the room with Ira's present: it was Ernie, all dressed up in a huge bow. The gift could not have been a better choice, because Ira has always loved horses.

AS A CHILD, IRA JUST WANTED TO RIDE

Ira remembers when he was three or four years old, helping a favorite uncle pet and feed his horses and mules. This was near Raleigh, North Carolina, where Ira was born.

"I was so little I remember sitting on the horses, but it wasn't safe for me to ride because these horses and mules were working animals. They were for pulling plows, and helping to farm," said Ira. "But that experience was a big deal to me back then. Even though I was a little kid, horses were special to me."

Horses were so special, in fact, that whenever he wanted to ride one of his uncle's work mules, for safety reasons Ira was instead put on the back of a large black Labrador. Young Ira knew the difference between a horse and a dog, but he enjoyed the riding part all the same.

A few years later Ira's dad relocated to Minnesota for business reasons. Their home in the state's capital, St. Paul, didn't have room for the farms and fields Ira and his family were used to seeing, but they did manage to grow some corn in their backyard. The family also was able to spend a few weekends every year trail riding in Wisconsin. Ira loved every minute of it.

IRA FINDS A CIRCLE OF MUSIC AND HORSES

But even though Ira loved horses and spending time out on the trails, he also was becoming an accomplished

"ERNIE ALLOWS ME TO RELAX AND APPRECIATE ALL THAT I HAVE. AFTER A CERTAIN AMOUNT OF SUCCESS, I THINK PEOPLE TAKE A LOT OF THINGS FOR GRANTED. ERNIE IS THERE FOR ME TO REMEMBER TO APPRECIATE HOW GOOD LIFE IS."

musician. By the time Ira was twelve, he was regularly playing in bars, and he moved to Nashville when he was just twenty. There, he honed his singer/songwriter skills and what followed is country music history.

Once a country star reaches a certain level in his or her career, many promotional opportunities come knocking. One that came Ira's way in 2003 was the opportunity to compete in the celebrity cutting at the National Cutting Horse Futurity in Fort Worth. Ira is very proud that he won the event, and even prouder of besting one worthy opponent in particular: fellow country music star Clay Walker. But unlike many other artists, Ira is not necessarily hooked on cutting.

"I did the competition the once, but I don't know that I'd do it again," he said thoughtfully, "unless Clay were to challenge me to a one-on-one. That I might go for!"

IRA AND ERNIE LIVE THE GOOD LIFE

While Ira admits he "got bit by the bug" when it comes to horses and riding, he most enjoys the mental and emotional relationship that people have with their equine friends. Like his little sorrel mule, Ernie.

"Ernie is my right-hand man; he's the bomb," said Ira. "He's like a big dog. I can go out to his pen and lay down with him and he'll put his head in my lap. He loves to be petted. People talk about dogs as man's best friend, but Ernie, he's the best for me. I completely lose track of time when I am with him. Hours can go by with the two of us just sitting there. And that time I spend with him makes me fall in love with life all over again. I forget everything, my problems, my career, personal relationships, it all goes right out of my head. Time stands still for Ernie and me and when it starts again, all is right in the world."

One prerequisite of friendship is having common interests, and both Ernie and Ira like to chill. When he is home, Ira frequently grabs a beer for himself and a frozen apple for Ernie and heads to the barn. There, they munch and drink and ponder life together.

"It's a way for me to get real, to forget all the stuff that comes with being a celebrity, and be a regular person for a while," he said. "Hanging with Ernie is stress relieving. I can take my watch off and turn the cell phone off. Ernie allows me to relax and appreciate all that I have. After a certain amount

It's easy to see that Ira and Ernie are best friends.

of success, I think people take a lot of things for granted. Ernie is there for me to remember to appreciate how good life is."

And while life is good for Ira, it's pretty good for Ernie, too. When Ira learned he was Ernie's new owner, he realized he had to have a place to keep him, so he bought seventy acres and fenced in a small portion for Ernie to call home. Then, of course, there had to be a barn, and then a bigger barn, and other horses for Ernie to befriend. Ira knows that horses are herd animals and thrive best in small groups. Plus, there are several other animals for Ernie to watch.

"I'm like this adoption agency for pets," said Ira. "Besides Ernie, I've got four dogs, a llama, and a goat."

Before the other animals arrived, Ira and his dad thought Ernie might be lonely, so they put a big mirror in Ernie's stall so he wouldn't be alone. It is obvious that in addition to having taken Ira's heart, Ernie also stole the heart of Ira's dad.

"Ernie is the closest thing I have to a kid. And I think he's even better because I get all the positive aspects of the relationship, like love and affection, and none of the negative, like crying and diapers," said Ira.

Human child or miniature equine, Ernie apparently doesn't realize that he is a little guy.

"Ernie definitely thinks he is way bigger than he really is. He sometimes can be a handful because he has a mind of his own. I've seen him get down on his knees to go under a fence. Ernie doesn't have any self esteem problems, that's for sure," Ira said.

Ira's other horses include former show jumpers owned by his friend, television host Melissa Rivers, and a stray Quarter Horse or two.

"I love to ride; have since I was a kid, but there's something about chilling with a horse, about the mental connection you get going between the two of you that recharges me like nothing else can," said Ira. "I just can't think of anything better."

Unless, of course, it is chilling with a miniature former pack mule named Ernie.

"PEOPLE TALK ABOUT DOGS AS MAN'S BEST FRIEND, BUT ERNIE, HE'S THE BEST FOR ME."

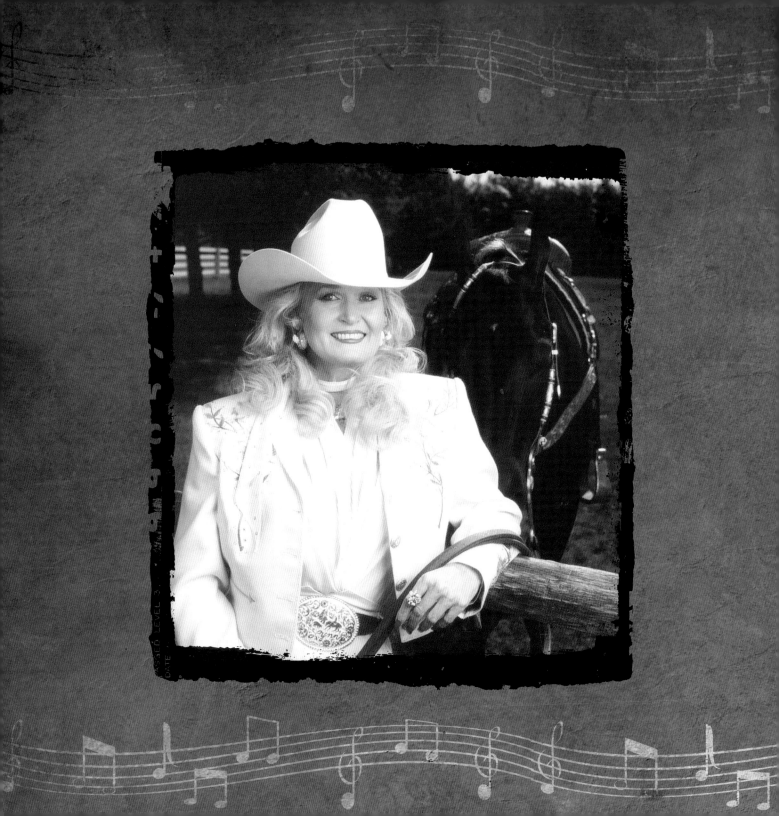

CHAPTER TWENTY-TWO **LYNN ANDERSON**

From her earliest years, Lynn Anderson has split her time between music and horses. One of the top-ranked female vocalists in any genre, Lynn is considered one of the finest entertainers in the world. She has performed for five United States presidents; the Queen of England; HRH Charles, The

Prince of Wales; princes Rainier and Albert of Monaco; and King Hussein; and has been featured on *The Tonight Show, The Carol Burnett Show, Solid Gold, Good Morning America,* and three Bob Hope specials. She has acted in episodes of *Starsky and Hutch* and *Country Gold,* and in an NBC Movie of the Week. Lynn has also starred in her own CBS television special.

Born in Grand Forks, North Dakota, and raised in California, Lynn's love of country music can be attributed to her mother, songwriting great Liz Anderson. Liz composed such smash hits as Merle Haggard's "The Fugitive."

By the time Lynn was twenty she had been with a national recording company for three years, and had scored a string of hits. When Lynn signed a contract with Lawrence Welk, she became the only country performer featured on national television at the time.

A few years later, Lynn entered the studio to record "(I Never Promised You a) Rose Garden," and

something extraordinary emerged. "Rose Garden" climbed to the top of the country charts, cracked the top-five on the pop charts and transformed the young singer into an international celebrity.

The song was followed by even more hits, including "Under the Boardwalk" and "Top of the World," which won the Country Music Association's Song of the Year. To date, Lynn has had eight number-one singles, earned sixteen gold albums, and won virtually every award available to a female artist. But she's not one to rest on her laurels; a recent CD, *Cowgirl,* earned four nominations from the 2007 Academy of Western Artists awards, and five nominations from the 2007 Western Music Association awards.

DUAL CAREERS FOR A SINGING COWGIRL

While many know of Lynn Anderson's recording career, they don't know about her dual career in the field of horses. There, Lynn has sixteen national championships, eight world championships, and several celebrity championships under her belt. Her wins include the National Chevy Truck Cutting Horse Champion, American U.S. Open Invitational Champion, and the National Cutting Horse Association Champion. Lynn has many equestrian honors from childhood on, but she is proudest of her accomplishments as a breeder of fine Quarter Horses and Paints.

From her earliest days Lynn has been passionate about attaining two lifelong goals: being inducted into

the Country Music Hall of Fame and the Cowgirl Hall of Fame. To date, she has been nominated for both.

"I started singing not too long after I started riding," said Lynn. "Music and horses are both lifelong passions and I am equally as serious about my horses as I am about my singing. I've been fortunate throughout my life in that I've been able to blend them."

APACHE, THE MUSTANG TEACHER

Lynn was just eight years old when her parents gave in to her ceaseless requests that they move to a ranch where she could have a horse.

"We moved to Sacramento," she recalled, "and got about four acres with twenty acres surrounding it that we could use, so this was my big horse ranch."

And, to complete the move, Lynn's parents bought her a horse.

"His name was Apache, and he and the saddle and bridle and breast collar and blanket cost a total of eighty-five dollars. Apache was the ugliest paint mustang you ever saw," laughed Lynn. "But that horse taught me a lot of good stuff about horsemanship, namely how to fall off and get back on."

Lynn said it took several weeks of concentrated effort before she could coax Apache out of a walk, kicking all the way.

"And once I got him trotting, he would trot faster, and faster, and faster," she smiled. "It was like Calamity Jane, you know, you get bouncing on your butt until you just bounce too high to come back down and land

in the saddle, so I'd land on the ground and have to catch him and drag myself back up."

> **"Music and horses are both lifelong passions and I am equally as serious about my horses as I am about my singing."**

But Lynn finally learned to ride well enough to urge Apache into a gallop.

"Of course, then he ran straight back to the barn. But those were lessons that you had to learn," she said. "I had to walk a couple of weeks before I could trot. He didn't crawl, or we'd have done that first! Apache was a mess and ugly as sin but I never will forget him."

EXCELLENT TRAINING EQUALS A LIFETIME LOVE OF HORSES

Soon after Lynn learned to ride Apache, her grandparents, who bred Tennessee Walking Horses, sent her a palomino Walking Horse stallion named Dakota Chief. By the time she was nine, Lynn had won a reserve championship in horsemanship at the esteemed Cow Palace in San Francisco.

Lynn went on to win championships with Tennessee Walking Horses, Paints, Quarter Horses, palominos, and American Saddlebreds; and has ridden Paso Finos, Peruvian Pasos, and Olympic-caliber jumpers.

"My trainers when I was a child are all in the Hall of Fame now," she said. "Don Dodge, Matlock Rose . . . those were people I worked with when I was a kid, when I was training to ride when I was nine, ten, eleven years old. They are all people that I still know, except now they are legends in the horse industry."

"Horses when they look at you are looking right at you, right into your soul."

THE STARLIGHT LINE

Out of all the horses Lynn has been involved with throughout her life, she said there are several major standouts.

"There's a bay Quarter Horse mare I had named Doc's Starlight who is in the Hall of Fame in the National Cutting Horse Association," said Lynn.

Doc's Starlight is an own daughter of Doc Bar and out of a Poco Tivio mare. She won more than $134,000 in cutting competitions, and her offspring have earned over $193,000.

"This mare's first baby was named Grays Starlight after my son, Gray, and her first daughter was named Bunnys Starlight after my daughter, Bunny," said Lynn. "Grays Starlight went on to be one of the top cutting horse stallions in the world, and his progeny have won more than nine million dollars. The Doc's Starlight line is now a very famous line in the cutting horse world and I'm very proud of that because these horses are kind of like my children."

LYNN RECEIVES A SPECIAL GIFT

Another favorite of Lynn's is a tobiano Paint mare called Delta.

"Delta was the first world champion cutting horse that was a Paint. She was world champion four times in the Paint world, but she was the first Paint to be in the Hall of Fame alongside the Quarter Horses in the National Cutting Horse Association," Lynn said.

Delta is also special because she was given to Lynn as a gift.

"At the time, I kept my horses at Pear Tree Quarter Horse Farm in Fairview, Tennessee. And the owner of the farm, Mr. Price, was one of the founders of the National Cutting Horse Association," she said. "Mr. Price let me play with this beautiful Paint mare, Delta, and when I got married, he gave her to me as a wedding gift."

Lynn developed Delta as the foundation mare of a strong line of Paint progeny that includes her son, Delta Flyer; her daughter, Delta Dawn; and Delta Flyer's offspring, Delta Doc O' Lena—all national or world champions in their own right.

"Delta was very special just because of what she was—her parents were both registered Quarter Horses and she came out with spots," said Lynn. "She was absolutely gorgeous. She would look at you and you could tell that she had been hurt very badly at some point in her life. Her tongue was all scar tissue except for about an inch, and the reason she would work her heart out for me is because I never pulled on her mouth. I never jerked her; I just let her go because she knew everything so much better than I did. She was doing it all on her own, so all I had to do was be a passenger and not get in her way."

Lynn and Delta won several cutting events at the Dixie National competition when they were both seven months pregnant. "It was one of those things where I was at home and all my other horses were out on the road. Everybody I knew was out showing and everybody was having fun except the two old pregnant girls sitting at home," said Lynn. "So I drug Delta out, and we went to Jackson, Mississippi, and we won the non-pro class and then we won the open cutting, and we were both big and fat and pregnant. That was Delta Flyer that she was carrying and I was carrying Gray Stream so we had a lot of progeny going there.

"These mares, Doc's Starlight and Delta, were

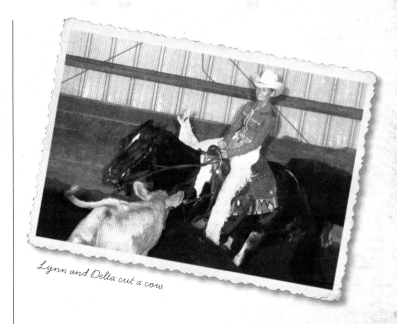

Lynn and Delta cut a cow.

both cutting horses," said Lynn. "Both of them had a different style, but they had the same huge eye, and huge heart, and a special quietness—like a quiet intelligence—and you know that these horses when they look at you are looking right at you, right into your soul. When you see pictures of people swimming with dolphins, people don't often think that horses are intelligent like that, but they are. They can look into your eyes and they see your heart. They know through your hands how you're going to treat them."

CHIEF AND CHILDREN

Even though several of the horses closest to Lynn's heart are national and world champion mares that founded her current breeding program, it is probably

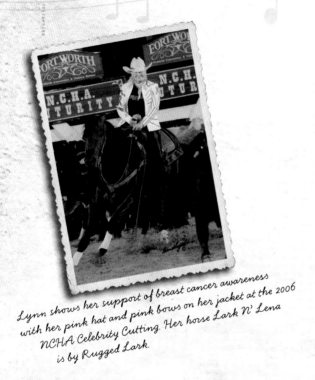

Lynn shows her support of breast cancer awareness with her pink hat and pink bows on her jacket at the 2006 NCHA Celebrity Cutting. Her horse Lark N' Lena is by Rugged Lark.

a little Quarter Horse gelding named Skipster's Chief of whom Lynn is most proud.

"I first saw Chief at the Indiana State Fair and there was a six-year-old little girl riding him. He was a chestnut horse with four white socks and a big blaze and a flaxen mane and tail. This fair was an absolutely huge place, hundreds of people, and here was this little tiny, tiny girl toodling around in and out of all these horses, racing around the ring, warming up," said Lynn in amazement. "This horse was a babysitter. He was holding her hand and taking care of her. Chief knew that he had this little precious treasure on his back and he went beautifully for her."

Lynn had been looking for a horse for her children to ride and felt that Chief was perfect for the job. He even had the same name as one of her first horses, the Tennessee Walking Horse her grandparents had given her.

"So that's the horse my children learned to ride on and since then he's probably taught a couple of hundred kids to ride," said Lynn. "He was a doll."

Lynn later donated Chief to Animaland, a therapeutic riding program for children with disabilities. At the time, it was one of the first programs of its kind in the country. Chief later became the poster horse for NARHA, the North American Riding for the Handicapped Association.

"He was so good," said Lynn. "Kids would shimmy up his legs. They could run underneath him and hang on his tail, which might have been good or might have been bad, but they trusted him so much. They'd probably use those practices around another horse and get kicked, but Chief was so gentle and so wonderful that you could not help but love him. Chief spent a good ten or twelve years being scratched and rubbed by kids all day every day, and you can't ask for a better life than that. He impacted the lives of so many kids in a really positive way. I am so proud to have had a part in that."

Chief was buried at Animaland, but before he died he was immortalized by the Breyer Company as a plastic model horse. Another of Lynn's horses, Lady Phase, a Leo- and Sugar Bars–bred mare, was chosen by Breyer as their model for "the perfect Quarter Horse."

THE LEGACY LIVES ON

The legacy of Lynn Anderson's breeding program continues. In 2006, Lynn's cutting horse, Lark N' Lena, made the American Quarter Horse Association Top Ten and qualified for the world championships in Junior Cutting. The horse is by Rugged Lark and out of Lynn's AQHA Honor Roll and world champion mare Sugar's Featherlite, who is an own daughter of the great cutting sire, Doc O' Lena. Lynn is especially proud that Lark N' Lena is the only Rugged Lark offspring ever to qualify for the world championships in cutting.

Lynn also won the 2006 Round Up for Autism charity cutting event and is on the Round Up for Autism board. Additionally, she supports National Cutting Horse Association charities that benefit cancer research.

Of all her equine pursuits, it is obvious that Lynn loves the breeding part of things the most.

"Mares are the most important part of the breeding program because stallions can breed a couple of hundred mares, but the very best of his crop is what you get from one special mare. I think a lot of people in the horse business will agree with me that eighty to ninety percent of what you get in a baby is from the mare," said Lynn. "Obviously you have to choose the right stallion to breed to, which is why I am so proud of being able to research the bloodlines and figure out what's going to cross and what's going to work.

"Take Delta," she illustrated. "We went to the Quarter Horse Peppy San Badger with her—he's

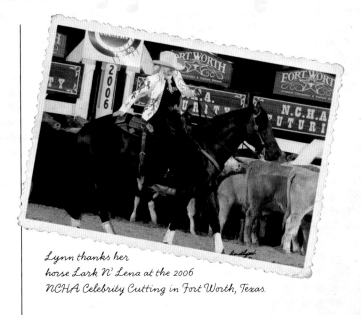

Lynn thanks her horse Lark N' Lena at the 2006 NCHA Celebrity Cutting in Fort Worth, Texas.

known as Little Peppy—but we used him because he's double-bred Leo breeding and Leo has a recessive white gene. I had a good feeling that crossed together they would make a nice Paint baby, and they did. Several times. I've studied bloodlines for a long time and that's the kind of research you have to do if you're going to get as far into the horse business as breeding.

"I had four really, really, good mares and they are the product of a lifetime of riding and loving horses," concluded Lynn. "I've always loved horses—you can develop such a strong bond with them. They truly do look through your eyes and see your soul. They have the ability to look right into your heart, and I don't know another animal on Earth that can do that."

CHRIS CAGLE

ASKING ME WHY I LOVE HORSES IS THE SAME AS ASKING ME WHY I LOVE MUSIC," SAID CHRIS CAGLE. "MUSIC JUST IS AND HORSES JUST ARE. I WISH I COULD PINPOINT WHAT IT IS ABOUT BOTH THAT DOES IT FOR ME, BUT I CAN'T. YOU EITHER LOVE IT OR YOU DON'T. I HAPPEN TO LOVE BOTH."

Chris was born in the small town of DeRidder, Louisiana, but his family moved to the Houston area when he was four. Chris began taking guitar lessons when he was six but quit a year later because it was difficult for his small hands to master such a large instrument. Instead, Chris took piano lessons through high school and resumed playing guitar after receiving an acoustic model for Christmas during his senior year.

After high school, Chris enrolled in the University of Texas at Arlington but was soon skipping finance courses to audit music classes. His nights were spent performing in Texas clubs, and by age nineteen Chris realized he was wasting his time at school, so he left Texas to pursue music full time. Chris moved to Nashville in 1994, and spent the next five years performing odd jobs—from waiting tables and tending bar to being a golf caddy—while polishing his songwriting skills.

A few years later, a chance meeting put one of Chris's demos in front of Scott Hendricks, then president of Virgin Records Nashville, and Chris found himself with a record deal. When Virgin closed its country division, Chris was absorbed onto the Capitol Nashville roster. In addition to several new albums, Capitol re-released Chris's debut album, *Play It Loud*, with two new songs, including the number one "I Breathe In, I Breathe Out." While music has always been important to Chris, the presence of horses in his life is important, too.

MAUDE AND PAW PAW

The first horse in Chris's life was a touchy chestnut Quarter-type mare that belonged to his grandfather. The mare was named Maude, after the Bea Arthur character in the television show of the same name. Chris was all of three years old.

"This mare was bitchy to everyone except me," said Chris. "My Maw Maw was a little worried about me spending time with this horse, but my Paw Paw knew the mare pretty well. He told Maw Maw that Maude somehow knew I was a child who was special to him, and that she would never hurt me. From that moment on I was never afraid of the mare, and Paw Paw was right. Maude never did anything to make me lose trust in her. She was always my horse when I went to visit the farm."

As Chris progressed through his school years and into his music career, he continued to ride. He currently owns several horses and spends every second he can with them.

MARIA CHOOSES HER NAME

"Each horse I have now is so devastatingly special," said Chris. "When I buy them, I literally sit in their stall with them until the right name comes to me. I think it is very important that a horse have a name that fits them, that matches their personality."

One horse that Chris named and hopes to have in his barn for a long time is a young filly called My Maria.

"I'll never forget the time I named her. I got a five-gallon bucket and flipped it over and sat on it in her stall. She came up to me and I loved on her. I let her know her boundaries with me and she respected that right away," said Chris. "I always have the radio on in the barn and when the Brooks & Dunn song 'My Maria' came on, she began nodding her head to Ronnie Dunn singing, and that's how she got her name."

Chris said the filly is an unusual dark maroon bay color, with silky jet-black points. With her beautiful build and coloring and her unique personality, it is easy to see how Maria stole Chris's heart.

"She is in the front stall in my barn and when I walk in she chuckles at me, 'Brrr, brrr, brrr.' It's kind of like she's saying, 'I'm fancy! I'm a prima donna! Come

Chris took this spectacular shot of one of his horses performing a sliding stop.

over here and see how special I am!'"

The horse is currently in training for the National Reining Horse Association (NRHA) Futurity and Chris has very high hopes for her.

"She is going to make a huge splash when she enters the arena," said Chris. "First of all, most people don't pick mares for this competition. People want their studs to win this. That way they have the next big thing."

And getting a horse to the NRHA Futurity finals is not inexpensive. By a horse's three-year-old year, it is

possible that in addition to the cost of the horse, an owner could spend twenty to twenty-five thousand dollars in training and nomination fees. That's a lot of money, Chris said, especially when you don't have the option of recouping any of the expenditure in stud fees. But it also shows how exceptional Chris thinks this mare is.

"A few days ago I spoke with [equine clinician]

"WHEN I HANDED PETEY'S LEAD ROPE OVER TO HIS NEW OWNERS I NEEDED THEM TO UNDERSTAND THAT THIS WASN'T JUST A BUSINESS TRANSACTION."

Clinton Anderson on the phone for almost two hours and he asked if I really thought I had one that could win the futurity," Chris said. "And I really think I do. I had two horses that I entered in years past and then pulled because I didn't think they had it. But this time . . . this time could be it."

HORSES MEAN FRIENDSHIP, TOO

Maria is just one of several horses to which Chris has become attached. As a horse person, horses instantly recognize that Chris knows what he is doing and that gives a horse a sense of comfort and security. Chris also has the ability to quickly understand a horse's personality. The result is that Chris and a horse can bond quickly and deeply.

Heza Majestic Chic is a cutting horse who won the Intermediate Open Reining class at the Quarter Horse Congress for Chris. Congress is an elite competition, so a win there is very impressive. Chris later sold the horse, which he named Petey, because he didn't think he had enough time to spend with him.

"[Television host] Lorianne Crook once asked me if it breaks my heart to sell one of my horses. I have to say that when I handed Petey's lead rope over to his new owners I needed them to understand that this wasn't just a business transaction anymore," Chris said. "My eyes welled with tears and I just began crying. I needed them to understand that, and they did. They did."

Chris finds comfort in knowing that his old friend has a special barn and paddock in Las Vegas, along with loving new parents. But he misses his old friend.

"If my back was to Pete, I allowed him to put his face down the center of my back. I'd lean into him and we'd stand there leaning into each other like two posts," said Chris. "When I was riding him, he'd actually cross his front legs right over left and lean back and stretch, just like a cat. He'd lean his whole body back so far that sometimes I'd have to pick my feet up or he'd put them in the dirt. Then he'd yawn with his big old tongue sticking out. You really had to see it to believe it."

CHRIS HELPS HORSES FIND THEIR PURPOSE

The Prophet is another of Chris's horses who is doing very well. Chris named this National Cutting Horse Association (NCHA) prospect "Knothead."

"This horse is just explosive on a cow," said Chris. "I don't know what this horse is going to do over the long haul. He holds his head a little higher than I would like, but that's what he does naturally. He's very impressive at this stage and he has a great personality. He is definitely one of my favorites."

And then there is Mr. Big, nicknamed Roswell.

"Roswell is a big, pretty thing with a big blaze. And he has all these spots running down his face so in the pasture it looks like he has four eyes," said Chris. "He got the name Roswell because from a distance the spots on his face make him look like an alien, but he has six Hall of Fame horses in his pedigree, from his grandsire on down.

"I just feel so fortunate to be involved with the kind of horses that I have," he said. "The more I communicate with my horses, the less I want to communicate with people. Horses are honest. Horses are kind. Most have a great sense of humor. All they truly want is a buddy and a friend, and to be sure no one is going to hurt them. I think deep down that's all people really want, too."

Each of Chris's horses has a purpose in life, whether it is cutting cows or competing in reining competitions, and Chris especially loves directing a young horse into the path for which he or she is best suited.

"THERE'S NOTHING LIKE GETTING TO KNOW A YOUNG HORSE AND DEVELOPING A RELATIONSHIP."

"There's nothing like getting to know a young horse and developing a relationship with them," he said emphatically. "I love watching them progress through their training. When they learn to lope when you kiss to them, when you shift your hips or your weight and the horse responds instantly by changing direction, or moving from a lope down to a trot, or just pointing to them from the ground and saying 'walk' and they walk—well, it's like magic."

HORSES ARE A REFLECTION OF THEIR PEOPLE

Chris also likes to set goals for his horses, and to help them achieve those goals. He does the

same for the people in his life, and if he can introduce a person who has never been around horses to

———❖———

"UNDERSTANDING THE HONEST AND SENSIBLE WAY A HORSE THINKS CAN ONLY IMPROVE THE PERSON."

———❖———

an equine friend, then he has accomplished one of his own goals.

"I know a lot of people who are afraid of horses —my own father is a little tentative around them," said Chris. "When I find someone like that all of a sudden I have a goal, and that is to replace that fear with respect and understanding. It doesn't matter if a person has been around horses all his life, or if he just met his first horse; people should realize that any problem a horse has is because of a problem owner."

As examples, Chris mentioned horses who walk over their owners, or who nip, or who will not respond when asked to move forward.

"Those horses have, or have had, owners who have either abused them, or for some other reason the horse does not respect them," he said. "I enjoy helping people get past that fear and teaching them to un-

derstand the ways of a horse because understanding the honest and sensible way a horse thinks can only improve the person."

The special understanding that Chris has with a horse, and his desire to help other people reach that same understanding, will most likely see Chris retiring from a music career into a full-time life with horses. Eventually.

"Don't get me wrong. I love music. I love my fans. I love the creative process of writing and recording songs. That will always be a part of me and a part of what I do. With music I'm traveling all the time, and then with horses, there is always a show, or an event, or a horse to go look at. It seems that all my passions involve not staying home," laughed Chris.

But the individual companionship that a horse can provide is something that is hard for Chris to pass up.

"Give me a horse, a place to ride, and a reason to go, and I'm there," he said. "As long as it involves a horse, I can't think of a better way to spend my time."

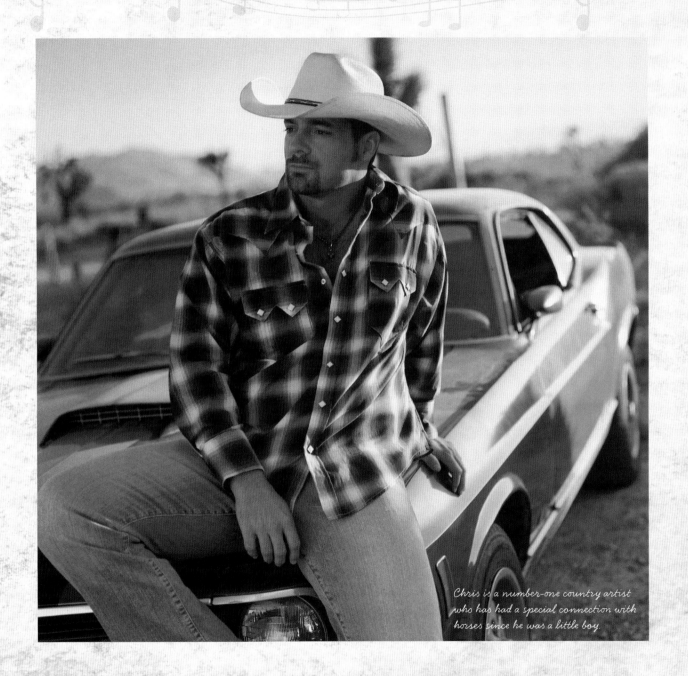

Chris is a number-one country artist who has had a special connection with horses since he was a little boy.

MELANIE TORRES

Melanie Torres may be the only country music star in Nashville with a degree in vocal performance opera. She's also won beauty pageants, and has a growing career in music that includes being a top-ten finalist on the USA network's reality show, *Nashville Star*. Melanie has accomplished a lot, but she gives most of the credit to a handful of horses.

Raised in a musical family, Melanie comes from several generations of musicians and singers. Her great-grandfather was a pioneer in traditional Hispanic norteño and ranchera music. Her grandfather had a band in which her father also played, and her father later branched out with his own band. Her maternal grandfather also loved music and played the organ. It's obvious that Torres family reunions are an occasion to play and sing, both in English and Spanish.

"For many years, horses *were* my life."

As a child, Melanie performed regularly in school musicals and state fairs, and sang in every choir she could find. As a teen she began participating in talent and beauty pageants as a way to win scholarship money, and earned the titles of Miss West Mesa and second runner-up in the Miss New Mexico pageant. Awarded a full scholarship, she attended the University of New Mexico where she performed in theatre productions with leading roles in such classics as *West Side Story*, *Pirates of Penzance*, *The King and I*, and *Oklahoma!*

After graduation, Melanie made her way to Nashville, and in March 2006 Melanie was selected as a top-ten finalist out of twenty thousand hopefuls for the fourth season of *Nashville Star*. The experience gave her career a huge jump-start and exposed her to thousands of new fans.

"It was a very interesting process," said Melanie. "As an artist, the show gives you the opportunity to learn about marketing, imaging, and a lot of the business decisions that go into an artist's career."

As an artist, she also learned about give and take. The show's producers chose to focus Melanie's imaging on her background with beauty pageants. Melanie understood the reasoning behind the decision, but said she would have felt more comfortable had they chosen to focus on her ten-year background of showing Quarter Horses.

"I began riding when I was six years old and stuck with it until I went to college," she said. "Pageants were a very short period in my life, but for many years, horses *were* my life."

It seems that Melanie comes by both her musical talent and a love of horses naturally. Melanie is very proud that she comes from five generations of horse people. In fact, one of her most treasured posses-

sions is a picture of her great-grandfather, who, with her great-great-grandfather, is herding cattle beside a covered wagon.

MELANIE SHARES A HORSE WITH HER SISTER

Melanie began showing in 4-H shows when she was nine. Her first horse was a chestnut half-Arabian, half-Quarter Horse gelding named Pistol.

"Pistol had four white socks and a blaze. He was beautiful, and he had this crazy personality," she said. "When I started showing, we didn't have a lot of money, so my sister and I shared Pistol. I remember in her first showmanship class, she and Pistol walked up to the judge and as soon as she stopped Pistol, he lay down, right there in front of the judge. I know she was mortified! A lot of people were concerned that he was not feeling well, but if you knew Pistol, you knew that wasn't it at all. He did it just because he could. He had this very odd sense of humor."

Melanie and her sister, who is fifteen months older, not only shared a horse; due to their closeness in age they often competed against each other in the same class. But instead of the expected sibling rivalry, the situation brought the sisters closer together.

"I was so lucky to be able to share those experiences with my sister," she said. "We were so close and it brought us even closer. When we both showed an interest in horses at a very early age, my parents wanted us to get involved in showing. It was an expensive hobby,

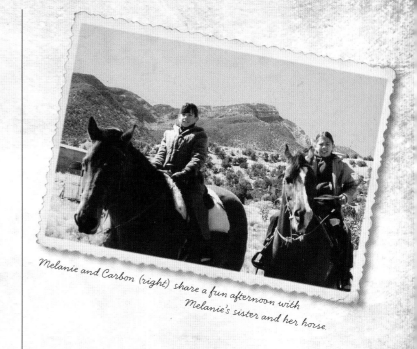

Melanie and Carbon (right) share a fun afternoon with Melanie's sister and her horse.

but my parents felt it was important because the experience could teach us a lot. It did, and we learned so much about sharing, responsibility, poise, confidence, and setting goals."

In fact, Melanie's experiences with horses have been one life lesson after the other. Some of the experiences were joyous, others heartbreaking, but she agrees that all have made her a better person.

"Had it not been for all the skills I developed in the show ring, I would not have done nearly so well when I began entering pageants, or when I began performing on stage," she said.

AN EMOTIONAL RIDE WITH CARBON

Eventually, when her parents believed that both girls were interested and motivated enough to stay in the show ring for a few years, Melanie got her own horse. The horse was a relatively young well-bred bay gelding named Zeus' Carbon Copy, who was by the great Quarter Horse sire, Impressive. Melanie and Carbon quickly grew very attached to each other and spent the next year riding, practicing, competing, and bonding. Then one day Melanie went out to the pasture to find her friend lying motionless in the hot midday sun. In just an instant, her beloved horse was dead and her world was rocked to its core.

As Quarter Horse breeders now know, Impressive often passed on a genetic mutation called hyperkalemic periodic paralysis, sometimes called HYPP, or Impressive syndrome. In the 1990s, research by the American Quarter Horse Association and the Equine Research Laboratory at the University of California, Davis, discovered the problem was related to elevated potassium levels in the blood serum. Symptoms include sporadic attacks of muscle tremors, weakness, collapse, or even sudden death. Most affected horses can now be controlled with medication and a low-potassium diet. Sadly, a test for the condition was not developed until 1992, and knowledge of the situation was not generally known until 1996, or later. As Carbon died in the late 1980s, both dates were far too late to help Melanie or her beloved horse.

"I was a mess for a long time after that. I was only nine or ten years old and the shock of his death was so devastating to me that I can't really put it into words," she said, still emotional about the loss many years later.

To help her through the grieving process, Melanie's parents leased a horse from her trainer, Debbie Warrick. The horse was an older show-ring veteran who was an easy ride and a loving companion. Tuffy Sweet turned out to be a very sweet transition for a young girl who was trying to regain her footing in life. He helped rebuild her fragile emotions, and when Melanie was again ready for actual horse ownership, her trainer found her the perfect horse.

"Through showing, I learned to be professional, to get along with others, and to be organized."

MELANIE FINDS A COMPASSIONATE COMPANION

Skippa's Rocket, nicknamed Rooster, was another sorrel horse with four white socks and a blaze, and an interesting past. Warrick's father had rescued Rooster from several aggressive stallions when Rooster was still a young colt. The stallions had cornered the young horse in a large drainage ditch, terrifying the colt. But after a few years of training, Warrick's daughter had competed on him with some success. By the time Melanie came into the picture, Rooster was a seasoned pro.

"Rooster was a very compassionate horse and was great for a girl like me who was growing up, crying regularly through the roller coaster ride of her teenage years," remembered Melanie. "Pistol was a ham, but Rooster was a very thoughtful horse. He loved standing outside at the end of his run at night looking at the stars, or at the heat lightning in the distance. I'd go out there and hug him and talk to him. I believe he not only listened to every single word I said; I believe he understood every bit of it. We had such a strong connection. He was such a great companion."

Melanie and Rooster began their 4-H and Quarter Horse show career in the 11 & Under age division and competed for the next seven years, until she was ready to go to college.

"We did it all. Showmanship at halter was my favorite because I loved the detail and precision of the groundwork, and the glamour of the class," she said.

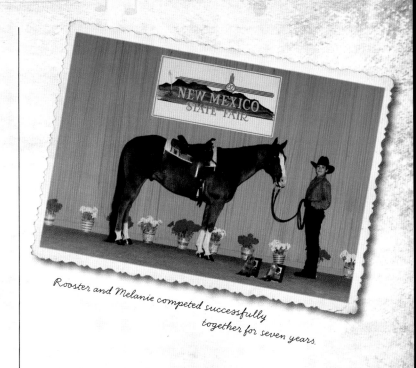

Rooster and Melanie competed successfully together for seven years.

"Before I got him, Rooster had gone to the AQHA world championships in trail, so he was very good with the obstacles in that event. And of course we did English and Western pleasure and equitation. Occasionally we'd trail ride or run barrels or poles, just to have fun, and he loved that. Show horses don't often get to do that kind of thing, so it was a special treat for him, and for me, too. Rooster was just this great all around horse."

When Melanie went off to the University of New Mexico she had a difficult decision to make. Should she keep Rooster at home, where she realistically

> **"The shock of his death was so devastating to me that I can't really put it into words."**

would not have much time for him, or should she sell him to someone who could give him the attention he deserved? Once she weighed her own needs against his, the choice became clear. Rooster deserved all the love and attention he could find. The choice became even easier when her trainer found another rider in the same barn who was looking forward to providing all that Rooster needed.

Years later, after his show career was over, Rooster was donated to a therapeutic riding facility. It's a place where, after a day spent helping people with disabilities, he can wander outside to look at the stars. Occasionally, Melanie visits him and together they remember old times.

SHOWING BRINGS MORE THAN BLUE RIBBONS

"Showing horses and the horses I showed gave me so much," said Melanie. "I am so grateful that my mom and dad were self-employed so they could arrange their schedules to cart us around, because I never could have accomplished all that I have today if I had not had those experiences. Showing taught me to be a gracious winner, and to smile instead of cry when I was disappointed in my performance. It taught me sportsmanship and how to be genuinely happy for another person if they placed higher than I did. Showing taught me to work hard and never to give up on your goal. It taught me the pride that goes with doing a good job. Through showing, I learned to be profes-

sional, to get along with others, and to be organized, and those are all skills I need in my everyday life."

Most importantly, the world of horse shows taught Melanie that money has nothing to do with success.

"When we'd go to a show, we'd pull up in our old truck and our little two-horse trailer, while everyone else was driving semis. We'd be walking around the show grounds while the competition was getting shuttled around in golf carts. They had saddles and horses that cost ten times what our saddles and horses cost. But you know what? We won a lot of our classes anyway. We worked hard and that was the source of our success, and I am so glad I had the opportunity to experience showing from that perspective, because it definitely has made me a better person."

Something else the show arena gave Melanie was experience in being judged.

"When I began doing pageants, and later with *Nashville Star*, so many of my competitors were not used to being judged. They hadn't learned that a judge's opinion is just one person's opinion and that there are a lot of other people and opinions out there," she said. "If you don't win, the rejection can be hard to take if you do not understand that. I had learned that many times over and was able to use the experience as a motivation to better myself. In that way, the ups and downs of pageants and *Nashville Star* did not affect me as much as some of the other contestants, because I'd been judged forever.

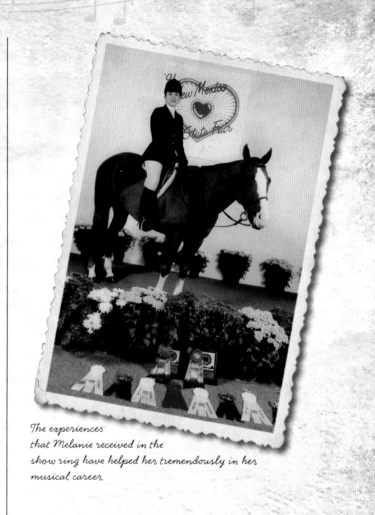

The experiences that Melanie received in the show ring have helped her tremendously in her musical career.

"I was also fortunate to have the horses I did at the times I did. Each horse was perfect for me for that time of my life. I'm pushing my career pretty hard right now but I definitely see horses in my future. Once you've had horses in your life, life is not quite the same without them."

CHAPTER TWENTY-FIVE **KIX BROOKS**

(BROOKS & DUNN)

KIX BROOKS WAS BORN IN SHREVEPORT, LOUISI-ANA, AND SPENT MUCH OF HIS YOUTH ON HIS GRANDFATHER'S DAIRY FARM. AND WHILE HORSES WERE NOT A HUGE PART OF HIS UPBRINGING, HIS CAREER IN MUSIC INTRODUCED HIM TO A HORSE WHO WOULD BECOME VERY IMPORTANT IN HIS LIFE.

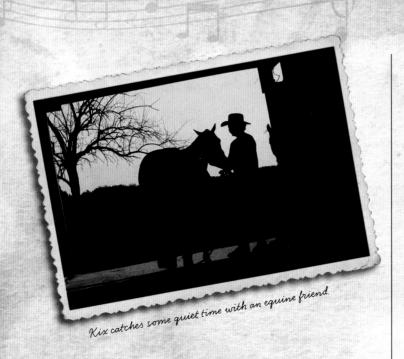

Kix catches some quiet time with an equine friend.

Music was always a passion for Kix, and at the age of twelve he made his public singing debut at a friend's birthday party. By the time he teamed up with Ronnie Dunn in February 1991, both Kix and Ronnie had promising solo careers.

You could say that the idea to join forces was a good one. To date, the duo that knocked Nashville off its feet has sold more than thirty million records, had twenty-three number-one hits, and won over eighty major industry awards. They have even appeared on the front of Kellogg's Corn Flakes cereal boxes. Brooks & Dunn currently hold the record for the most awards won at ceremonies for both the Academy of Country Music and the Country Music Association. Kix also serves as the host of *American Country Countdown*, an internation-

ally syndicated radio program that counts down the top forty country songs of the previous week.

Both Kix and Ronnie make it a point to lend their time and names to worthy causes. Kix served as president (2004), and chairman (2005), of the Country Music Association. He remains an active board member and serves as part of the Blue Ribbon Committee, a select group of professionals chosen to bring the city of Nashville and the music industry closer together. Kix is also on the boards of Vanderbilt Children's Hospital and the Nashville Convention and Visitors Bureau.

With singles such as "Ain't Nothing 'Bout You," "How Long Gone," "My Maria," "Hard Workin' Man," and "Boot Scootin' Boogie," Kix Brooks and Ronnie Dunn have managed to reach the top and stay there for close to two decades. They obviously spend a great deal of time on the road, but when each steps off his bus, it's family time that is important.

KIX DELIVERS A SURPRISE

Kix and his wife of more than twenty-five years, Barbara, are heavily involved in breeding and showing Quarter Horses and Paints, and are seen regularly on the cutting horse circuit. But it wasn't until the early 1990s that horses came into their lives.

"I surprised Barb with a horse one year for Christmas," said Kix. "We went down to my dad's farm in Louisiana for Thanksgiving, I think this was in 1993, and we got there real late at night. I'd planned this all out ahead of time. I had some longhorn cattle down

there, so after we got there, I said to her, 'Let's go see the longhorns.' So I found a flashlight, and led her past this corral where this horse was and the horse came up to the fence. Barb started petting the horse and asked, 'Whose horse are you?' And I said, 'Guess.' Well, it was a horse I got for her. It was her first horse and she was thrilled."

The gift of the horse, a beautiful Paint mare named Angel, provided one of Kix and Barbara's closest moments as a couple.

KIX MEETS PRIETO

Through Angel, and through Barbara's love of horses, Kix became involved in horses himself. But he hadn't found that one perfect horse to bond with until he went to a remote location in South Texas to film the music video for "My Maria." There he fell in love with a big, black horse with a distinctively narrow white blaze named Prieto. Prieto is the horse he rode in that video.

It's easy to see why Kix loves the horse, as the video is as much a showcase for the horse's talents as it is for the song, or for Brooks & Dunn. Prieto was selected for the role because of his ability to rear on command, and there are some very impressive shots of Kix and the horse reaching up into the desert sky. But the horse has many other talents, including willingness and versatility. Much of the video shows Kix and Prieto splashing through a river, or galloping down a narrow canyon, across a mesa, or up a rocky bluff.

"This horse is so athletic," said Kix. "It doesn't matter what you ask him to do, he just gets it done."

Kix was so impressed with Prieto that he eventually bought him. When Kix first met Prieto, a man named Happy Strand, who was involved in bringing the film industry to Texas, owned him. When Happy died, Kix bought the horse from his wife. Prieto, whose

"THIS HORSE IS SO ATHLETIC. IT DOESN'T MATTER WHAT YOU ASK HIM TO DO, HE JUST GETS IT DONE."

name means "dark" in Spanish, has since developed his own group of fans. The "My Maria" video continues to be included on top playlists on the Internet, and many people watch the video specifically for glimpses of Prieto. Kix is not surprised.

"There is just something special about this horse," Kix said. "I still am amazed at everything this horse can do. He also has this presence that I can't

quite describe. In a person it would be called charisma. It's that extra something that makes you sit up and take notice of him. Prieto is also very smart and

"THESE HORSES EACH HAVE A PERSONALITY THAT MAKES THEM VERY UNIQUE AND VERY SPECIAL."

very well-trained. I just had to bring him home because he provides everything I ever thought a horse should provide—companionship, intelligence, fun, beauty—it's all there.

"I can't tell you how glad I was to have gotten him," said Kix. "Very glad, because from the moment I saw him I couldn't stop thinking about him. But I know my manager wishes I'd bought him before we filmed the video. I think he would have come a little cheaper!"

A PASSION FOR CUTTING

Prieto's home is at Kix and Barbara's Painted Springs Farm. The farm is located just outside of Nashville, near property owned by Tim McGraw and Faith Hill. While the farm has been home to many kinds of horses,

including miniatures, in recent years, the farm has become well known in the Paint horse industry, and in the Quarter Horse world for its quality cutting horses.

"Cutting horses are horses that can run, and stop, and turn on a dime," Kix explained. "A good cutting horse can mirror the moves of a cow perfectly, until the cow just turns away in defeat. It is an incredible, beautiful process to watch and can be mesmerizing when done right."

Kix added that riding a cutting horse is an experience like no other, and compared it to a wild carnival ride. "Good riders and good horses make it look easy, but riding a cutting horse is hard—a lot harder than it looks," he continued. "If you're not careful, they'll flat throw you out of the saddle with their moves."

Kix and Barbara breed most of their horses to sell, but Kix has found that even though there are a lot of willing buyers, sometimes the selling part becomes a problem.

"Barb gets too attached to the horses and doesn't want to sell," he laughed. "Trying to buy a horse from Barb is more rigorous than getting into the Augusta Country Club."

THROUGH THICK AND THIN

Kix said that in addition to Prieto, each horse he spends time with grows on him. One horse in particular, Playboys Lil Peppy, came to Painted Springs Farm as a three-year-old and has a wonderful story. Barbara had showed the mare at a number of major cutting

horse events, and not only consistently ended up in the finals, but won a good number of the events. But after one competition, the mare somehow kicked through her stall wall and injured her hind leg.

"There were some cuts on her leg, but nothing at all that led us to believe that she couldn't continue her training," said Kix. "We all thought she was going along just fine."

But several weeks later, her trainer noticed a hesitation when he asked the mare to back up.

"We took her to the vet and found she had a very small fracture to her cannon bone," Kix said. "We all were heartsick. This horse had done so well for us and we were very concerned about her. But we rested her up and fortunately she healed very well. A few months later she was back at it.

"You really can't help but get attached to these horses," he said. "It is very easy for them to become like family. For us it is a business, but these horses each have a personality that makes them very unique and very special. So when something happens, there is no choice. We have to get the horse the best care there is."

KIX AND BARBARA GIVE BACK

In the fall of 2001 Kix and Barbara hosted the first annual Music City Futurity. The event featured nine days of cutting competitions, and Kix and Barbara were heavily involved in everything from planning to execution. More than five hundred participants came from as far away as California, Oregon, New Mexico, and

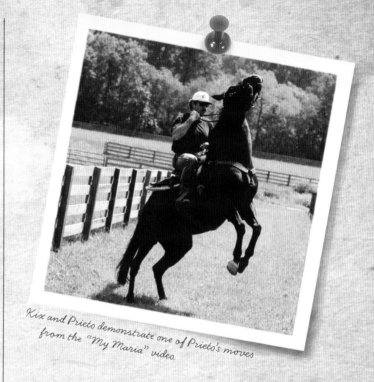

Kix and Prieto demonstrate one of Prieto's moves from the "My Maria" video.

Rhode Island. In cutting horse circles, the Saturday night concert headlined by none other than Brooks & Dunn was not only a highlight of the event, but of the entire year. After the event Kix and Barbara presented Vanderbilt Children's Hospital and the Ronald McDonald House a check for more than $68,000. Over the years, the futurity has grown into an even larger annual event with close to $200,000 in added purse money.

That's a lot of money, but Kix probably wouldn't take that for Prieto.

"I have found the perfect horse," he said. "I couldn't ask for more."

TODD FRITSCH

It's hard to tell which Todd Fritsch loves more: cowboy life or country music. The good news is that this talented Texan doesn't have to choose.

Born in Brenham, Texas, and raised in the tiny Southeast Texas town of Willow Springs, Todd is the most recent member of an elite group that includes George Strait and the late Chris LeDoux.

They are all real-life cowboys who have made their mark in country music.

Todd's dad founded the Fritsch Cattle Company, a four-hundred-acre ranch that handles up to forty thousand head of cattle every year. Todd grew up on the ranch and in the ranching way of life.

"The cowboy way is what I'm all about," said Todd. "I grew up with my two older brothers hauling feed, riding horses, driving tractors, working cattle, and cutting hay. And to this day I still train horses, doctor cattle, ride the fence line, and repair the fencing. That lifestyle and work ethic is my heritage and is something I'll never give up."

While Todd won't give up ranching, he may have to cut back a little because another thing Todd won't let go of is his love for writing and performing traditional country music. He's racked up over 200,000 miles in the last two years, performing at rodeos, honky-tonks, and large fairs and festivals. The impressive number of miles doesn't even include his numerous international performances, which earned him the title of 2006 European Country Music Association Male Vocalist of the Year. He also won their Album of the Year award for his self-titled debut disc.

But not all Todd's success is overseas. Todd has been one of the top acts on the Texas Music charts, seen his music videos played on country music cable channels Great American Country and Country Music Television, and made the top five in *Music Row* magazine's Favorite New Artist Poll of 2005.

TODD FINDS A ROCKY, ROCKY ROAD

While Todd loves music and spending time with his fans, he also enjoys spending time with his favorite horse, Rocky.

"I started Rocky under saddle the first year I was out of high school," said Todd. "He was out of a mare that we bought at a sale barn—a running Quarter Horse mare. We didn't even know she was bred, then one day she bagged up and out popped this beautiful bay colt."

A little research turned up the fact that the colt was a well-bred Hank Leo descendant. Hank Leo was

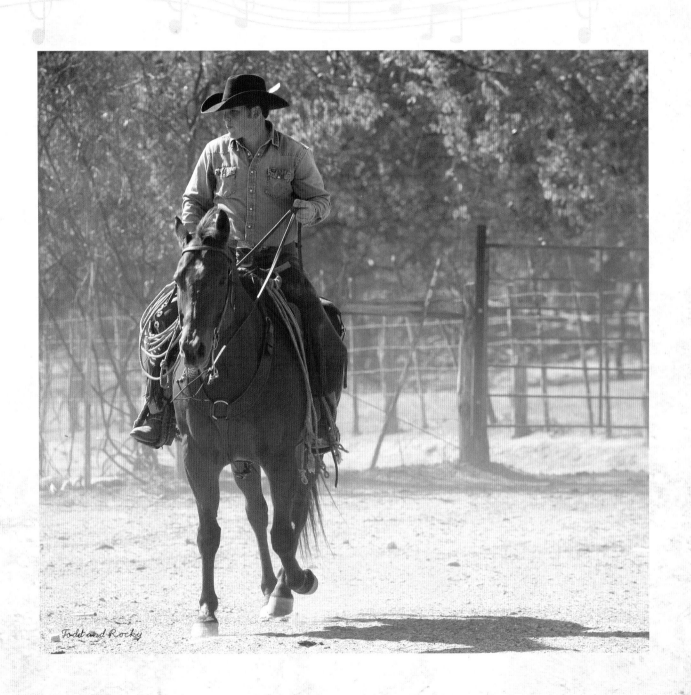

Todd and Rocky

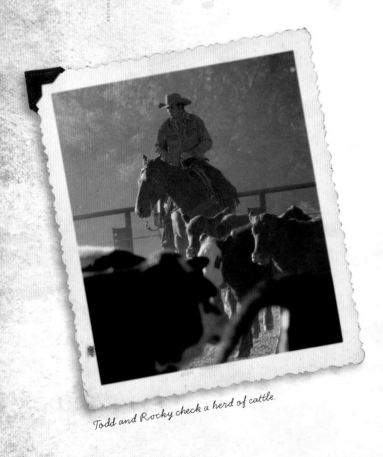
Todd and Rocky check a herd of cattle.

⚬⚬⚬

"He's the only horse I've ever had who will die on my place."

⚬⚬⚬

an own son of the mainstay Quarter Horse sire Leo and out of a granddaughter of the Quarter Horse foundation sire King.

"About that same time, my dad said he wanted to buy us kids some colts," said Todd. "I knew this horse was special, so I told him, 'Thanks, but I already have mine.'"

The singing cowboy, who spent four years in the Fayetteville, Texas chapter of the Future Farmers of America, said that Rocky really didn't take to training all that well.

"I was to the point of giving up on him as a four-year-old," Todd said with a shake of his head. "Then I got in a bind with some other horses and had to ride him a lot."

The miles Todd put on the colt helped, because one day everything seemed to click for Rocky, and for Todd.

"It was like all his ducks lined up in a row and he quit fighting me," said Todd. "Now he's one of the best horses we've got on the ranch and I wouldn't part with him for anything. Actually, he's the only horse I've ever had who will die on my place. Even after he's too old to ride, he'll always have a home with me."

In a business where working cowboys can exchange horses as often as car dealers trade cars, what is it about Rocky that puts him at the top of Todd's list of favorite horses?

"Well, if I need to rope a big bull cow, he's definitely the man," said Todd. "Whatever comes my way,

I know I can count on Rocky not to get me in a jam. If I have to ride wide open I know I can trust him. If a mistake is made it'll be my mistake, not his. Rocky knows what he is doing and I'd trust his judgment over mine any day."

Todd said that as a younger horse, Rocky was not very friendly. So Todd turned him out in a pasture near the house and eventually Rocky began wandering over when people came outside. The fact that Rocky came over to see what the people were doing led Todd to believe that Rocky's intelligence and natural curiosity would eventually win out over his tendency to be standoffish. It did, but not right away.

"As a young horse, Rocky would swish his tail all the time, and he did it in a way that showed me he was angry. Man, he was one angry horse," laughed Todd. "And you know, he still does that occasionally today. Because I've spent so much time with Rocky I know that when the tail starts going, we're done. He's fed up—either with me, or the situation—and I've lost his attention for the day. It doesn't happen very often anymore, but when it does, he's usually right. It's time to quit."

DOING HIS HOMEWORK PAYS OFF

Knowing specific information about Rocky has helped the pair bond and Todd said that knowing the ins and outs of a particular horse is important.

"I spend countless hours watching a horse before I begin to work with it," he said. "I want to know ev-erything I can about the horse. I want to know what it does when the lawnmower starts up, how it behaves in the barn, who the horse hangs with in the pasture, if it is afraid of dogs. Every bit of that information can be useful to me in training and riding a horse. I don't always know how, but I want to have the answer ready when the time comes."

Todd feels that knowing a horse that well is not just a matter of safety. It helps the horse feel comfortable enough to generate some trust.

"The day Rocky turned the corner, his personality changed because that was the day he began to trust me," Todd explained. "I like to look a horse in the eye and once the eye is calm, that's when you can really accomplish something with a horse. That's when a horse is ready to learn. Before that day, Rocky's eye was never completely calm; he was never truly at peace around me. Then I guess he figured out that I was an okay guy and that it would be better if we worked together. Now, sometimes it seems I just think something and Rocky does it. We're that close.

"Some horses, though, never get that way," he added. "They never trust you enough to become one with you. But once they become solid with you, the relationship, like the one I have with Rocky, is incredible."

It took Todd many years and dozens of horses to figure that out.

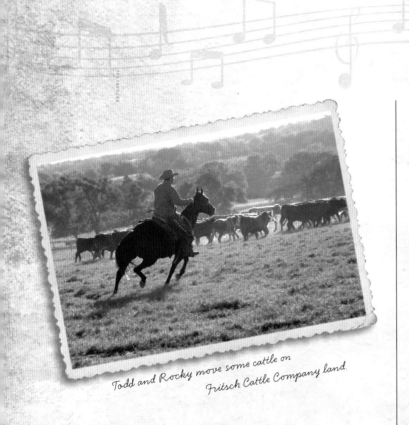

Todd and Rocky move some cattle on Fritsch Cattle Company land.

A BIG HORSE HELPS A SMALL CHILD

While Todd has been riding since about the time he began walking, he didn't have a horse that was "his" until he was about five.

"I had some ponies, but the very first horse I had was an ex-racehorse, another running Quarter Horse, and we called him Big Boy," said Todd. "My dad had used this horse on the ranch and he was a big bay horse with a blaze face, 16 hands or so. He was so big they'd have to chuck me up on him so I could ride. If you can imagine me up there with short little legs sticking out about sideways; if I came off in the brush or when I was penning cattle, I had to lead him all the way back to the pens to where I could climb up on a fence and get back up on him."

The process gave Todd a good incentive to stay on the horse. And looking back, Todd reasoned that his dad had to trust the big horse a great deal to let his young son have free rein. And even at age five, Todd knew that Big Boy would take care of him.

"This horse let me walk right up to him and catch him. Every time," marveled Todd. "I mean how big is a five-year-old boy? This horse could have walked away from me, he could have run across the pasture or kicked out at me, but instead he dropped his head down so I could reach it and let me come right on up and take him back to the barn. He was just this amazing horse."

TODD ENCOURAGES COMMON SENSE

Not all the horses Todd has come into contact with have been quite so remarkable.

"When we were kids, my dad never had the money to buy a trained horse, so he'd go to the sale barn, bring one home, put us boys up on the horse and tell us to have at it," said Todd. "Early on, I got bucked off and run through trees. But it made all of us better cowboys because we learned so much from these horses that other people had messed up. It kind of made me

believe the old saying 'More horses make good cowboys than cowboys make good horses.'"

Today Todd and his brothers buy a lot of yearlings and two-year-olds. Some they train and sell. Others they keep to use on the ranch. But while that works for him, it's not something he recommends for the inexperienced horse enthusiast.

"The first thing *not* to do is go buy yourself a young horse and think you and the horse will learn together. Go buy a trained horse. Buy something that knows what he is doing or you'll both go and get hurt," said Todd.

Todd said that it is common sense in any venture to learn from someone who knows more about the subject than you do. And no one knows more about being a nice, quiet, respectful, well-trained horse than an older nice, quiet, respectful, well-trained horse.

"Plus, to increase your chances of getting a good horse, buy from someone you trust. If you don't know any horse people, ask the person you are dealing with for references . . . and then talk to the references," said Todd. "If you are going to stay safe, you have to trust your instincts. If a horse is broncy, if it bucks or rears, pins its ears flat back, runs away, or bites, don't buy it. Just like dogs and people, there are good horses and bad horses. And don't be a hot shot. Buy a nice quiet horse the first few times around."

The advice is important to Todd because he'd like to see more people get involved with horses.

"It's a great way to have fun, and to spend time with your friends. If you have the slightest interest, I say go for it. Personally, I love the challenge of learning a new horse," he said. "I love the quiet companionship a horse gives a person. Spending time with a horse is a great way for me to de-stress. Honestly, horses are simply one of the best things in my life."

"I just think something and Rocky does it. We're that close."

GEORGE JONES

GEORGE JONES GREW UP IN A SMALL, RURAL COMMUNITY IN EAST TEXAS. IF PEOPLE IN GEORGE'S NECK OF THE WOODS WERE LUCKY ENOUGH TO HAVE A HORSE, IT WAS DEFINITELY A HORSE THAT EARNED ITS KEEP MORE LIKELY, INSTEAD OF A HORSE, THEY'D HAVE A WORK-WORN MULE. IN THE THIRTIES AND EARLY FORTIES, WHEN GEORGE WAS A SMALL BOY, HE OFTEN

spent summers at the home of an older sister and brother-in-law. They kept a mule, and one summer day, with grasshoppers threatening to take over the cotton planted in the fields, George learned an important lesson.

"We had a big, handmade wooden sled with a railing around it that we hooked to this mule," said George. "I was supposed to hang onto this rail and drive this mule up and down the rows of cotton while my brother-in-law, Dub, poured a mixture of bran and arsenic and syrup by hand over the cotton."

The mix was tasty to grasshoppers, but also lethal. At some point, George stopped the mule as he and Dub happily surveyed the growing number of dead insects. But there was more work to be done, so there was not a lot of time for reflection.

"I had just hollered at the mule to get going," George recalled, "when this dog cornered a skunk not too far from us."

But at the time, George and Dub didn't know it was a skunk, thinking instead that the dog might have cornered one of the many varieties of poisonous snakes found in the area. They cautiously left the mule, and went to investigate.

"When we realized it was a skunk, we both lit out of there as fast as we could go," said George. "I was running toward the mule and yelling, and mules aren't dumb. He knew something was up."

Horses (and mules) often take their cues from their human partners, and this time was no different. The mule apparently thought that if George and Dub were running and yelling, he should be too. So the mule promptly galloped off across the rows of cotton, flinging the tub of Dub's insecticide every which way before running through a barbed wire fence.

"The mule just took the fence and a gate clean out," said George. "I was all upset—the mule was bleeding, the fence and gate were ruined, the sled was a pile of broken pieces of wood, and I was sure Dub was going to whup me good."

GEORGE GETS A SECOND CHANCE

Instead of a whupping, Dub gave George a hug and together they spread ointment on the mule's cuts.

"You'd have thought after that fiasco that Dub wouldn't have trusted me to drive that mule. But he did," said George.

The next day George, Dub, and the mule were all back out in the field with more of Dub's homemade insect brew, and at least part of the cotton crop was saved. The incident taught George a little bit about mules and a lot about people.

"That next day, I wasn't going to let go of that mule for anything," said George. "I'd learned that much, for sure. I didn't even let go when my sister came out to bring us lunch. I just ate with one hand holding onto those reins. And I had definitely learned not to run and scream and yell so's he'd take off. That poor mule hadn't done anything I hadn't told him to do with all my carrying on. I promised myself that in the future I was only going to act in a way that was going to give me the response from the mule that I wanted. I wasn't always successful, but I sure tried."

George also learned that kindness and trust—and maybe even a second chance—go a lot further with a person than harsh words and a whipping.

When he was a little older, George occasionally skipped school and took off into the woods. Sometimes one of his many relatives would happen by on a mule and George would hop on behind, enjoying the ride and the few hours of freedom. Since then, George's experiences with horses, even the long-eared variety, have been far more positive and constructive in nature.

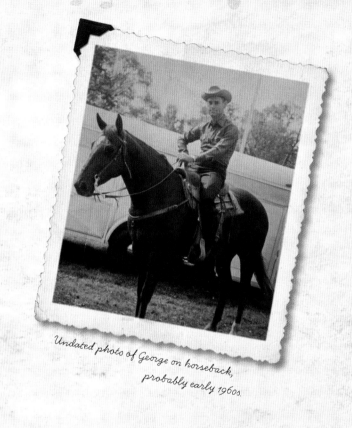

Undated photo of George on horseback, probably early 1960s.

"THAT POOR MULE HADN'T DONE ANYTHING I HADN'T TOLD HIM TO DO."

MUSIC CALLS

George left the cotton fields for the honky-tonks when he was still a young teen. He first hit the music charts in the 1950s and is one of only a handful of artists who can count number-one records in every decade since. He is regarded by many as the world's leading honky-tonk singer, and has the life and the career to prove it.

In 1962, and again in 1963, George was voted Male Vocalist of the Year for the Country Music Association. And when George found the perfect duet partner in Tammy Wynette, they hit number-one several times, including with "We're Gonna Hold On," "Golden Ring," and "Near You."

George won his first Grammy in 1981 for "He Stopped Loving Her Today." That song also earned him Single of the Year honors from the Country Music Association in 1980 and again in 1981, along with virtually every other award available. His video for "Who's Gonna Fill Their Shoes" won the Country Music Association's Video of the Year in 1986, and in 1992 the Country Music Association recognized George's monumental career by inducting him into the Country Music Hall of Fame. A few years later, in 1996, George released his autobiography, *I Lived To Tell It All*, which made the *New York Times* bestseller list.

In 1999, George celebrated the fortieth anniversary of his first number-one record, "White Lightning." It was also the year he won his second Grammy, this one for Best Male Country Vocalist for the single, "Choices," which marked George's 164th charted record. In fact, George Jones has had more charted singles than any other artist in any format in the history of popular music.

GEORGE'S SIMPLE PLEASURES INCLUDE HORSES

Over the many years of his career, George has realized that it's the simple things in life that bring him joy and relaxation. And throughout his life, George has found horses to be one of the simple pleasures that life brings.

"There's something about being around a horse that is relaxing to me," George said. "I have always found that to be true, but even more so now than when I was younger."

Somewhere around 1966 George bought a few acres in Texas and began stocking it with Appaloosas,

Quarter Horses, and some Black Angus cattle. He also built a house, a guesthouse, several livestock barns, and a riding ring, and circled it all with beautiful post and rail fencing. There, George built up quite a herd of well-bred horses.

"I like all kinds of horses, including Quarter Horses, which I had a lot of back then," said George. "And I love horse racing. There's nothing quite like seeing horses running down the backstretch toward the finish line."

During that time, George became so involved in his horses and in racing that he was honored with an annual Quarter Horse race bearing his name at New Mexico's prestigious Ruidoso Downs racetrack.

By the early 1990s George had established Country Gold Farms just south of Nashville. He began breeding and raising the working variety of Quarter Horses, horses that instinctively knew how to cut cattle from a herd, and that had the speed and athletic ability to perform the hard sliding stop necessary to a good rope horse.

GEORGE LOVES HORSES BOTH SMALL AND TALL

A few years later one of George's daughters saw a miniature horse at a horse sale and came home very enthusiastic about the tiny animals. Before too long, George's Country Gold Farms had close to twenty of the miniatures.

"These horses are about the size of a real big dog, but they still eat like a horse," laughed George. "For a

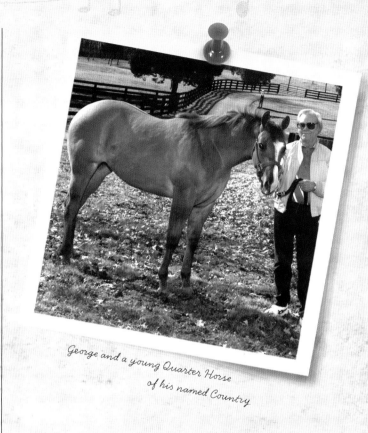

George and a young Quarter Horse of his named Country.

"THERE'S SOMETHING ABOUT BEING AROUND A HORSE THAT IS RELAXING TO ME."

while we had a trainer and got into showing them and I enjoyed that very much. It was something my wife, Nancy, and I could do together that we both enjoyed that was away from the music business."

"IT WAS SOMETHING MY WIFE, NANCY, AND I COULD DO TOGETHER THAT WE BOTH ENJOYED."

The miniature horses also provided some important one-on-one time for George and his grandchildren.

"We had a little buggy—a little carriage—that we'd hook one of them up to and we'd load up one of the grandkids and ride around. They loved it," he said.

George eventually sold the miniatures and, although the number varies from time to time, he still usually has several horses, either there on his farm or with a trainer.

In late 2002, George sent one of his favorite horses, a big two-year-old, 16-hand, 1,725-pound gray Percheron filly named Lakota (by Avatars Knight's Commander) to Florida to be trained for carriage driving. Driving draft horses is as different from racing or rop-

ing as fire is to water, but as George said, he likes all kinds of horses.

A RELAXING PASTIME

While you probably won't see George Jones on the back of a horse or roping cows any time soon, he gets a strong sense of satisfaction by loving his horses from the ground. Indeed, George said he gets immense enjoyment out of watching his horses graze in the pasture.

"I find horses very relaxing," he said, "and totally unlike the entertainment business with all the lies and politics on the business side. My fans have been very good to me and I've had a great career. I've been singing professionally for more than fifty years. I sing from my heart, I love country music and I love the people that respond to it. But sometimes I like to step back from that. I like walking around the fields and watching the sun set. I don't have nearly the time that I'd like to spend with horses, but they bring something extra to my day to see them out there. I just like to lean on the fence and take it all in. For me, horses are therapeutic that way."

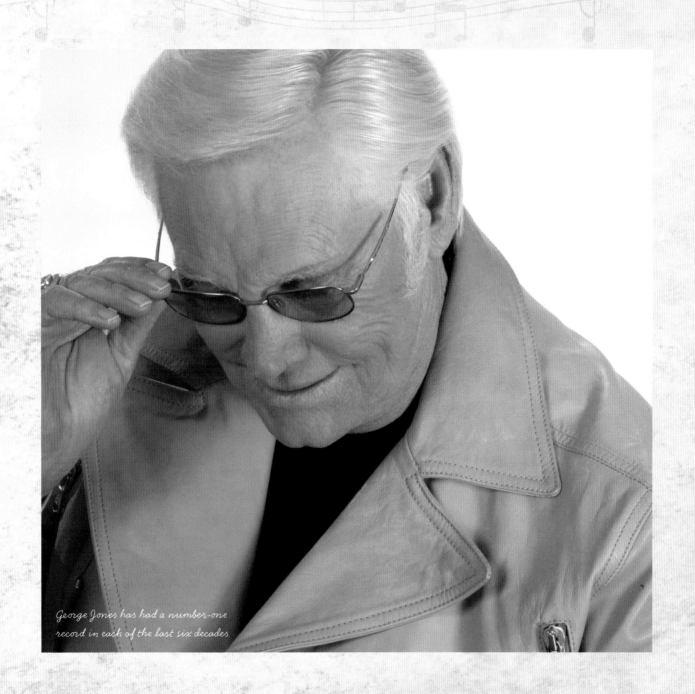

George Jones has had a number-one
record in each of the last six decades

GLOSSARY

Appaloosa: a breed of horse characterized by a white sclera around the eye, vertical stripes in the hooves, mottled (or spotted) skin (especially on the nose), and by either a white "blanket" and spots over the hips, or by many small white or dark spots over the entire body.

Arabian: an ancient breed known for its elegant build and movement, and its versatility.

Bay: a reddish or dark brown horse with a black mane, tail, nose, and legs.

Blaze: a wide, white stripe running down a horse's face from forehead to nose.

Buckskin: a golden-colored horse with a black mane, tail, nose, and legs.

Cannon bone: the long, straight bone that is located below the horse's knee or hock.

Chestnut: a reddish horse with a reddish or lighter-colored mane and tail.

Colt: a young male horse generally three years of age or younger. Usually refers to an uncastrated horse, but sometimes includes a young gelding.

Cow horse (calf horse): a horse who is bred and/or trained to work with cattle.

Croup: the area at the very top of the horse's hindquarters that slopes to the tail.

Cutting: the art of separating an individual cow from the rest of the herd. Many horses are bred specifically for this and have an instinctive sense of how a cow moves and thinks.

Dam: the genetic mother of a horse. A horse is often referred to as "out of" a particular dam.

Dorsal stripe: a narrow strip of darker hair running from the horse's withers to the top of its tail. Often seen with the colors dun and buckskin, and on mules, donkeys, and burros. Sometimes referred to as a "line-back."

Draft horse: a big, heavy horse such as a Belgian, Clydesdale, or Percheron traditionally known as a "work" horse. Draft horses were originally bred in the Middle Ages as war horses, but more recently were used for pulling plows. A draft/Thoroughbred

mix is a popular cross for sport horse enthusiasts, including those involved in fox hunting or eventing.

Dressage: a training program of suppling, balance, and obedience work with varied levels of proficiency.

Dun: a golden or reddish horse with a darker brown mane and tail and a dorsal stripe.

EPM: equine protozoal myeloencephalitis is an infection of a horse's central nervous system. It is caused by ingestion of possum droppings and can result in death.

Foaling: process during which a mare gives birth; assisting a mare in giving birth.

Finished horse: a horse who has completed his or her training in a specific area, such as reining, roping, or jumping.

Filly: a young female horse, generally three years of age or younger.

4-H: an international youth organization that teaches leadership, citizenship, and life skills. Typically thought of as an agricultural organization, 4-H actually encourages members to learn about many topics.

Futurity: any competition for young horses where the horse is entered months (or years) in advance. The owner or trainer then periodically pays progressively larger fees to keep the horse's nomination for the event current.

Gaited: a horse that has a smooth alternative gait either in addition to, or instead of, a trot.

Gelding: a neutered male horse of any age.

Go: short for "go round." All contestants in a competition compete in the "long go," while only finalists compete in the "short go."

Handle: the quickness with which a horse responds to a rider or handler's cues. A horse who has a "good handle" is exceptionally responsive.

Hand: the measurement used to determine a horse's height at the withers. Each hand is four inches, so a horse that stands sixty inches at the withers is said to be 15 hands.

Heading: the art of roping a calf or steer over the horns or head while mounted on a horse.

Heeling: the art of using a rope to catch a calf or steer by one or two back legs while mounted on a horse.

Mare: a female horse generally over three years of age.

Morgan: one of the first horse breeds developed in the United States.

Mule: the sterile hybrid offspring of a male donkey and a female horse, characterized by long ears, a short mane, and a loud "eee-haw" braying sound. Mules come in all sizes and colors, depending on the genetic contribution of sire and dam.

Paint: a stock-type breed similar in build to the Quarter Horse that features large splashy light or dark markings throughout the body.

Palomino: a golden-colored horse with a white mane and tail.

Pony: a small horse; a horse who stands less than fifty-eight inches, or 14.2 hands, at the withers.

Quarter Horse (American Quarter Horse): a stocky breed of horse known for its ability to run fast for short distances, and to rope, work cattle, and turn and stop quickly.

Reining: a difficult Western competition in which horse and rider demonstrate a pattern of fast starts, sliding stops, spins, backing, turns over the haunches, circles, figure eights, and lead changes.

Roan: an equine coat color that has white hairs mixed with the base coat. A red roan is a mixture of chestnut and white, blue roan mixes black and white, and bay roan mixes bay and white.

Roping: using a long lasso-style rope to catch a calf or steer by its head, horns, or heels.

Showmanship at halter: a horse show competition that judges how well a handler presents a horse from the ground.

Sire: the genetic father of a horse. A horse is often referred to as "by" a particular sire.

Sorrel: a horse with reddish-brown coloring. Often used interchangeably with *chestnut*.

Spotted Saddle Horse: a gaited breed that has a colorfully spotted coat pattern.

Stallion: a male horse of breeding age.

Starting: the beginning process, or early stages, of a horse's training.

Steeplechasing: an old sport in which the gentry raced horses several miles over neighboring fields and fences from one church steeple to another.

Stud: another term for stallion.

Team roping: a ranch maneuver for branding or veterinary work, or a competition in which two horse and rider combinations rope the same calf or steer. The header ropes the head or horns first, then keeps the roped animal moving while the heeler catches the back legs, or heels.

Tennessee Walking Horse: a gaited breed of horse known for its unique "running walk."

Therapeutic riding: aiding the development of a person's physical, cognitive, or emotional abilities via horses.

Tobiano: a pattern of coat color spotting in Paint horses in which the base color of the horse is dark and the splashes of paint markings are white.

Trot: a two-beat gait in which the horse's left front and right hind, and right front and left hind, move forward in diagonal pairs.

Warmblood: one of several breeds (including Friesian, Hanoverian, and Bavarian) originally developed in Europe (often by crossing Thoroughbred or other riding horse breeds with draft horses); also a generic term for a riding horse/draft horse cross.

Weaning: separating the foal from the mare and the mare's milk. Can happen anywhere from the time the foal is three months to a year in age.

Withers: the bump that joins the horse's back with its neck. Universally used as a guide to determine a horse's height.

Wrangler: a mostly behind-the-scenes horse handler in the television or movie industry.

RESOURCES

ARTISTS

www.bradpaisley.com

www.brooks-dunn.com

www.charliedaniels.com

www.chriscagle.com

www.chrisledoux.com

www.claywalker.com

www.georgejones.com

www.halketchum.com

www.heidinewfield.com

www.jasonmeadows.com

www.joniharms.com

www.lacyjdalton.com

www.ifco.org/lynn_anderson/
 lynn_anderson.htm

www.myspace.com/
 melanietorresmusic

www.montgomerygentry.com

www.ridersinthesky.com

www.royclark.org

www.sawyerbrown.musiccity
 networks.com

www.tanyatucker.com

www.tobykeith.com

www.toddfritsch.com

www.tracybyrd.com

www.trentwillmon.com

www.twofootfred.com

www.willienelson.com

BOOKS

www.globepequot.com

www.lisawysocky.com

www.lyonspress.com

COUNTRY MUSIC

www.acmcountry.com

www.countrymusichalloffame.com

www.countryweekly.com

www.cmaworld.com

www.cmt.com

www.gactv.com

www.ifco.org

EQUESTRIAN

www.allbreedpedigree.com

www.careityfoundation.org

www.celebritycutting.com

www.habitatforhorses.org

www.horsecity.com

www.horsehavenoftn.com

www.kyhorsepark.com

www.letemrun.com

www.narha.org

www.nutrenaworld.com

www.thehorseshow.com

PHOTO CREDITS

Brad Paisley promotional photo: David McLister

Brad Paisley and Pal: Karen Will Rogers

Chris Cagle promotional photos: Russ Harrington

Chris Cagle horse photo: Chris Cagle

Charlie Daniels promotional photo and on horse-back: from the collection of Charlie Daniels

Charlie Daniels and TP King Bear: Dennis Keeley

Chris LeDoux promotional photo and photos with horses: courtesy Capitol Records

Chris LeDoux and bucking horses: from the archives of Doug Hart

Clay Walker promotional photos: courtesy of Webster PR

Clay Walker photo with horse: courtesy of Webster PR and Clay Walker

Eddie Montgomery promotional photo: Margaret Malendruccolo, provided by Webster PR

Eddie Montgomery on horseback: courtesy of Eddie Montgomery

Fred Gill and Gretel: Tony Phipps

Fred Gill promotional photo: by Kristen Barlowe and courtesy of Fred Gill

Fred Gill on horseback: © Tony Phipps

George Jones promotional photo and with horses: courtesy of George and Nancy Jones

Guitar photo: Colby Keegan

Hal Ketchum promotional photo; Gina Ketchum

Hal and Fani Rose Ketchum with horse, Sami: Paula Brown

Heidi Newfield promotional photo: Jim Shea

Heidi Newfield with horses: courtesy of Heidi Newfield

Ira Dean/Trick Pony promotional photo: Mark Mosric

Ira Dean and Ernie photos: Brooke Burrows

Janis Oliver promotional photos: Russ Harrington

Janis Oliver and Redondo: Mark Levine

Jason Meadows horse and promotional photos: courtesy of Baccerstick Records

Joni Harms promotional photo and photo with Duke: Tony Baker

Joni Harms and Midnight: courtesy of Joni Harms

Kix Brooks and Prieto: Ronald C. Modra

Kix Brooks with horse in barn: Ronald C. Modra

Kix Brooks promotional photo: Russ Harrington

Lacy J. Dalton and Mackay: Ronnie Hannaman

Lacy J. Dalton and Mimi: Ronnie Hannaman

Lacy J. Dalton promotional photos: Aaron Anderson

Lynn Anderson promotional photo and photo with Delta: courtesy of Lynn Anderson

Lynn Anderson with Lark N' Lena: by Don Shugart, courtesy of the Careity® Foundation

Mark Miller and Sawyer Brown photos: courtesy of Beach Street Artist Management

Mark Miller family pony, Maddie: photo by Colby Keegan

Melanie Torres horse and promotional photos: from the collection of and courtesy of Melanie Torres

The Riders In The Sky promotional photos: McGuire

The Riders In The Sky taping photo: Michael Marks

The Riders In The Sky gravesite photo: courtesy of The Riders in the Sky

Too Slim on horseback: courtesy of Fred LaBour

Roy Clark promotional photo: © 2007 Chris Hollo / Hollophotographics

Roy Clark with horses: courtesy of Roy Clark Productions

Roy Rogers photos: from the collection of the Steiner family

Street sign photo: Colby Keegan

Tanya Tucker promotional photo: courtesy of Tanya Tucker and submitted by Webster PR

Tanya Tucker with cutting horse: by Don Shugart, courtesy of the Careity® Foundation

Tanya Tucker with Jessie's Girl: courtesy of Tanya Tucker and submitted by Webster PR

Toby Keith photos: courtesy TKO Management

Todd Fritsch promotional photos and photos with Rocky: Marc Morrison / Retna LTD ©2007 and courtesy of Todd Fritsch

Tracy Byrd promotional photo: courtesy of David McLister

Tracy Byrd on horseback: Don Shugart Photography for the Celebrity Cutting and Careity® Foundation

Trent Willmon promotional photo: courtesy of David McLister

Trent Willmon on horseback: courtesy of Trent Willmon

Willie Nelson promotional photo: Randi Radcliff

Willie Nelson horse and Willie Nelson with horses: Turk Pipkin

ABOUT THE AUTHOR

Lisa Wysocky is a former country-music publicist turned therapeutic riding instructor, award-winning writer, and equine clinician. She is the also the author of *My Horse, My Partner* (published by The Lyons Press in 2007). In addition to speaking at songwriting and country music events, Lisa presents equine clinics to horse groups nationwide. Thousands of people hear Lisa speak each year, and most of her presentations are for people who wish to improve their relationship with their horse. She lives in Nashville, Tennessee.